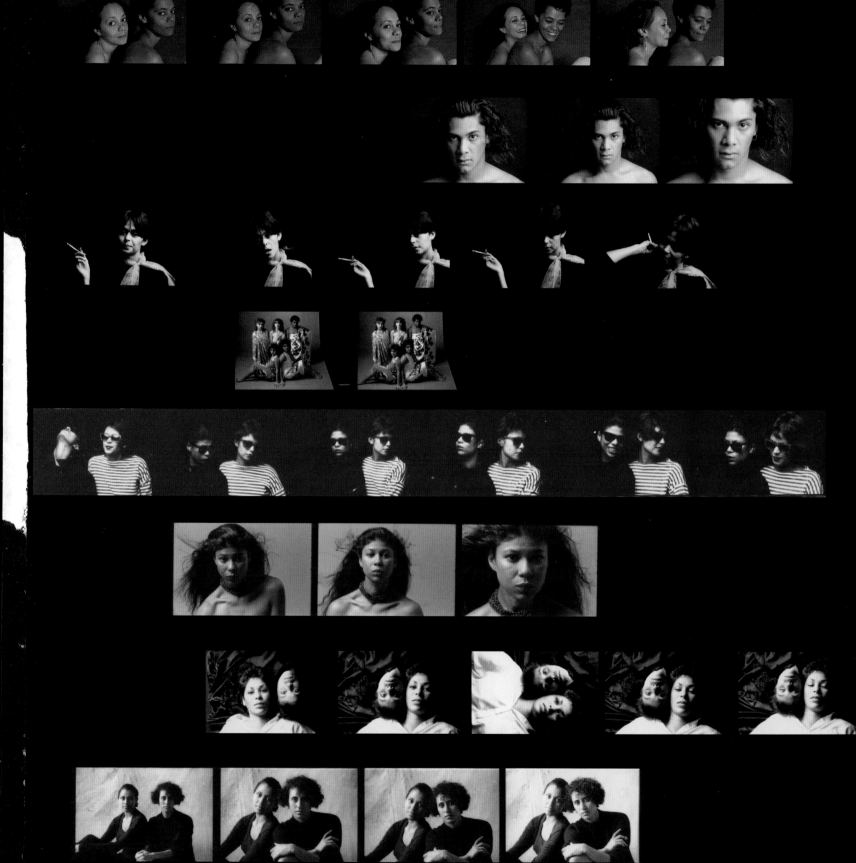

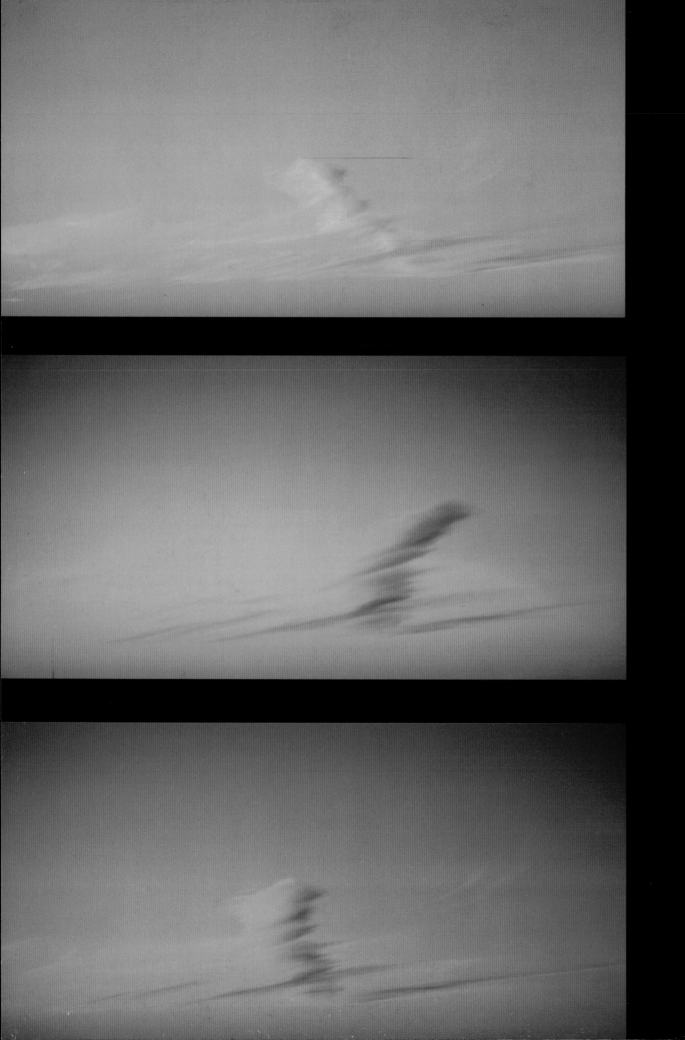

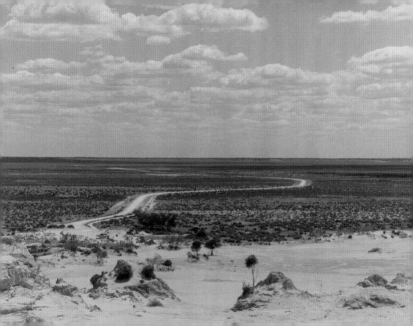

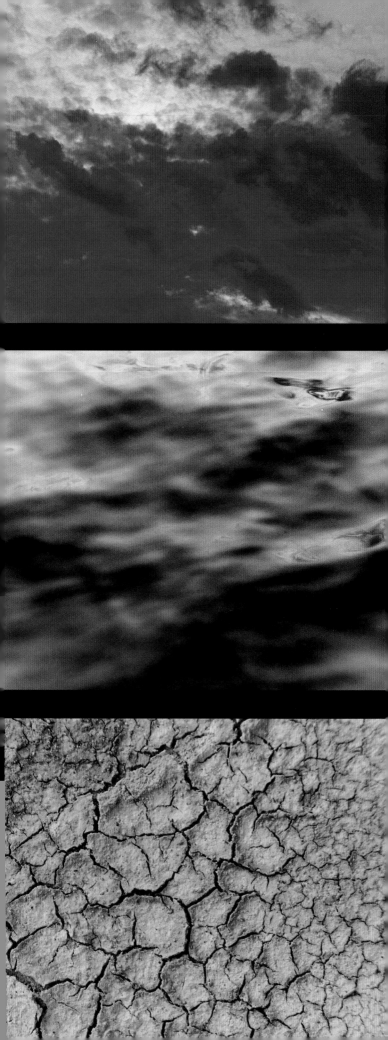

MICHAEL**RILEY**

MICHAEL RILEY SIGHTS UNSEEN

BRENDA L. CROFT

national gallery of **australia**

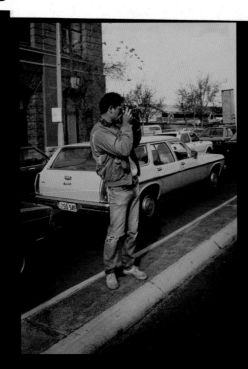

In memory of Michael Riley
(1960–2004)
a strong and generous
Wiradjuri and Kamilaroi man

For the Koori and Murri communities
of Dubbo and Moree
For his friends and family in Sydney and elsewhere
For his son Ben

Michael taught us to keep looking for things
that other people don't see

Produced by the Imaging and Publishing section of the National Gallery of Australia

nga.gov.au
The National Gallery of Australia is an Australian Government Agency

Editor: Kathryn Favelle
Designer: Kirsty Morrison
Rights and permissions: Lisa Cargill
Printer: NCP, Canberra

Cataloguing-in-Publication data
 Riley, Michael, 1960-2004.
 Michael Riley : sights unseen.

 Bibliography.
 Includes index.
 ISBN 0 642 54162 0

 1. Riley, Michael, 1960-2004–Exhibitions. 2. Artists, Aboriginal
 Australian–20th century–Exhibitions. 3. Photography–Australia–
 Exhibitions.
 4. Motion picture industry–Australia–Exhibitions. I. Croft, Brenda L.
 II. National Gallery of Australia. III. Title.

 779.092

Distributed in Australia by
Thames and Hudson
11 Central Boulevard Business Park
Port Melbourne, Victoria 3207

Distributed in the United Kingdom by
Thames and Hudson
181A High Holborn
London WC1V 7QX, UK

Distributed in the United States of America by
University of Washington Press
1326 Fifth Avenue, Ste 555
Seattle, WA 98101-2604

This publication accompanies the National Gallery of Australia's travelling exhibition *Michael Riley: sights unseen*

National Gallery of Australia, ACT 14 July – 16 October 2006
Monash Gallery of Art, Wheelers Hill, Vic 16 November 2006 – 25 February 2007
Dubbo Regional Gallery, Dubbo and Moree Plains Gallery, Moree
 12 May – 8 July 2007, 19 May – 15 July respectively
Museum of Brisbane, Qld 27 July – 19 November 2007
Art Gallery of New South Wales, NSW 22 February – 27 April 2008

Exhibition organised by the National Gallery of Australia with the assistance of the Michael Riley Foundation

Proudly supported by the National Gallery of Australia Council Exhibitions Fund

Exhibition curated in Canberra by Brenda L. Croft, Senior Curator, Aboriginal and Torres Strait Islander Art, National Gallery of Australia

Exhibition administration: Tina Baum, Curator, Aboriginal and Torres Strait Islander Art, and Simona Barkus, Trainee Assistant Curator, Aboriginal and Torres Strait Islander Art, National Gallery of Australia

All works reproduced in this publication courtesy of the Michael Riley Foundation and VISCOPY, Australia

(page 1, top to bottom) *Toni and Maria* proof sheet c.1984 print from colour negative; *Darrell* proof sheet 1990 print from negative; *Avril* proof sheet 1986 print from negative; *Aboriginal designs and models* proof sheet mid-1980s print from colour negative; *Kristina and Avril* proof sheet 1988 print from negative; *Kristina* proof sheet 1988 print from negative; *Melissa and Kelly* proof sheet 1988 print from negative; *Delores and Jules* proof sheet 1990 print from negative All images Michael Riley Foundation
(page 2) *Spirit clouds* 1997 triptych cibachrome photographs Monash Gallery of Art
(page 3) *Road to Mungo* 1999 c-type cibachrome photograph Ruark Lewis
(page 4 top to bottom) *Mission* 1990 triptych *Clouds; Water; Desert* gelatin silver photographs Linda Burney
(page 6) *Darrell* c.1989 gelatin silver photograph National Gallery of Australia, Canberra
(page 8) Michael photographing protest march, Sydney c.1984 Ian 'Yurry' Craigie
(page 9) *Michael Riley* 1997 colour photograph Courtesy of the Australian Broadcasting Corporation

Contents

Foreword

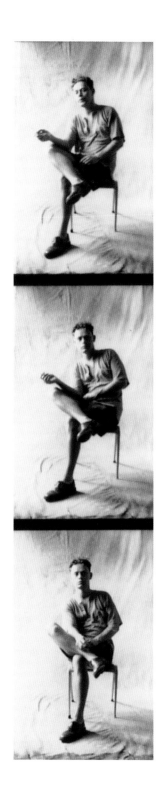

The site where the National Gallery of Australia stands is on the traditional lands of the Ngambri and Ngunnawal people and I am pleased to pay tribute to the original peoples of this region.

Officially opened in 1982, the National Gallery of Australia is one of the newest fine art museums in Australia. Its holdings, however, date back to the late 1950s and include early recognition of the significance of work by Australia's Indigenous artists.

As in other, older public art and socio-historical museums throughout Australia, the first Indigenous works acquired as works of art, not ethnographic objects, were watercolours from Hermannsburg in the Northern Territory. In 1959, pencil drawings and watercolours by the Hermannsburg school of watercolourists, including the renowned Arrernte artist, Albert Namatjira (1902–1959), were acquired for the national collection. Today, the National Gallery of Australia's Indigenous collection spans nearly two centuries of Indigenous arts/cultural practice and consists of almost 5000 works, comprising bark paintings, paintings, sculpture, weavings, textiles, photomedia and works on paper. The earliest work, a shield from the south-eastern region of Australia, is dated to the early 1800s.

Photography and new media by Aboriginal and Torres Strait Islander artists have been important components of this collection since the late 1980s. The exhibition, *Re-take: Contemporary Aboriginal and Torres Strait Islander photography* (1998), highlighted the collecting work undertaken by both the Aboriginal and Torres Strait Islander and Photography departments. Following its opening at the National Gallery of Australia, the exhibition toured nationally. Michael Riley's work was an essential part of that exhibition and, since his work was first acquired in 1990, we have been building upon his representation in the collection.

Michael Riley: sights unseen is one of the most significant exhibitions of Indigenous art to be held at the National Gallery of Australia. A major retrospective of one of the country's leading Indigenous contemporary artists, it is the first exhibition to focus on the career of an Aboriginal artist from the south-east of

Australia. Previous retrospectives have honoured the work of Dr David Daymirringu Malangi (2004), Albert Namatjira (2002), Rover Thomas (Joolama) (1994) and George Milpurrurru (1993).

One of the most important contemporary Indigenous visual artists of the past two decades, Michael Riley's contribution to the urban-based Indigenous visual arts industry was substantial. His film and video work challenged non-Indigenous perceptions of Indigenous experience, particularly those of the most disenfranchised communities in the eastern region of Australia. Over 20 years, he built a steady and consistent body of work, ranging from black-and-white portraiture through to film and video, conceptual work, and digital media.

Michael Riley: sights unseen reveals the prolific talents of a quiet observer, whose photomedia, video and film continue to have a profound effect on our contemporary representation and comprehension of Indigenous Australia. The exhibition and this accompanying publication bring together a comprehensive body of work, charting the vision and experience of one of the country's most important Indigenous visual artists, and chronicling a period of intense cultural development and achievement. The exhibition and publication not only profile Riley's most recognised photomedia, films and video work, but also present many images previously unseen in the public domain.

Significant projects require substantial funding, and we have been very fortunate to secure support for both the retrospective exhibition and the publication of this book in the form of a grant from the Aboriginal and Torres Strait Islander Arts Board of the Australia Council. We have also received support-in-kind from the Michael Riley Foundation and Boomalli Aboriginal Artists Co-operative: the former organisation responsible for ensuring that Michael Riley's legacy is maintained; the latter intrinsically linked with the life and career of one of its founding members and former Chairman.

The contributions from Michael's many family members, friends and colleagues must be acknowledged – we greatly appreciate their support and enthusiasm. I also wish to pay tribute to my predecessor, Dr Brian Kennedy, for his initial support for this project. Thanks also to all the staff of the National Gallery of Australia who contributed to the success of this project. I would also like to thank the staff of the Aboriginal and Torres Strait Islander Department, and Gael Newton, Senior Curator, International and Australian Photography, who has been an advisor to this significant project. Finally, I wish to thank the curator of this exhibition, Brenda L. Croft, Senior Curator, Aboriginal and Torres Strait Islander Art. Drawing as it does on her long friendship with Michael Riley, this project has been both an extremely personal and professional undertaking.

The exhibition has been generously sponsored by the newly formed National Gallery of Australia Council Exhibitions Fund, a bold initiative of this Gallery Council to bolster support the exhibition program.

We hope that *Michael Riley: sights unseen* will generate a greater awareness of the multi-faceted career of one of Australia's most outstanding contemporary Indigenous artists. In doing so, the exhibition highlights the ongoing innovation of contemporary Aboriginal and Torres Strait Islander visual art and culture and the extraordinary contribution it makes to Australian life.

Ron Radford
Director

(opposite) Self-portrait from *Portraits by a window* shoot 1990
proof strip, print from negative Michael Riley Foundation

Introduction

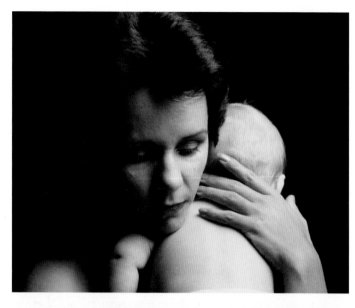

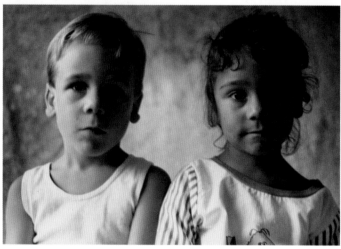

Linda and Binni c.1982 print from negative Michael Riley Foundation;
Binni and Willurai [Kirkbright-Burney] 1990 Linda Burney

It is enormously humbling to have been invited by the National Gallery of Australia to provide this introduction for the catalogue to accompany the exhibition, *Michael Riley: sights unseen*.

I loved Michael and still think of him many times everyday. He was my soul mate, 'little brother', uncle to my children and dear friend. When I think of Michael, I remember him driving me rather alarmingly to the hospital for the birth of my eldest child, Binni. I see his artistic spirit that he nurtured in my daughter, Willurai.

Michael was a funny, complex person. We would sit together for many hours, neither of us feeling the need to talk. As taciturn as he could be, we all adored him, as did our collective offspring. They picked up on his mischievousness. They all had a funny story about Uncle Micky. His lack of patience underpins most of them: like the time he was trying to book a cab on a voice-animated system – Michael yelling at the machine and slamming the phone down using language that could only be described as 'blue'; or the time he was taking Ben, Binni and Willurai to the beach and got stuck on the roundabout near Sydney Airport. The kids still laugh their heads off about these incidences.

I met Michael in Sydney in 1977 – he was about 16 or 17. He became one of the 'little brothers' in a wonderful network of friends, colleagues, relatives and share houses. Little did I know then how close we would become, how talented he was, and how unfair and painfully short his life would be. Friendship with Michael was based on loyalty and reciprocity. Being friends with Michael was forever. He was a shocking gossip but knew how to keep important secrets.

Michael has an amazing family radiating out through Wiradjuri country on his father's, Allen's, side and Kamilaroi country on his mother's, Dot's, side. Dubbo and Moree were his towns.

There was an 'otherness' about this Wiradjuri–Kamilaroi man. Michael saw things we could not. This 'otherness' is so clear in his art, capturing a look, gathering light, reflecting pain, survival

and challenge. The sheer beauty of Michael's landscapes, portraits and films are all bound up in narratives of the most powerful kind. It was from Michael Riley I learnt a fundamental element about Aboriginality and the making of art. He taught me it's the making that's important, not necessarily the monetary value of the finished product. It is the telling of a story about culture and our experience.

Michael Riley: sights unseen is about two things. It is about the gathering together of the main bodies of Michael's work – it is about *cloud* (2000) and *Sacrifice* (1992) and all the other works that he is known and celebrated for. It is the public Michael Riley. It is also about stepping into the shoes of the private Michael. The person I spent the most time with, the person who took the photos of children and families hanging on our walls, sitting on dresser tops and in our drawers and photo albums. My family home is blessed with lots of Uncle Micky. One of my most treasured possessions is an old red t-shirt painted by Michael. It has travelled with me for 20 years.

Michael's son Ben is 21. He also has a granddaughter, Janaya – she is five. I truly believe it was Michael's love of Ben that kept him alive during some desperately grim times. There were lots of them. How well we got to know the Intensive Care Unit and the Dialysis Unit at the Royal Prince Alfred Hospital.

Michael was not a terribly organised person. His wallet was testament to that, stuffed full of little bits of paper with people's phone numbers on them. I gave him an address book once but to no avail. Similarly, negatives were scattered in numerous locations – they're still turning up.

The Michael Riley Foundation has been established to take care of his legacy. I have the honour of being part of the Foundation. The Foundation knows we are dealing with precious things. The very fact that the Gallery has undertaken this retrospective is a testament to just how precious.

I want people to look at Michael Riley's work and focus on just how beautiful it is. A beauty with, at its foundation, the ethereal man himself. I want people to be at ease. Think of Michael's shy cheeky smile, his eyes lighting up at the sniff of gossip. His love of flash, white-linen shirts. His sense of humour and fun. Most of all, I want people to remember his enormous generosity and humility.

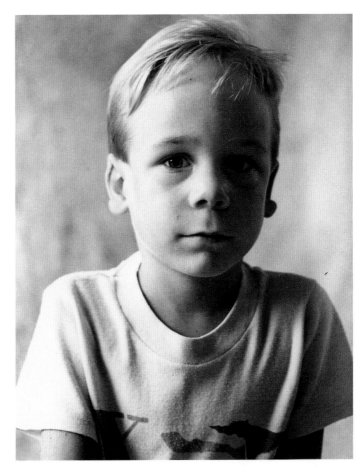

Binni (Kirkbright-Burney) from the series *Portraits by a window* 1990 gelatin silver photograph Linda Burney

I will miss the beautiful big bunches of lilies he would bring me, when he knew I was feeling blue. My family misses him – we all do. Michael would just love the fact that all of his work – the private and the public – has been gathered together by the National Gallery of Australia. Thank you to the National Gallery of Australia and everyone who has worked towards this wonderful celebration of not just Michael Riley's work, but his life.

Linda Burney
Chairperson
Michael Riley Foundation

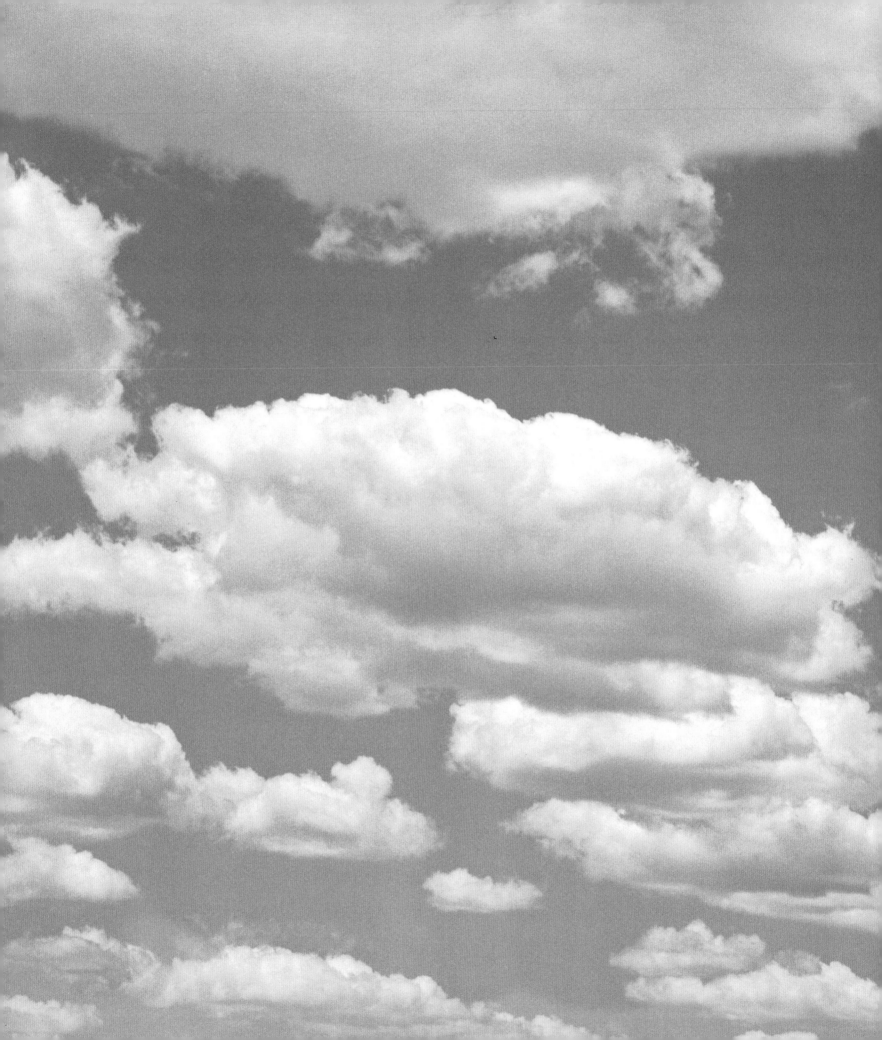

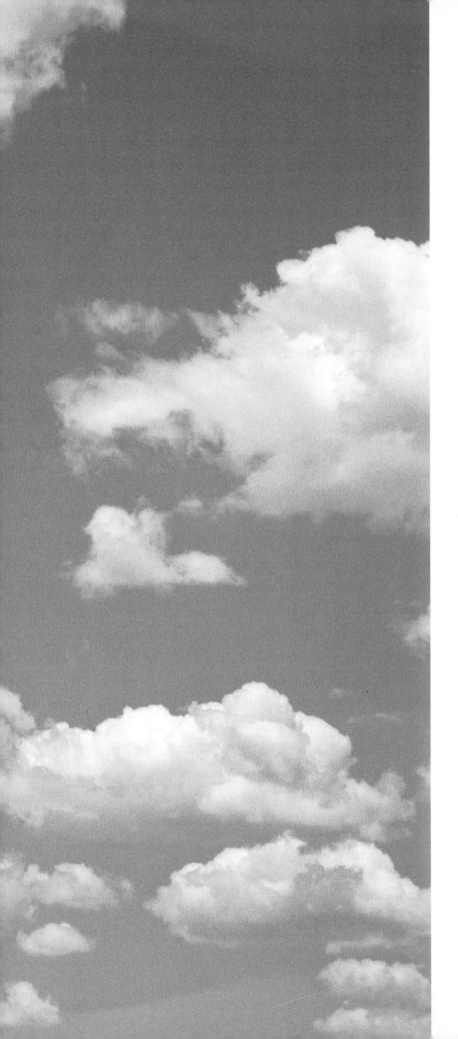

Up in the sky, behind the clouds

Brenda L. Croft

> I do what I do because I like doing it, I'm not chasing fame … Photography is just a medium for me, a way of putting across my views and images to the world. It's no big deal.[1]

Big sky. Flat, open plains. Scudding clouds, as if swept across the canvas by a colossal invisible hand. The plane shudders as its landing gear drops – clunk – and, when its wing dips to the right, the black soil of Moree rises up in greeting. I was travelling there to meet with the family and friends of Michael Riley (1960–2004), whose mother's people were part of the Moree Kamilaroi community, and whose father's people came from the red-soil western plains of Dubbo, Wiradjuri country, to the south, where I had travelled some weeks earlier.

How do you measure a person's life? Through their creative output? Their traces left behind, the *memento mori*? Through the reminiscences of others, in the spoken and written word? Through their family, their ancestors and descendants? Michael left us physically in August 2004, aged 44, suffering the after-effects of childhood poverty – the fate of too many Indigenous people in Australia, a First-World country, where the majority of the Indigenous people continue to live in Third-World conditions. By any standards Michael's life was extraordinary and he has left behind a body of work that encompasses the complexity of contemporary Aboriginal life in myriad forms: portraiture, social-documentary and conceptual photography and film, and fine-art film. And he remains a strong and positive presence in the memories of his family, friends and colleagues. His last series, the otherworldly *cloud* created in 2000, remains the best known of his prolific creative output. However, it would be remiss to consider this visually luscious series as Michael's signature work, since it is but one facet of a multi-dimensional body of work created over two decades, drawing on the collective experiences of millennia.

Untitled [*blue sky with cloud*] from the series *flyblown* 1998
chromogenic pigment print National Gallery of Australia, Canberra

There it goes, up in the sky
There it goes, behind the clouds
For no reason why[2]

For Michael, land was life. His roots were deep in the red and black soil of western and north-western New South Wales – Wiradjuri and Kamilaroi traditional lands. That was why I had to visit his birthplace, and that of his parents.

Along with his indissoluble connections to his peoples' country, Michael also established and retained strong links with Sydney, the largest city on the continent, where he lived from the late 1970s onwards. It was in this bustling, energetic, badly-planned city that he created his photographic, film and video work; that he bore with dignity and stoicism the enervating, endless cycle of hospitalisation and treatment; and where he was buried. Although Michael travelled extensively within Australia and overseas in the two decades of his artistic career – curtailed as this was in his last years – his life's work revolved around the invisible triangular axis of Dubbo, Moree and Sydney.

Michael's mother, Dorothy Wright, was from the Moree Kamilaroi people, and she settled in Dubbo after marrying Michael's father, Allen, better known as 'Rocko', a Wiradjuri man. Michael, their second child, was born at Dubbo Base Hospital in 1960. He spent much of the first years of his life on Talbragar Aboriginal Reserve, 7.3 hectares of land located on the outskirts of Dubbo, at the junction of the meandering Talbragar and more powerful Macquarie Rivers.

Screen grabs from *Blacktracker* 1996 ABC TV

His family has long links with the region directly around Dubbo, unlike many Aboriginal people who travelled or were brought to the town. They had lived for generations on their traditional lands, which, as with other land grants, were established as an Aboriginal Reserve during the reign of Queen Victoria (1838–1901).[3]

Michael's paternal grandfather, Alexander Riley, best known as Alec or 'Tracker', was a vital influence on his life, remaining inspirational long after his death at the age of 86 on 29 October 1970. Born in 1884, Sergeant Tracker Riley worked for the New South Wales Police Force from 1911 until 1950 and, at the time of his death, was still the only Aboriginal person to have achieved the rank of Sergeant. He was instrumental in solving some of the state's most infamous crimes, including the Moss Murders, the state's biggest serial murder case in the 1930s. Awarded the highest police award, the King's Medal in 1943, Tracker Riley was honoured with a state funeral following his death and in 2003 an historical display was installed in his memory at Dubbo Gaol, the result of efforts by his descendants to ensure his achievements were officially acknowledged in his hometown.

Tracker Riley was the patriarch and revered elder at Talbragar Aboriginal Reserve and, with his wife Ethel, remained contentedly on the reserve long after other residents had moved into town under the Aborigines Welfare Board's assimilation policy of the 1960s. He refused to move into the new town houses in Dubbo, scornfully referring to town living as 'a rat-race'.[4] The Rileys were among the last families to live on the reserve, with the last family group being 'encouraged' to move off the reserve and into Dubbo by Aboriginal Welfare Officers in 1970. Many family members – particularly the grandchildren who loved exploring the nearby

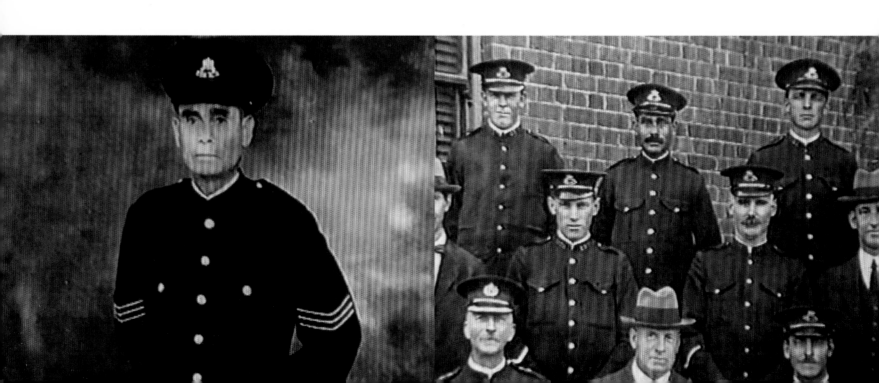

rivers and surrounding countryside – recalled visiting the old man and his wife, Ethel, throughout the 1960s.

Michael's cousin, Ron Riley, remembered sitting with his brother Allen, or 'Rocko', Michael's father, and other cousins listening to their grandfather's stories for hours and poring over photographs in the albums.[5] This was a recollection that stayed with Michael all his life, too.

In 1996 Michael brought the story of his grandfather's life to the screen in *Blacktracker*, which he wrote and directed when he worked with ABC Television's Aboriginal Programs Unit. Tracker Riley's life 'encompassed a period of great oppression in the history of Aboriginal people, but [his] legendary skills and deep humanity lifted him above the ignorance of the times.'[6] The film, which Michael worked on with many family members, including his cousin, Ron's daughter, researcher Bernadette Yhi Riley, remains a source of great pride for the Wiradjuri community in Dubbo. In turn, *Blacktracker* was the inspiration for *One night the moon* (2001), directed by Rachel Perkins – Michael's colleague and co-director of the Indigenous film company, Blackfella Films – and produced under the auspices of mdTV (Music Drama Television) for SBS Television.

It was while living at Talbragar Aboriginal Reserve that Michael first encountered Christianity through Sunday School classes taught by representatives of the Aborigines Inland Mission (AIM) and attendance at other churches, such as the Salvation Army and Seventh Day Adventist Church.[7] Although as an adult Michael expressed ambivalence about and distrust of Christianity and its ongoing impact upon Indigenous people, his mother Dot recalled that, as a child, he 'loved going to church, yeah.'[8] This may have had

more to do with the games devised by the Minister to entice the children's attendance – including finding hidden shillings – than with becoming one of God's converts, a saved 'heathen' soul.

Although the last family moved away from Talbragar Aboriginal Reserve in 1970, after Tracker Riley died, his son, Boykin, lived in the old house until 1986 before moving into town. After Boykin's death, the house was demolished. However, the site continues to be considered sacred by Tracker Riley's descendants and other former residents. Now in the care of the Dubbo Local Aboriginal Land Council, the site is fenced off, under lock and key, to keep local yobbos from doing burnouts in their utes[9], or stealing or destroying the carefully constructed facilities – toilet block, barbeque, benches, water tanks – and newly planted trees.

Devoid of the weatherboard and tin houses – which were kept spotless – the reserve is a tranquil place, where former residents and family members visit to sit and reminisce about who lived where, what hi-jinks children got up to, the camaraderie among the community, fishing, floods and broken bones, and listening to Grandfather Riley talk about the people in the photos in his albums and scrapbooks. These memories formed the basis for Michael's photographic series *Yarns from the Talbragar Reserve* (1998), which so beautifully portrays many community members who lived on, or were associated with, Talbragar Aboriginal Reserve, many of whom have since died. This series, acquired by the Dubbo Regional Art Gallery in 1999, will go on permanent display in Dubbo's new cultural centre following its completion in late 2006.

All those who shared their memories with me recalled Michael as being a good child; quiet like his brother and sisters, always

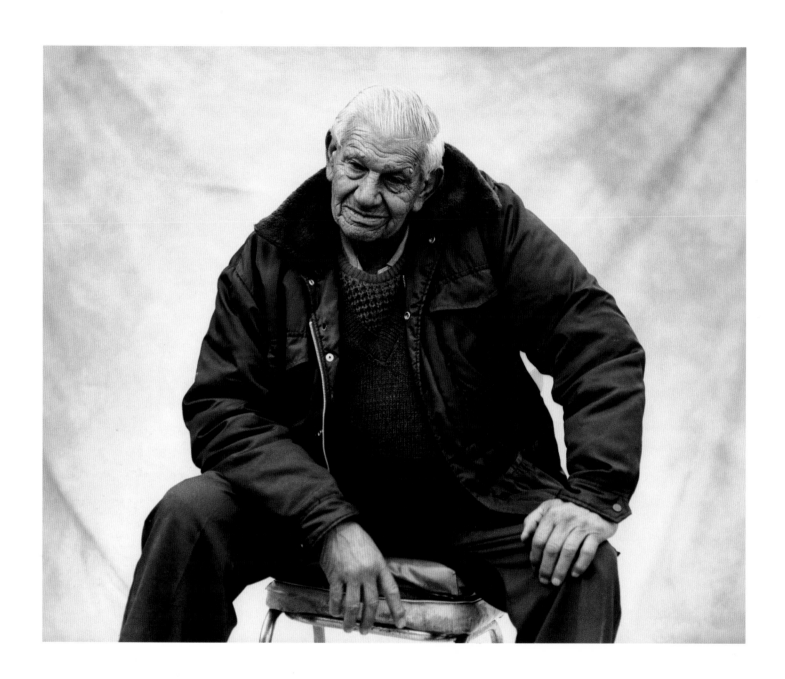

(above) *Willy Hill*; (opposite, clockwise from top left) *Tucker Taylor*; *Alma Riley*; *Mary Toomey (Cookie Carr)*; *Merle and Frank Pearce*; *Violet Fuller*; *Florence Nolan (Florrie Carr)*; from the series *Yarns from the Talbragar Reserve* 1998 gelatin silver photographs Gift of the Artist – Guardianship Dubbo Regional Art Gallery

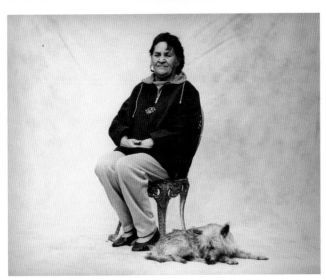

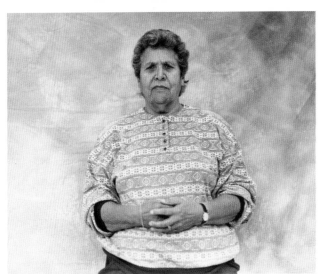

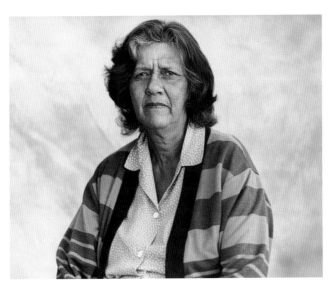

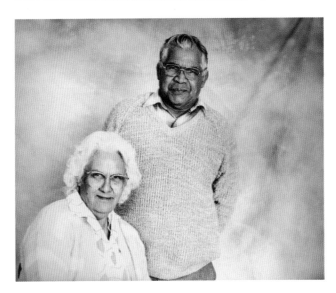

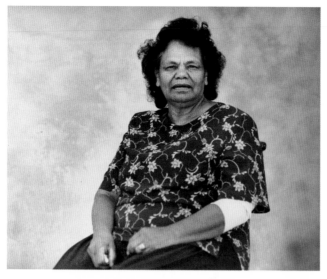
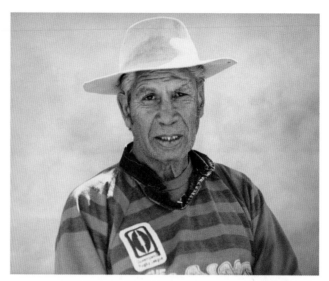

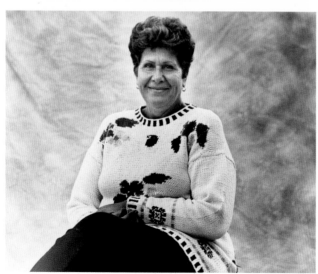
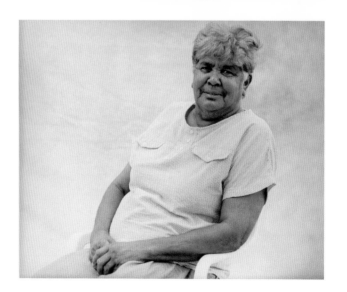

observant, with a loving nature and a cheeky laugh, which in later years could be put to wicked effect as he regaled friends and family with the latest, tantalising gossip. Many of his cousins and friends recollected that, even as a child, he had an unusual perspective on life. He stood outside the crowd, watching and listening, easily recognisable in the distance because of his lion's mane of red curls and freckles – traits passed on from his maternal grandfather, Reuben Wright. Also known as Bengalla, after the pastoral station on which he was born in 1908, Wright was a Kamilaroi man from Moree, who was renowned for his green eyes, red hair and freckles.[10]

In Michael's father's country at Talbragar, the big sky is ever-present. It is easy to imagine Michael as a small boy lying on his back on the earth, with the grass waving around him in the breeze, staring up at the clouds skimming overhead, following the line of telegraph wires as they looped from pole to pole, becoming smaller and smaller, till they vanished in the distance, leaving him to wonder where they led.

Michael's mother's family had moved from the small Aboriginal township of Boggabilla near the New South Wales–Queensland border to Moree in 1939. Situated on the banks of the Macintyre River, Boggabilla is a mainly Aboriginal community of approximately 750 people, quite poor in a rich agricultural region, nine kilometres south-east from Goondiwindi on the Queensland border, and 118 kilometres north-east of Moree.

Bengalla Wright moved with his wife, Maude (born 1904), and family into Moree in 1939 at the request of the Aborigines Protection Board to manage a hostel on Moree Aboriginal Reserve – also known as Moree Mission – for Aboriginal women from surrounding communities such as Boggabilla, Toomelah, Boomi and Muningindi requiring pre-natal care. Bengalla and Maude were married at Boomi in 1929 and their marriage produced ten children, with Michael's mother, Dorothy or Dot, being the fifth child. Bengalla and Maude made a striking couple. He was noted for being an extremely handsome young man, a reputation supported by historical photographs showing a lantern-jawed presence, green eyes piercingly apparent in faded black-and-white images, his mane of hair a mirror of Michael's. Images of Maude as a young mother depict a clear-eyed, attractive, strong woman – not someone to be messed with, by family accounts. An early image of Dorothy, pictured with her best friend, portrays a beautiful young woman whose face would be closely echoed by Michael's own.[11]

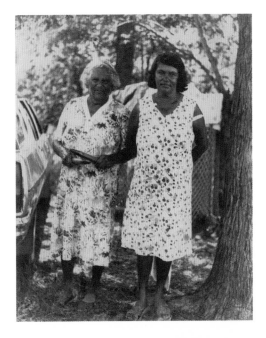

(above top) *Nanny Wright and Dot Riley, Moree* c.1970s black-and-white photograph Wendy Hockley; (bottom) *Maude and Ben Wright, Moree* c.1970s black-and-white photograph Cathy Craigie
(opposite, clockwise from top left) *Pat Doolan; Malcolm Burns; Keith Murphy; Maggie Smith-Robinson; Coral Peckham; Margaret Riley* from the series *Yarns from the Talbragar Reserve* 1998 gelatin silver photographs Gift of the Artist – Guardianship Dubbo Regional Art Gallery

Untitled [*long grass*] from the series *flyblown* 1998 chromogenic pigment print National Gallery of Australia, Canberra

The Wright family moved, following Bengalla Wright's search for work – to Moree Station, and then to Dubbo, where Ben was employed, like Tracker Riley, as a Police Tracker.[12] It was in Dubbo, that Dot met Michael's father, Allen 'Rocko' Riley, whom she married and moved with to Talbragar Aboriginal Reserve, where they had their own family, including David, Wendy, Michael and Carol.

Although Michael grew up in the red-plains country of Dubbo, his mother's family ties ensured that the Riley clan returned to her country, the black soil of Moree, each year for Easter and Christmas holidays.

Moree was a unique community. In the town, local landowners, cow cockies, and pastoralists mingled with members of the Murri community, and Lebanese, Greek, Afghan and Chinese residents. The internationally renowned Moree artesian baths attracted overseas visitors, notably northern Europeans and Japanese. Relationships weren't always formed on 'the wrong side of the blanket' and the links between different local communities spread, like river tributaries, through the generations.

The Moree Aboriginal Reserve was home to an independent community, which experienced similar sparse conditions to Talbragar. During Michael's childhood, his maternal grandparents, Bengalla and Maude, were the caretakers at the reserve, with Ben also responsible for maintaining the mission's swimming pools. Michael's relatives, particularly his aunts, recalled a community in which everyone shared and respected each other. The reserve was self-sufficient, running the country's oldest Aboriginal pre-school and Aboriginal funeral fund. Archival photographs from the 1950s show an extremely well-catered for and well-kept community.

Moree, however, was no country idyll. Although a strong sense of community existed, on the reserve and in the fringe-camps, families lived in poverty. Under the policies of the Aborigines Welfare Board, hundreds of children were 'removed' from their families and placed in foster homes or state-operated 'part-Aboriginal' children's homes, or were adopted out. Until the Freedom Ride of 1965, when Charles Perkins entered the Moree Baths with local children in tow, the colour bar operated in the town, preventing Aboriginal people from entering pubs, some shops and the artesian baths.

This process showed the ugly face of Australia very publicly – long known by Indigenous people living in similar small towns and the 'Black' areas of cities across the country. Images of Perkins being forcibly removed from the baths by the local constabulary were countered by the positive outcome: Perkins later sitting in the cool waters of the pool on a scorching summer day, surrounded by local Murri kids. What had been accepted as the status quo for decades could exist no longer, but this freedom did come with a price.

Moree holds different memories for different generations. The older generation – those of Michael's parents' age – fondly recall the dances, informal get-togethers, and major events, such as trips to the local agricultural show to watch the touring boxing troupes, which often included many local Aboriginal men.[13] For many young Aboriginal men, boxing was an alternative to seeking work as a fencer, shearer, wheat bailer, station-hand or itinerant seasonal worker, and it brought the added glamour of attracting young Aboriginal women. Michael recreated this world in his documentary, *Tent boxers* (1997), directed while at the Aboriginal Programs Unit at ABC Television.

For the next generation, the memories are harsher and remain bittersweet. Lyall Munro Jnr was the first local Murri man to leave town by a different route – a sports scholarship to De La Salle College, Armidale – and was one of six local Murri children who, in 1965, were escorted by Charlie Perkins into the Moree Baths. The ideological liberty that the Freedom Ride offered awakened in Lyall Munro Jnr an indelible desire to see his people no longer relegated to Australia's equivalent of America's 'Deep South' servitude. But it also came at a high personal cost – he was barred from entering the town for three years in the early 1980s, shortly before the death of his cousin, 'Cheeky' Macintosh, who was killed during an altercation between local Murri people and the police. His despair was still palpable as he recalled his early encounters with Michael, when Michael would return to Moree each year from Dubbo with his family, to visit his mother's people.[14] Michael's life as an Aboriginal person was very much shaped by the experiences of his people in the 1960s and these were sources of inspiration for his later work.

The annual trips between Dubbo and Moree continued throughout Michael's life, and he easily slipped between the two communities, all the while maintaining his quietness, his ability to stand apart and observe, yet be considered integral to both places. His inscrutable nature enabled him to observe unimpeded the bravado of his Moree mob; engaging in the communal gossip, the happily heated exchanges and discussions, while retaining the stillness of his father's family. His father, who died unexpectedly in 1985 while Michael was on his first trip to Europe with his Moree cousin, Cathy Craigie, was much loved by the Moree community and was spoken of warmly

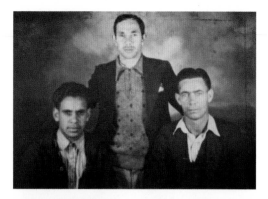

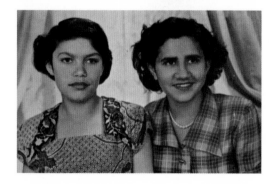

(top to bottom) *George Waters, Eric Craigie and Reuben 'Ben'*
Wright, Moree c.1930s; *Eunice and Maude Wright, Moree*
1952; *Dorothy Wright and Madge Swan, Moree* c. late 1950s
Images reproduced from *Burrul Wallaay (Big Camp), Moree*
Mob, vol.2 by Noeline Briggs-Smith Northern Regional
Library Service, Moree NSW, 2003
(opposite) *Toni and Maria* c.1984 colour photograph
Cathy Craigie

by many during my recent visit – and people often mentioned that
Michael took after his father.

Dot remembers Michael's early interest in photography, recalling
how he earned enough money collecting golf balls from the
waterholes on the golf course to purchase a small 'Box Brownie'
camera. His earliest images were of family members in domestic
settings: his younger sister Carol, arranged with her toys on her bed,
smiling coyly at her big brother. Michael and his cousin, Lorraine
Riley, dreamed of becoming fashion designers, and another cousin,
Diane McNaboe (née Riley) remembered being co-opted as a
model in those early days when they were inseparable due to the
close proximity of their ages.[15] People recalled his love of beauty,
his aesthetic sensibility – questioning the design flaws in a piece
of furniture – or how he persuaded his (usually innocent but all-
consuming and transparent) crush-of-the-moment to pose for
photographs.

> Gonna look back in vain
> And see you standing there
> And all that'll be there
> Is just an empty chair

In the late 1970s Michael moved to Sydney in search of employment,
along with many of his family and other young Aboriginal people
from regional areas. His intention was to be an apprentice carpenter
and it was during this time of great personal growth that he met
some of the most influential people in his life. There has always
been an internal migration within Australia of poor, working-class
and Indigenous people from regional and remote areas to larger
towns and cities where they established de facto communities and
proxy families.

In Sydney, Michael initially lived in Granville, meeting people who
became not only lifelong friends, but his surrogate family: Linda
Burney, brother and sister John and Raelene Delaney, Dallas Clayton
and David Prosser. Here, too, he created enduring bonds with *true*
family, including cousins Lynette Riley-Mundine, Cathy Craigie,
Maria (Polly) Cutmore, Ian 'Yurry' Craigie, Craig Jamieson and others.
His elder brother, David, was also closely involved in this fluctuating
group.

His fledgling interest in photography was reinvigorated in Sydney
when he reconnected with Yurry Craigie, his cousin from Moree,
through contact with Yurry's older sister, Cathy, who had moved
to Sydney prior to Michael. Cathy remembers Michael turning up

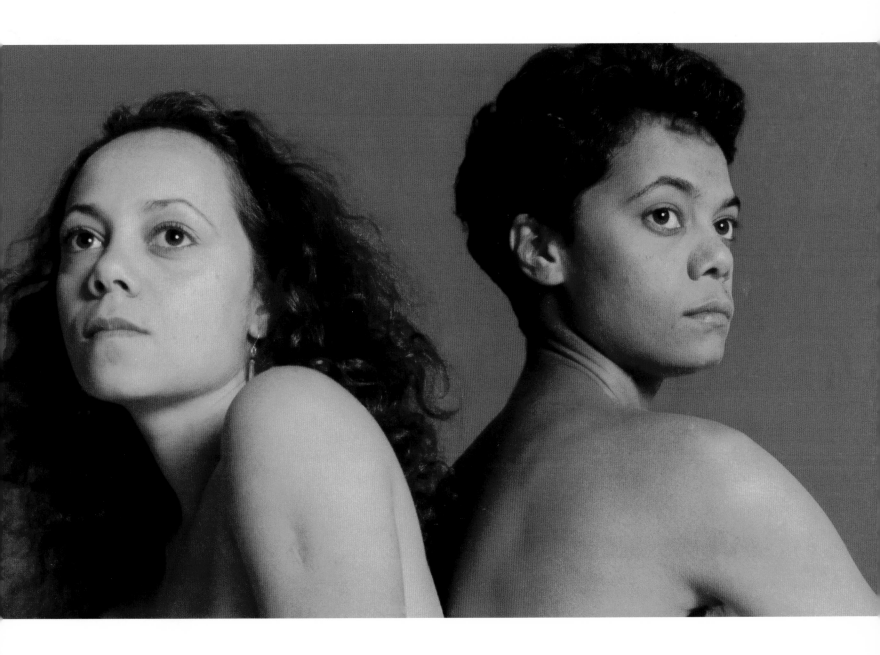

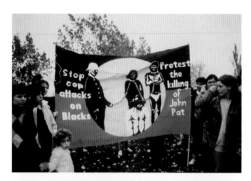

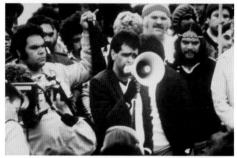

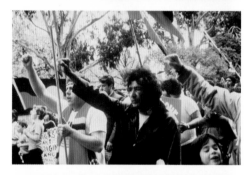

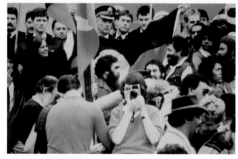

(top to bottom) *Stop Black Deaths in Custody banner,
Land Rights rally, Canberra* c.1983; *Gary Foley with
loudspeaker, Land Rights rally, Canberra* c.1983;
Kevin Gilbert on Land Rights march, Canberra c.1983;
*Land Rights rally, Canberra, Kevin Gilbert, Bob Weatherall,
Geoff Clarke and others* c.1983 colour photographs
Michael Riley Foundation

on her doorstep in Leichhardt in 1980–81, wearing the ubiquitous flannelette shirt, a favourite item of clothing, and introducing himself with 'Hi, I'm Michael, Michael Riley'.[16]

Cathy Craigie and her cousins, sisters Maria (also known as Polly) and Toni Cutmore, intrigued Michael. They were definitely part of the 'out there' Moree mob, not afraid to speak their minds, and the two sisters were the subject of many of Michael's early attempts at what he imagined 'fashion photography' to be: big hats, soulful eyes, gorgeous girls. These were an extension of his earlier forays into home-style fashion 'design'. The only thing was that these gorgeous black women would not grace the pages of any of the major national fashion publications of the era as they were too 'Aboriginal', neither exotic nor generic enough.

In Leichhardt in 1987, Michael moved into a house with Linda Burney, and his cousins Lynette Riley and Craig Jamieson. The house acted as a community meeting place, with a fluid cast of visitors, some staying for varying periods and who, having entered each other's lives, never really lost touch. John Delaney, a young Aboriginal man who moved to Sydney in his late teens to undertake an apprenticeship, recalls staying in Michael's room at Leichhardt after turning up with his belongings in a plastic garbage bag – what little was had individually was shared among all.[17] John's older sister, Raelene, was extremely close to Michael during this time.

Among the hundreds of negatives collated after Michael's death is a roll of film that includes images of Michael's baby son, Ben, being held by a smiling John, and images of Linda with her first-born baby, Binni. His images of women friends and their children are stunning and incredibly intimate, showing the bond between photographer and subject, as much as that between mother and child.

In the early 1980s, having lost interest in his apprenticeship, Michael was encouraged to revisit his photographic leanings more seriously by his cousin, Yurry, who was working as a technician at the Australian Centre for Photography in Paddington, under the tutelage of Jo Holder.[18] After undertaking a Koori photography course in 1982 at the Tin Sheds Gallery, University of Sydney, Michael met a person who came to be a crucial mentor, photojournalist and teacher, Bruce Hart. This was a turning point in his life and Hart's encouragement set Michael free to follow his artistic vision, combining it with his cultural heart.

In the early 1980s, inner-city Sydney was a haven for artistically inclined Aboriginal and Torres Strait Islander people from all over

Australia. From the passion of the antipodean Black Power movement of the early 1970s – which heralded such events as the Aboriginal Tent Embassy's establishment, or anti-establishment, opposite the Provisional Parliament House in Canberra in 1972 – had emerged such cultural powerhouses as the National Black Theatre, Redfern Aboriginal Dance Theatre, and the Aboriginal and Islander Dance Theatre (AIDT), established in the late 1970s by African-American dancer, Carol Johnson.

The AIDT was based in an old church building on Bridge Road, Glebe, with many of the students and staff living nearby. Glebe was a haven for low-income earners, left-wingers and artistic types, with its beautiful old terrace houses and workers' cottages, surrounded by cafes, alternative bookshops and an art-house theatre. Cathy Craigie, Maria and Toni Cutmore lived in a share-house at the end of Glebe Point Road near Black Wattle Bay and Michael was a regular visitor, organising photo-shoots, co-opting his cousins into posing for him. His subjects soon expanded to include students from the AIDT, particularly favourites Kristina Nehm, Darrell Sibosado and Gary Lang, fellow artist Tracey Moffatt, and later students Tracey Gray, Telphia Joseph, Delores Scott and Alice Haines.

Indigenous visual artists were also studying at the tertiary art schools in Sydney.[19] They exhibited their work in seminal shows such as *Koorie Art '84* and *Urban Koories* (1986), the latter perhaps lumbering the emerging movement with its unwieldy title, still refusing to be discarded two decades later.[20]

As he explored 'art' photography, Michael's main foci for subject material were the numerous rallies, marches and rock gigs held in Sydney and Melbourne, and documenting gatherings of family and friends, especially those around the birth of children. He and Yurry participated in rallies and marches in Sydney and Melbourne. Yurry's portraits of Michael at that moment really capture his 'insider/outsider' spirit – the faraway look on Michael's face as he sits lost in thought on a Melbourne tram, evoking fellow photographer and reviewer, Robert McFarlane's 1963 portrait of a young Charlie Perkins, riding home on a Sydney bus at night, gazing pensively out the window.[21]

Both images perfectly encapsulate the unknown future of two young Aboriginal men, each of whom will later be struck down by the same disease, although unaware of this at the time of their unexpected portraits. Some elusive quality in their respective portraits suggests a prescience that they would later become part

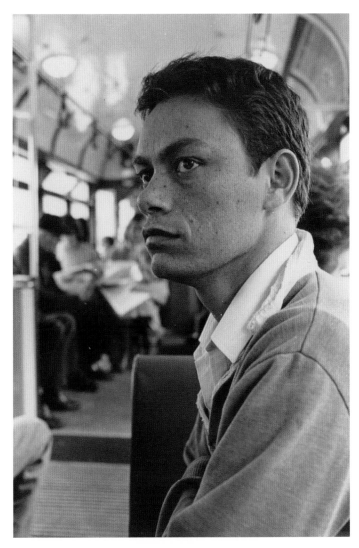

Michael on Melbourne tram c.1984 black-and-white photograph Ian 'Yurry' Craigie

of the horrific statistics which shadow Indigenous peoples around the globe: poor health stemming from childhood poverty, leading to shorter life expectancies than for non-Indigenous communities.

Those of us who were fortunate enough to be a small part of these exciting times were unaware then that we were making history; we were just having fun and learning as much from being with each other as from any tertiary-accredited study. We were growing into our Aboriginal identity as well as our adulthood and we were lucky to be able to share this together. Michael was one of those people around whom different worlds revolved: he became an axis for many of us who, like him, had travelled to Sydney from other places to live and work. He was instrumental in establishing Boomalli Aboriginal Artists Ko-operative (later Co-operative) in late 1987, working particularly closely with Avril Quaill, another founding member whom he had met in 1984 at Sydney College of the Arts. [22] Avril was also a subject in Michael's earliest portraits, which were first exhibited in *NADOC '86 Exhibition of Aboriginal and Islander photographers* at the Aboriginal Artists Gallery, Sussex Street, Sydney, September, 1986. Avril's and Michael's works, both featuring Kristina Nehm as a subject, were reproduced alongside each other in the exhibition catalogue accompanying *Koorie art '84*.[23]

Another young photographer and filmmaker, Tracey Moffatt, who was working ahead of Michael in the dual media, was also a centre of activity at this time, for it was she who invited Michael and others to be a part of the landmark exhibition, *NADOC '86 Exhibition of Aboriginal and Islander photographers*, which she curated with the assistance of Anthony 'Ace' Bourke.[24] Michael's image of his cousin Maria (Polly) Cutmore, hung in the exhibition, has become a classic image of the time, and a print was acquired by renowned Australian photographer, Max Dupain.

What a productive time the late 1980s were, particularly around the establishment of Boomalli: Fiona Foley was picked up by Roslyn Oxley9 Gallery; Bronwyn Bancroft had established a small fashion boutique, *Designer Aboriginals,* in Balmain; Tracey Moffatt's career rocketed skyward at a phenomenal rate shortly after Boomalli's first exhibition in late 1987; and other south-eastern artists such as Brent Beale, Gavvy/Kevin Duncan, Robert Campbell Jnr, David Fernando, and Sheryl Connors either joined or had their work exhibited at Boomalli.[25] Concurrently, Indigenous visual and performing arts

Alice and Tracey from the series *Portraits by a window* 1990 gelatin silver photograph National Gallery of Australia, Canberra

organisations were being established across Australia in Brisbane, Darwin, Perth and Melbourne.

Slightly earlier, in January 1987, the first Black Playwrights' Conference was held at the Australian National University in Canberra, bringing together established and emerging Indigenous playwrights, actors, writers, directors, performers, set-designers and interested observers from all over Australia for an intensive two-weeks of workshops. The talent in one place was impressive: Brian Syron, Kath Walker (later changing her name to Oodgeroo Noonuccal in protest against the 1988 Bicentenary), Jack Davis, Ernie Dingo, Bob Maza, Justine Saunders, Kevin Smith, Maureen Watson and many others. From this fertile pool of Indigenous creativity the Aboriginal National Theatre Trust (ANTT) was established in Sydney in 1988, fostering emerging talent such as Lydia Miller and Rhoda Roberts under the enthusiastic Syron and Kath Walker's son, Vivian Walker, among others.[26]

The second Black Playwrights' Conference was held at Macquarie University in February 1989 and Michael, then working with the Aboriginal Programs Unit of ABC Television, invited me to assist him in documenting the full two-week program on video. Participants included relative unknowns Lillian Crombie, Stephen Page, Darrell Sibosado, Raymond Blanco, Kristina Nehm, Kylie Belling, Lawrence Clifford, Joe Hurst, Billy McPherson, Frances Peters-Little, Alice Haines, Christopher Robinson and Matthew Cook, alongside stalwarts such as Bobby McLeod and those mentioned previously. Important working relationships were created at the conference, which led to, or were associated with, the establishment of cultural organisations such as Bangarra Dance Theatre, Sydney (1989); Ilbijerri Aboriginal and Torres Strait Islander Theatre Co-operative in Melbourne (1989); Yirra Yaakin Noongar Theatre, Perth (1993); Kooemba Jdarra Indigenous Performing Arts, Brisbane (1993); and Blackfella Films, which Michael and Rachel Perkins established in Sydney in 1993.

As well as documenting the second Black Playwrights' Conference, Michael also presented his first film, *Boomalli: Five Koorie artists*, made for Film Australia in 1988. The Playwrights' Conference footage – never screened, remaining deposited with the ANTT archives at the New South Wales State Library – included gems such as the early development of Jimmy Chi's *Bran nue day*, Ray Kelly's *Get up and dance* and Johnny Harding's *Up the road*.[27]

Michael's art films and photographic stills work overlapped with his television experience, the latter being where he created

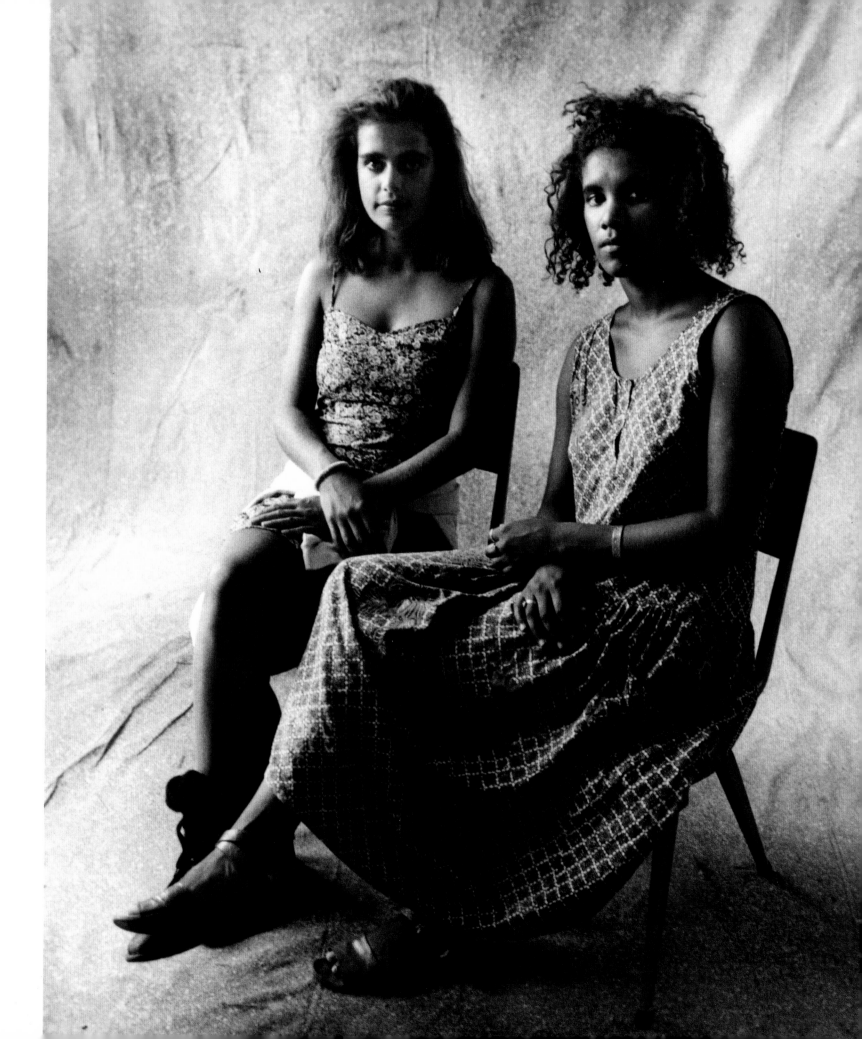

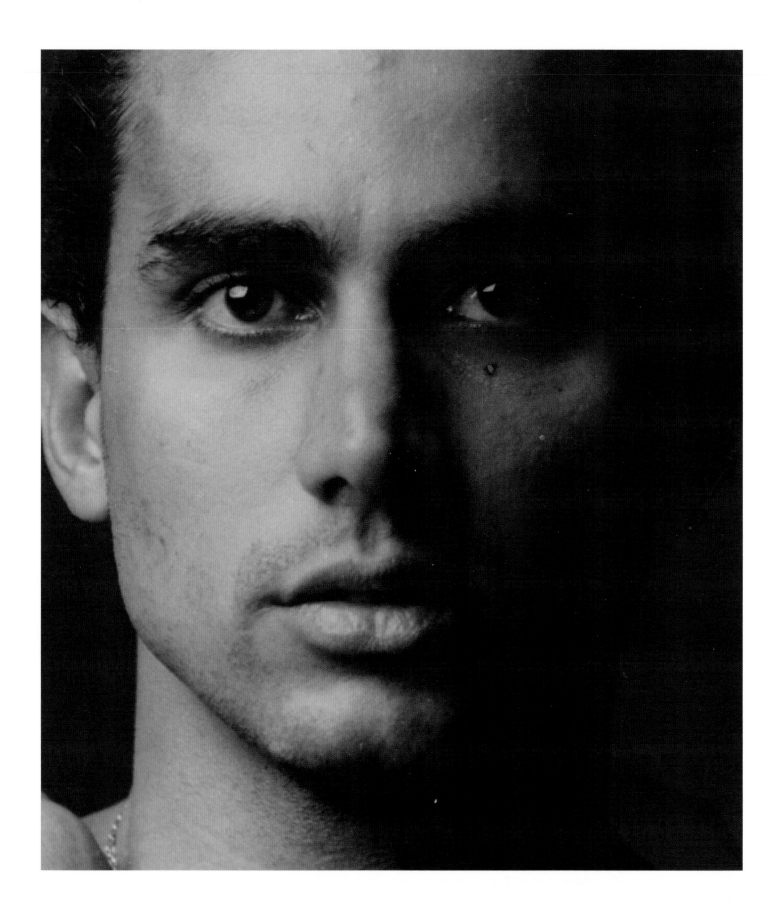

a series of documentaries on Indigenous issues, specific to his own experiences and that of his communities.

His beautiful black-and-white stills series, *Portraits by a window*, was shot at Boomalli's Chippendale premises in 1990. He invited friends and their families to sit in front of a simple, paint-spattered backdrop on whatever chairs were available, lit by the suffused, side-light from the large windows in the artspace premises.[28] As one of those photographed, I remember sitting next to my father, Joseph, his arm resting around my shoulder, warm and protective. I was 24-years-old and within six years my father would be gone, but you would never have guessed that from the distinguished man that he appeared in that frozen moment.

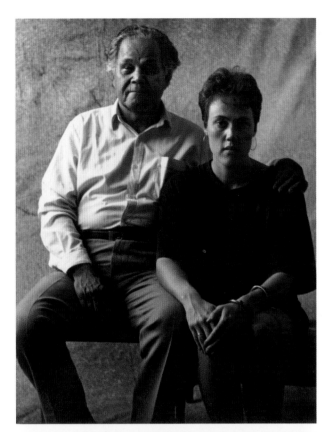

Michael's images are moving and so unaffected: Avril Quaill with her newborn daughter, Miya; John and Raelene's sister, Dorothy/Tudley Delaney, looking like a compatriot of early twentieth-century African-American writer, Zora Neale Hurston; Tracey Gray and Alice Haines, young dance students in their prime; Delores Scott, resembling a Modigliani sculpture; Charles Perkins and his doppelganger son, Adam, resplendent in their business suits; and so many others, graciously captured by Michael's vision. Whereas the respective gazes of the women he photographed for the 1986 Aboriginal photography exhibition were searingly direct, in *Hetti*, the subject is caught unawares. With her eyes closed in repose, the image conveys an intimate moment of reflection replicating the spiritual pose of the male subject in *Darrell*. These two images could be referencing moieties, the yin and yang of contemporary Indigenous life. Michael's statement about his friend Hetti explained his fascination with beauty and urban-based Indigeneity:

> Hetti is a good friend of mine, not a model and has beautiful cheekbones, beautiful face and shoulders ... I didn't do much setting up ... Very glamourous, just the way she is ... I just want to show young Aboriginal people living in the cities today; a lot of them are very sophisticated and a lot of them are very glamourous. A lot of them have an air of sophistication which you don't see coming across in newspapers and [television] programs. I'm just talking about positive things really, positive images of Aboriginal people.[29]

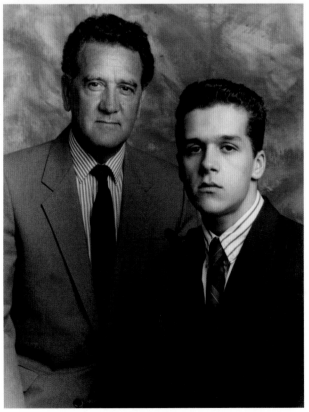

(opposite) *Gary* 1989 gelatin silver photograph Anthony Bourke
(above and below) *Joe and Brenda* from the series *Portraits by a window* 1990
gelatin silver photograph Brenda L. Croft; *Charles and Adam* from the series
Portraits by a window 1990 gelatin silver photograph Hetti Perkins

I'm gonna live my life
Like everyday's the last
Without a simple goodbye
It all goes by so fast

The late 1980s and early 1990s were an extremely dynamic time for Michael, as if he knew that ill health would strike him soon. In 1987–88 he directed *Dreamings: The art of Aboriginal Australia* to accompany a groundbreaking exhibition of the same name, which received critical acclaim at the Asia Societies Gallery in New York. It was as if his work was a counter to the insidious whitewash of the Bicentenary in 1988.

1991 saw the public release of two very different but equally important films. *Malangi* highlighted the achievements of one of the country's most renowned bark painters and central Arnhem Land artists and statesmen, Dr David Malangi. Michael travelled to Arnhem Land to meet with and film Malangi in his traditional homeland and the film resonates with the empathy and mutual respect of the filmmaker and the subject. It is a beautiful film, capturing the dignity and honour of a great artist. Michael never lost his respect for Aboriginal elders.

Poison, a highly innovative experimental film, which received the Golden Tripod Award and the Bronze Award for Best Short Television Drama at the New York Film Festival in 1991, was based on the reporting of a number of tragic heroin overdoses of young girls in the Aboriginal community centred around 'The Block', Eveleigh Street in Redfern. Michael had read 'Seven little Australians' in *Rolling Stone* magazine, which presented the bleak and sorrowfully curtailed lives of a group of young Aboriginal teenage girls, afflicted by the influx of narcotics into the community.[30]

Prior to the 1980s, alcohol and cannabis were the most insidious drugs affecting Indigenous communities. A cannabis shortage, coupled with the decreasing cost of 'smack', opened up horrible new tracks – literally – to personal oblivion and cultural destruction for the lost kids of urban-based Aboriginal communities. The demographics had changed: when Michael took the journey from Dubbo to Sydney, it was an optimistic pathway, one where you were meeting up with and being joined by your mob, achieving things together. You might not finish that apprenticeship but there were

Nanny Wright and dog from the series *A common place: Portraits of Moree Murries*
1991 gelatin silver photograph Moree Plains Gallery

other options and people willing to take a chance on you, support you and encourage you.

By the time of *Poison* these possibilities seemed to have vanished: the roads were now dead-ends for those young kids whose lives should have mirrored ours. *Poison* featured Lydia Miller, Lillian Crombie, Rhoda Roberts, Binni and Willurai Burney and another of our treasured community, Russell Page, the gifted younger brother of Stephen Page, who died in 2002. Another important collaborator who worked with Michael on this project was Joe Hurst, who designed the set: friends from school days, they were also artistic contemporaries.

Opinions were divided about the influence on *Poison* of Tracey Moffatt's *Night cries: A rural tragedy*, made in 1989, and tensions existed between the two artists for some time. The irony was that Michael and Joe were far more influenced by 1960s sci-fi television series, particularly *Star Trek*, but given the social intimacies of urban-based Indigenous artists throughout the 1980s and 1990s, it was not surprising that ideas and influences were subliminally shared and exchanged, rejected and consumed by many of us.

In 1986–87 Michael was one of a number of Indigenous and non-Indigenous photographers who travelled to Indigenous communities around the country to work with and document people as a direct response to the Bicentenary in 1988. An initiative of the Australian Institute of Aboriginal and Torres Strait Islander Studies, the resulting publication *After 200 years* is an impressive document of the times. Michael worked with another Aboriginal photographer, Alana Harris, visiting the country communities of Leeton in New South Wales, and Robinvale in Victoria. Of the hundreds of images, he took a number that were published in *After 200 years*, some of which were subsequently acquired by the National Gallery of Australia.[31] These were included in the travelling exhibition *Re-take: Contemporary Aboriginal and Torres Strait Islander photography*, organised a decade later by the National Gallery of Australia.

From the mid-1980s onwards Michael travelled overseas regularly, to exhibitions and cultural events, including the aforementioned *Dreamings* exhibition and the major cultural festival associated with *Tagari lia: Our family*. This international Aboriginal arts festival was an initiative of the Aboriginal Arts Management Association (AAMA) and included visual arts, the then fledgling Aboriginal/non-Aboriginal rock group, Yothu Yindi, and an Indigenous film, literature

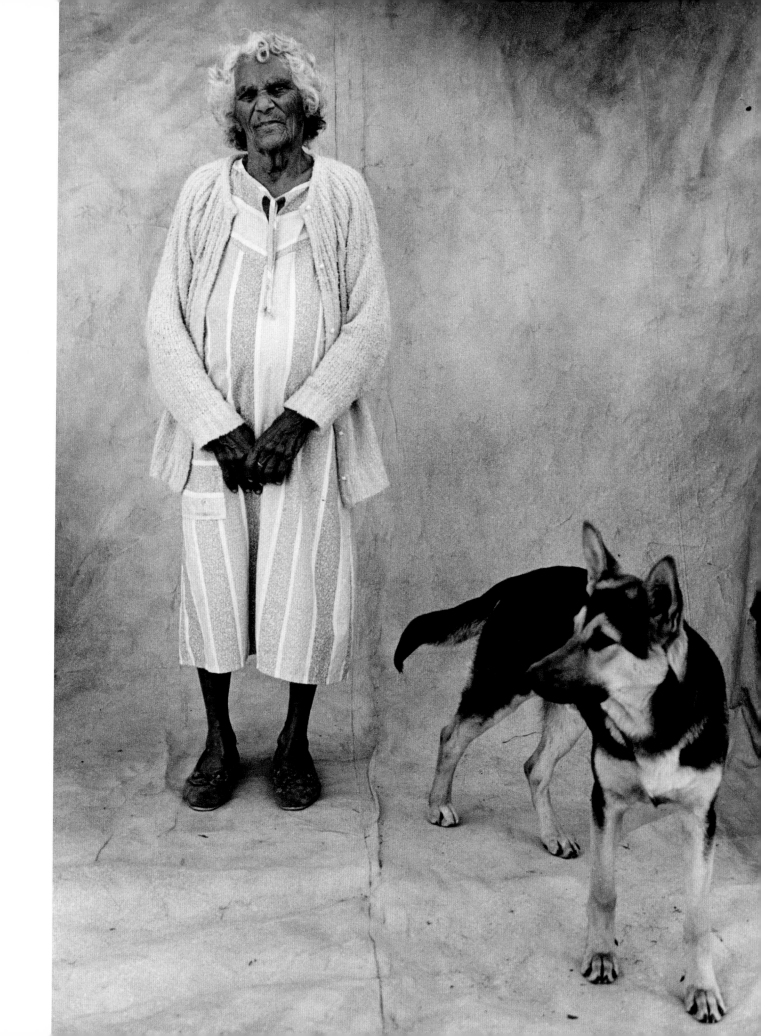

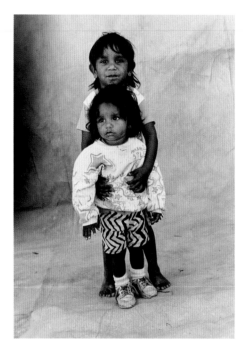
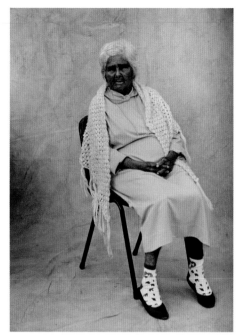
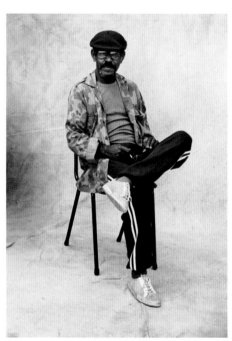
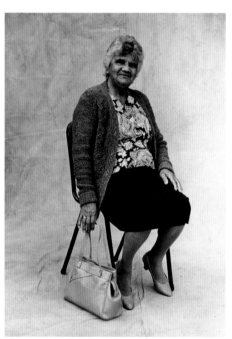
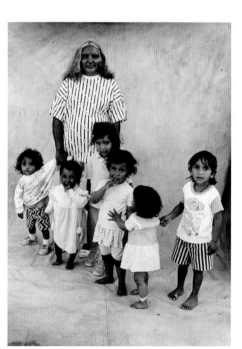

(clockwise from top left) *Jag*; *Moree kids*; *Phyllis Draper*; *Jessie and grandkids*; *Mum Maude*; *Kenny Copeland* from the series *A common place: Portraits of Moree Murries* 1991
gelatin silver photographs Moree Plains Gallery

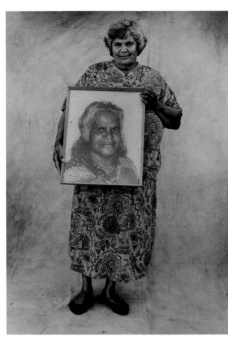
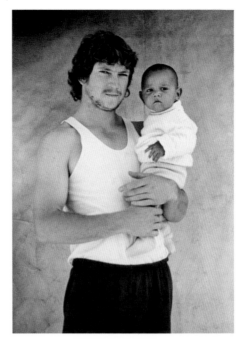

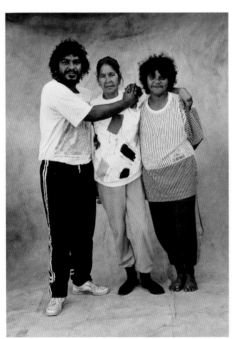
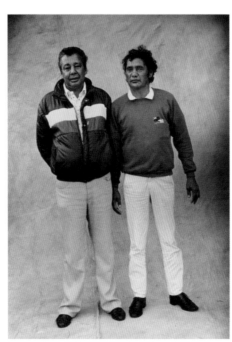
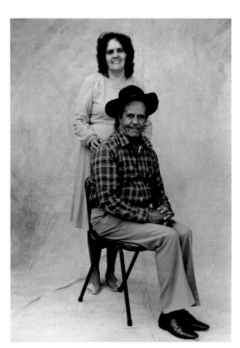

(clockwise from top left) *Aunty Ruthie*; *Glenn and son*; *Jim*; *Mr and Mrs Lyall Munro*; *The Drifter and The Crow (Trevor Cutmore and Herb Binge)*; *Mary Stanley with son and daughter-in-law* from the series *A common place: Portraits of Moree Murries* 1991 gelatin silver photographs Moree Plains Gallery

and theatre program.[32] This 1990 program – which included an exhibition of the same name at the Third Eye Centre in Glasgow, Scotland – was the brainchild of AAMA's Chairperson, Lin Onus (1948–1993), whose mother was from Glasgow.[33] During this visit to the United Kingdom, Michael met Australian expatriate, Rebecca Hossack, at her gallery of the same name, in Windmill Street, London. She staged his London showing of *A common place: Portraits of Moree Murries* in 1993.

Sacrifice (1992) was another turning point in Michael's work and life, created in a particularly fruitful year for the artist. This conceptual series employed one of Michael's favourite subjects and closest friends, Darrell Sibosado. Darrell related recently how the setting was 'a perfect day', with Michael turning up at his place in Darlinghurst, having talked through the concept of the shoot earlier, and using whatever props came to hand, including a handheld torch for the sensual lighting effects.[34] Though a person of very few words for much of the time, Michael's subjects trusted him implicitly, and most recall very little in the way of discussion before a film or stills shoot commenced. Michael nominated *Sacrifice* as the moment where his work deviated from the classical studio set-up, and his imagination was freed to create a new visual language, although one can see the hand of other artists such as Robert Mapplethorpe, and closer to home, Olive Cotton and Max Dupain, with their particular use of the sharp-edged southern light.

Sacrifice has a languid, sultry air, bordering on putrefaction: everything seems over-ripe, bleeding – literally, in the image of the stigmata – or about to ferment. The black-and-white works were printed with a colour process, hence the luscious tones, and were exhibited at Sydney's Hogarth Galleries in Michael's third solo exhibition. The series had an immediate impact – similar to that of Tracey Moffatt's *Something more* shown at the Australian Centre for Photography in 1989 – drawing the attention of major public institutions. The National Gallery of Australia acquired a full series, this being the first acquisition of Michael's work for the national collection.

Michael's work at this point developed ideas he initiated with *Poison*, crossing into the ethereal, bringing his fascination with Christianity and symbolism to the fore, and letting any overt Indigenous reference sink into the layering effect of a potent body of work. There is timelessness to the images or, perhaps, a hint of the earliest representations of the photographic process, a tinge of gothic gloom and universality that could place them as being from *anywhere*. Yet they are rooted in the Aboriginal history of this country.

In 1993 Michael travelled overseas to see the selection from *A common place: Portraits of Moree Murries* included in the major survey exhibition *Aratjara: Art of the First Australians*. As *Dreamings* was to North America, *Aratjara* was to Europe.[35]

Quest for country (1993), written and directed by Michael, was produced under the international Indigenous *Spirit to spirit* co-production for SBS Television, and was the filmic bridge between *A common place: Portraits of Moree Murries* (1991) and *Yarns from the Talbragar Reserve* (1998), a photographic series of the Dubbo Aboriginal community. *Quest for country* was the most autobiographical of all Michael's work, and his quiet determination is evident as he is filmed driving through the countryside of New South Wales, travelling home from Sydney to Dubbo, through a desecrated landscape – power stations ominously spewing water vapour, clouds roiling in fast time-exposure, casting shadows over the land. The technical aspects of the film evoke US director Godfrey Reggio's *QATSI* trilogy (1975–1982), particularly the first film, *Koyannisqatsi* (a Hopi term meaning 'life out of balance'), and Francis Ford Coppola's urban dreamscape/nightmare, *Rumble fish* (1983).[36]

The 1990s were an incredibly productive period in both still and moving imagery for Michael. In 1995 the Museum of Sydney commissioned the film *Eora*, which proved to be a love letter to, and eulogy for, the original custodians of the Sydney region.

Screen grabs from *Tent boxers* 1997 ABC TV

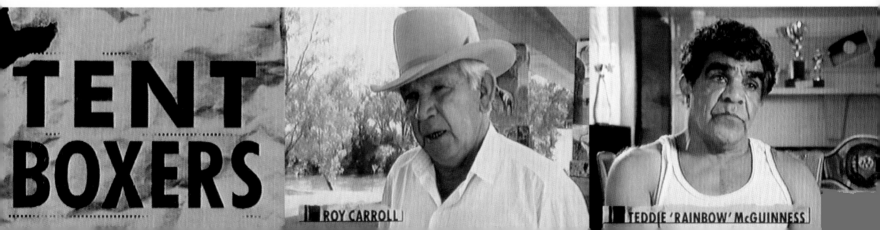

Shot in and around the harbour of the country's largest city, the metropolis is barely apparent. Riley makes vivid use of the natural beauty of the bush and water, paying homage to the reminders of the Eora/Yura clans, in the form of the prolific, but mostly unknown rock engravings in the region. Michael co-opted family, friends and colleagues from the AIDT as participants, and a poignant footnote is that one of the young dancers, Keith Connors, died in a tragic accident overseas prior to the launch of the film.

Throughout the mid-1990s, Michael worked for ABC and SBS Television, completing a series of documentaries including *Blacktracker* (1996) and *Tent boxers* (1997) for ABC, and *The masters* (1996) for SBS. The latter remains the only sit-com portraying contemporary Indigenous urban life produced in Australia and the cast included Destiny Deacon, Lillian Crombie and Lee Madden. A number of projects were developed through Blackfella Films. In 1996–97 Michael was commissioned by Sheryl Connors, Aboriginal Education Officer at the Australian Museum, to produce a series of portraits of eminent Indigenous people based in Sydney. This series is displayed in the Indigenous Australians Gallery of the museum, and the rapport between the photographer and his subjects is evident.

Empire, a film commissioned by Rhoda Roberts for 1997's *Festival of the Dreaming* program of 2000 Sydney Olympic Games Organising Committee (SOCOG), has proven to be Michael's *pièce de résistance*, and resonates as strongly today as when it was premiered. Arguably, it can be considered the final work in a series comprising *Poison*, *Quest for country*, *Eora* and *Empire*, in which *Poison* and *Eora* comment on the losses and dreams of urban-based Indigenous people, and *Quest* and *Empire* trace the connections with Indigenous peoples' traditional lands. Other Indigenous emerging filmmakers and actors who worked with Michael on projects over this time remember his quiet demeanour and lack of conversation, masking his intense focus on the scene at hand.

Interspersed with these seminal films, Michael also produced short educational films, experimental works and music clips for friends and colleagues, including *Breakthrough: Alice* (1989), an anti-racism short film for the Department of Education, Employment and Training about the life of a young urban-based Aboriginal woman, Alice Haines; *Frances* (1990), about his close friend and fellow filmmaker, Frances Peters-Little, exhibiting Warhol-ish influences in the 'film test' feel of the footage; music clips for Indigenous singers – *Starlit bushes* and *Mother Earth* (1992); *A passage through the aisles* (1994), about the childhood experiences of his dear friend, Linda Burney; and *Songlines* (1998). He also worked with artist Destiny Deacon, on numerous satirical projects over the decade: a short sat-com (as in satirical-comedy) series for *Blackout* on ABC TV – *Welcome to my Koori world* (1992) – culminating with the cuttingly edgy, witty, almost painful to watch *I don't wanna be a bludger*, commissioned for the contemporary biennial art event, *Living here now: Art and politics – Australian perspecta* (1999) at the Art Gallery of New South Wales.

Michael moved easily between working as a creator of stills and moving imagery. Of his later photographic series – *A common place: Portraits of Moree Murries* (1991), *Fence sitting* (1994) and *They call me niigarr* (1995), *flyblown* (1998) and *Yarns from the Talbragar Reserve* (1998) – *flyblown* and *Yarns from the Talbragar Reserve* had the greater impact. *They call me niigarr* was his last exhibition at the Hogarth Galleries. His most overtly political exhibition, it was also his least successful in terms of the public's response. The series was included in *Abstracts: New Aboriginalities* which was exhibited at Spacex Gallery, Exeter, and undertook a regional tour in Britain in 1996–97.[37] The exhibition's title, *They call me niigarr*, was a pun on the subject's – David Prosser, dressed in a suit and bow tie – language group, Niigarr, and the artist's statement accompanying the work was Michael at his most outspoken:

> The exhibition is about racism. Racism comes in many forms. It can be blatant, it can be hidden, patronising, and plain demoralising. For many Aboriginal people the result of racism has been all these things. Names such as these are not intentionally meant to be offensive. Non-Aboriginal people joke as they use these words. The words and images of this exhibition come from my childhood experiences with racism – experiences shared by my people.[38]

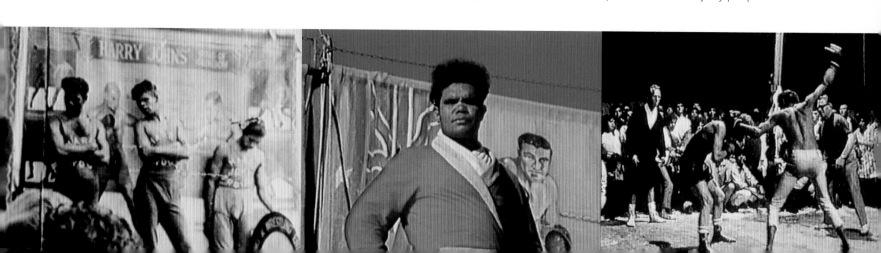

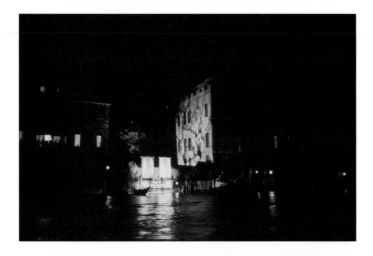

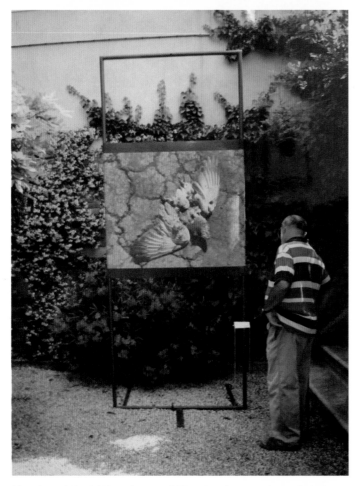

(above) *Untitled [galah]* from the series *flyblown* (1998) projected on wall of Palazzo Papadopoli, Venice Biennale, Italy 1999 Brenda L. Croft
(below) *Untitled [galah]* in *Oltre il mito (Beyond myth)*, Venice Biennale, Italy 1999 Brenda L. Croft

flyblown was first shown at Gallery Gabrielle Pizzi in Melbourne in November 1998 and closely echoed the imagery in the film *Empire*, during which it was shot.[39] During its showing Michael met with musicians Paul Kelly and Kev Carmody, who were in the early stages of writing the music for Rachel Perkins' film *One night the moon*. The initial intention had been for Michael to also work on the film, but by that stage he was already constrained by the weekly dialysis in Sydney that his illness required.

In January 1998 Michael was diagnosed with renal failure, having collapsed at home in Glebe around New Year's Day, and being admitted to Royal Prince Alfred Hospital in Camperdown, Sydney. I was shocked to run into him there on a visit to another friend. How familiar that place was to become in relation to Michael's wellness, or lack of it, over the next few years. At that time though, he seemed as stunned as I that he had been admitted, but the diagnosis made sense of the constant headaches he had suffered throughout his years in Sydney. A childhood bout of rheumatic fever had attacked his immune system and the effects were now being felt.

In 1999 Gabrielle Pizzi curated an exhibition by Indigenous photo-media artists for the *al latere* section of the 48th Venice Biennale, which included a selection from *flyblown*.[40] *Oltre il mito (Beyond myth)* was shown in the beautiful *giardini* of the Palazzo Papadopoli, on the Grand Canal, and the artists' works were displayed in the gardens during the day and projected on the *palazzo* wall at night, which looked incredibly cinematic when viewed from passing *vaporetti* (water buses) or the other side of the canal.[41]

Unfortunately, Michael was unable to travel to Venice and share in the acclaim his work received. This was Michael's biggest source of frustration in the last six years of his life – the restrictions his illness placed on travelling for work prevented him from accepting many opportunities that the rising profile of his work offered. However, he refused to complain and, as if in response to his increasing restrictiveness, his output not only remained constant, but the content and context was elevated to another (other-worldly) plane.

It is in *Sacrifice* that the symbol of the cross, that most potent of Christian symbols, first appeared, looming large against a turbulent sky. Christianity is a subject to which Michael returned again in later work such as *flyblown*, *Empire*, and his last and most potent series of photographs, *cloud* (2000). His images reflect what he described as the 'sacrifices Aboriginal people made to be

Christian'.[42] They resonate with loss, experienced not only by the individual but by entire Indigenous communities: 'loss' of culture and land in enforced, and sometimes embraced, 'exchange' for Christianity. Biblical elements abound in *Sacrifice* – the cross lying on the chest and standing out sharply against the sky in an unseen cemetery; the shimmering skin of the fish, in stark contrast to the parched earth on which it rests; the oozing liquid in the dark palms of the Black Christ-like figure evoking his struggle on the cross; the granules of sugar, flour and coffee echoing the rations meted out to Aboriginal people on missions, and hinting at the struggles present-day communities face with the onslaught of drugs.

Michael's involvement with, and support by and for, Boomalli Aboriginal Artists Co-operative was integral to his creativity at this time. He worked closely with Jonathan Jones, then Exhibitions Co-ordinator. Although Michael had let his membership lapse for a period in the 1990s, his commitment to the organisation he had been instrumental in founding cannot be overlooked. Even though his illness caused his health and well-being to fluctuate, he was chairperson of the organisation during a period of major transition. He remained dedicated to Boomalli until the end, and was supported in his work by long-time colleagues, Joe Hurst, Jeffrey Samuels, family members Joyce and Melissa Abraham, and Tracey Duncan.

cloud is Michael's legacy and the work for which he is best known in Australia and overseas. The first series to move into digital manipulation, it was a natural progression from *Sacrifice*. Michael was assisted in bringing his concept to fruition by Jonathan Jones and Francisco Fisher, then Exhibitions Manager at the Australian Centre for Photography, where the series was first exhibited in 2000, in conjunction with *Empire*.

Unbeknownst to many, Michael's health had suffered badly, with extensive periods of hospitalisation and a couple of very close calls. In fact, after one particularly bad turn where he had to be resuscitated, I remember visiting him at night, and seeing him asleep in his darkened room. Disturbed by his thinness, I wrote a note at the Nurses Station and went to leave it with him before departing without disturbing him. However, when I re-entered his room, he was awake and he grabbed my arm, whispering so softly that I had to lean down to hear him: 'I'll tell you what I saw on the other side'. Not wanting to tire him and perturbed at what he might tell me, I reassured him that he could tell me during my next visit when he felt better. We never had that conversation as he

could not remember my visit, but whenever I look at *cloud* I feel as if that is the trace of his vision.

As his work gained increasing critical acclaim within Australia and overseas, as it soared in spirit, his body was failing him. *cloud* was selected for the 2002 *Asia–Pacific triennial of contemporary art* at Queensland Art Gallery. That same year, as part of the Festival of Sydney, *cloud* was flying high above Circular Quay. It was included in *Photographica Australis*, curated by Alasdair Foster for ARCO 2002, Spain, and its Asialink tour in 2003–04, where his work was awarded a grand prize in the *11th Asian art biennial*, Bangladesh (about which he joked in his usual dry wit: 'Trust me to win a prize from a country with no money!').[43] In 2003 *cloud* and *Empire* were selected for *Poetic justice*: *8th international Istanbul biennale*, which his friend, Anthony 'Ace' Bourke, attended on his behalf and who later accompanied Michael and Boomalli's then Exhibitions Co-ordinator, Tracey Duncan, to the award ceremony at the Australian Centre for Photography in Sydney.[44] Today, *cloud* continues to have an independent life. A selection of images from the series will be permanently installed, as part of the Australian Indigenous Art Commission, at the new Musée du quai Branly, Paris, opening in June 2006.

Christians and Indigenous people both believe in something other than what we see is tangible – right in front of us. The afterlife, the Dreaming, call it what you like: what a pity that all too often there has been conflict between the two belief systems. It would seem that much of Michael's work is about dealing with these contradictions; not only the contradictions between Indigenous and non-Indigenous existence, but also the contradictions that Indigenous people face in determining where they see home, especially those of us who have grown up with fractured cultural experiences and traditions. Fractured but not irreparable. And it is ironic that, while so much of Michael's work seems to deal with loss, these are the biggest gifts he gave us all.

Michael's legacy is also the pride with which he invested his communities of Dubbo, Moree and Sydney. It is reflected in his family, friends and colleagues who were touched by him, his talent and his work, which remains with us. The recent visits to Dubbo and Moree were not only about recalling his presence: his spirit was there watching, in the company of the native animals – the brown snake, wedge-tail eaglehawks, echidna, wallaby, brolga, kookaburra and seemingly millions of bats that made themselves known. These totemic animals were ever watchful, either standing silently or circling overhead, like sentinels. He was there, along with

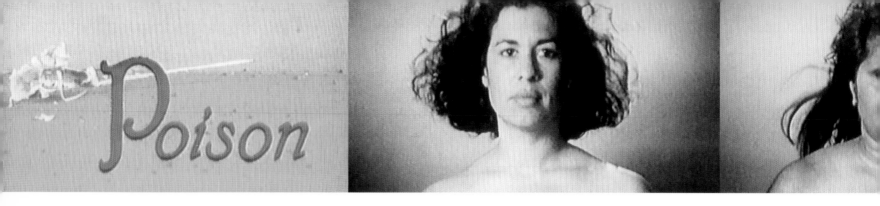

his ancestors, in the wind that rustled the leaves of the trees under which I sat with his family and friends as we recalled his quietness, his observation, his wicked sense of humour, his love of gossip, his mentoring of others and his generosity of spirit.

Big sky. Red soil, black plains. Sunrise, sunset. Love and respect. Claiming. Pride. Michael's art cannot be separated from his life. He showed that there is more than meets the eye when we view the world around us.

> You just really keep your eyes open and look for things that other people don't see. You just see things and then take the picture.[46]

Notes

1 Michael Riley quoted in Kleinert, Sylvia and Neale, Margo (eds.), *Oxford companion to Aboriginal art*, Melbourne: Oxford University Press, 2001, p. 687.
2 This and subsequent quotes from lyrics are from Williams, Victoria, 'I can't cry hard enough', recorded on *Swing the statue*, USA: Mammoth Records, 1994.
3 See Riley-Mundine, Lynette, 'Talbragar Reserve' in Riley, Michael, *Yarns from the Talbragar Reserve*, exhibition catalogue, Dubbo, NSW: Dubbo Regional Art Gallery, 1999.
4 *Dawn: A magazine for the Aboriginal people of NSW*, January 1967, Sydney: NSW Aborigines Welfare Board, 1967, p. 4. '*Dawn* and *New Dawn* were magazines published between 1952–1975 by the New South Wales Aborigines Welfare Board, with the aim of providing interesting information and an exchange of news and views. The *Dawn* and *New Dawn* served as a way for people to keep in contact. The magazines also contain articles about the conditions and activities on reserves, stations, homes and schools throughout New South Wales. During its time of publication the magazines were also used to highlight the work of the Aboriginal Welfare Board. Today the magazines are a valuable source of family history information as they include details of births, deaths, marriages and baptisms, as well as hundreds of photographs.' From What are Dawn magazines?, Fact Sheet 16, Australian Institute of Aboriginal and Torres Strait Islander Studies, Canberra, viewed 23 April 2006, <http://www.aiatsis.gov.au/library/family_history_tracing/fact_sheets/fact_sheet_17>.
5 Ron Riley in conversation with the author, Talbragar Aboriginal Reserve, Dubbo, NSW, February 2006.
6 ABC Content Sales: *Blacktracker*, Sydney: Australian Broadcasting Corporation, 2006, viewed 23 April 2006, <http://www.abc.net.au/programsales/s1190767.htm>.
7 The AIM of Australia was established in 1905 by missionary Retta Dixon in the Singleton district of the Hunter Valley, New South Wales. Retta Dixon is best remembered for the Retta Dixon Children's Home for part-Aboriginal Children, which operated in Darwin from 1946 to 1980, and housed hundreds of Aboriginal children who had been forcibly removed from the care of their families and community under the assimilation policies of the time. These children are known as the 'Stolen Generations'.
8 Dorothy Riley (née Wright) in conversation with the author, Talbragar Aboriginal Reserve, Dubbo, NSW, February 2006.
9 Utilities; tray-backed working vehicles, the vehicle of choice in most rural communities.
10 See Briggs-Smith, Noeline, *Burrul Wallaay (big camp), Moree Mob*, vol. 2, Moree, NSW: Northern Regional Library and Information Service, 2003, pp. 293–5.
11 Briggs-Smith, Noeline, pp. 293–5.
12 Briggs-Smith, Noeline, pp. 293–5. See also 'Along the mail route' in *Dawn: A magazine for the Aboriginal people of NSW*, July 1952, Sydney: NSW Aborigines Welfare Board, 1952, p. 10.
13 Sisters Edna Craigie (née Cutmore) and Gloria (Dort) French (née Cutmore) in conversation with the author, Moree, NSW, March 2006.
14 Lyall Munro Jnr in conversation with the author, Moree, March 2006.
15 Diane McNaboe in conversation with the author, Talbragar Aboriginal Reserve, Dubbo, NSW, February 2006.
16 Cathy Craigie in conversation with the author, Sydney, February 2006.
17 John Delaney in conversation with the author, Sydney, January 2006.
18 Jo Holder is a contemporary artspace director with a lengthy involvement in the Sydney contemporary art scene, particularly in relation to Indigenous art and artists. She has been involved with Mori Gallery, Artspace, the Australian Centre for Photography and most recently, Cross Art Projects, Potts Point, NSW.
19 These included the National Art School in the former women's gaol in Darlinghurst, later called East Sydney Technical College, before reverting to its original name; Alexander Mackie College in Paddington, now the College of Fine Arts, part of the University of New South Wales; Sydney College of the Arts

at its White Bay Campus, now located in the former asylum at Rozelle; and the Eora Centre for Aboriginal Studies, originally in Regent Street, Redfern, now in Abercrombie Street, Chippendale.

20 The source of the first wave of contemporary Indigenous art (initially labelled Urban Koori Art) can be traced to the exhibition *Koorie art '84*, held at Artspace, Sydney, 1984, when Arone Raymond Meeks, Avril Quaill and Gordon Syron exhibited alongside Arnhem Land artist, Banduk Marika. In 1986 *Urban Koories*, held at the Workshop Arts Centre in Willoughby, Sydney, brought together many of the artists who had exhibited in *Koorie art '84*, including Euphemia Bostock, Fiona Foley, Michael Riley and Jeffrey Samuels. These two exhibitions were seminal to the development of a discrete contemporary Indigenous art movement on the eastern seaboard. At the time there was significant resistance to, and rejection of this new yield of artists in the same assimilationist manner that had been in covert existence since the first half of the century, in that the artists and their work were dismissed as 'second-rate white art/ists', ie, not truly Aboriginal art/ists.

21 McFarlane, Robert, *Charles Perkins travelling to university*, 1963, gelatin silver photograph, 33.6 x 22.5 cm, National Library of Australia, viewed 23 April 2006, <http://nla.gov.au/nla.pic-an21225034>.

22 Boomalli Aboriginal Artists Co-operative's founding members were Bronwyn Bancroft, Euphemia Bostock, Brenda L. Croft, Fiona Foley, Fernanda Martins, Arone Raymond Meeks, Tracey Moffatt, Avril Quaill, Michael Riley and Jeffrey Samuels. The co-operative was formed to provide a place where Indigenous artists could create, exhibit and promote their work on their own terms. Its inaugural exhibition, *Boomalli au-go-go*, was held in November 1987, at the premises of a former sewing/sweatshop in Meagher Street, Chippendale.

23 *Koorie art '84: Artspace, 5th–29th September 1984*, Surry Hills, NSW: Artspace, 1984, pp 65–66.

24 The artists were Tracey Moffatt, Michael Riley, Tony Davis, Brenda L. Croft, Chris Robinson, Ros Sultan, Ellen José, Terry Shewring, Mervyn Bishop and others [sic – as stated on the invitation featuring *Kristina*]. The exhibition opened on Monday 8 September 1986.

25 Kamilaroi artists Beale and Duncan knew Michael from Moree; Ngaku/Dunghutti artist, Campbell Jnr, was from Kempsey and, with Fiona Foley, was among the first Aboriginal artists to be represented by a contemporary gallery in Sydney – Roslyn Oxley9 Gallery. Campbell Jnr also organised *Kempsey Koori artists* which was shown at Boomalli in 1988 and included the work of Kamilaroi artist David Fernando. Sheryl Connors became a member of Boomalli in 1988 and curated an exhibition of Michael's work at the Australian Museum in 2004, where she is Aboriginal Education Officer.

26 Brian Syron and Vivian Walker lived and worked for many years overseas, including in New York where Syron studied with Stella Adler. Syron was behind the establishment of the Australian National Playwrights' Conference in 1972.

27 Aboriginal National Theatre Trust Limited, video recordings, 1980, 1988–c.1990, VT 523 – VT 661, State Library of New South Wales.

28 Michael photographed many people and the final selection of works exhibited were, in order of the catalogue: Delores (Scott), Frances (Peters-Little), Dennis/Dillon (McDonald), Charles and Adam (Perkins), Kylie (Belling), Darrell (Sibosado), Hetti (Perkins), Binni (Kirkbright-Burney), Avril and Miya (Quaill), Telphia (Joseph), Alice (Haines) and Tracey (Gray), Dorothy (Delaney), Djon (Mundine), Maria (Polly Cutmore), Tracey (Moffatt), Kristina (Nehm – all three from the original 1986 exhibition), Joe and Brenda (Croft).

29 Dewdney, Andrew and Phillips, Sandra (eds), 'Liking what I do': Interview with Michael Riley, part 1 in *Racism, representation and photography*, Sydney: Inner City Education Centre, 1989, p. 143.

30 Holmes, Natalie, 'Seven little Australians' in *Rolling Stone*, October 1990, pp. 78–81.

31 *After 200 years: Photographs of Aboriginal and Islander Australia today*, exhibition catalogue, Canberra: Australian Institute of Aboriginal and Torres Strait Islander Studies, 1990.

32 AAMA is now known as the National Indigenous Arts Advocacy Association, Inc. and is based in East Sydney.

33 From the Yorta Yorta nation on the Victorian and New South Wales border, Lin Onus was a great supporter of younger Aboriginal artists and he played an influential role on the Aboriginal Arts Board (1986–1988), becoming Chair (1989–1992), before helping to establish AAMA.

34 Darrell Sibosado in conversation with the author in Sydney in February 2006.

35 *Aratjara: Art of the First Australians*, a decade in the planning, was curated by Bernhard Luthi, with the assistance of numerous people from Australia including Djon Mundine. This survey exhibition travelled to Kunstsammlung Nordrhein-Wesfalen, Dusseldorf; Louisiana Museum, Copenhagen; Hayward Gallery, London in 1993.

36 For more information on the QATSI Trilogy, see 'The QATSI Trilogy', viewed 23 April 2006, <http://www.koyaanisqatsi.org>.

37 The tour included 198 Gallery, London and Huddersfield Library and Art Gallery, Huddersfield, Britain.

38 Riley, Michael, *They call me niigarr*, artist's statement, October 1995.

39 *flyblown* was shown in conjunction with the author's solo exhibition, *In my mother's garden*.

40 The other Australian artists exhibited were Brook Andrew, Destiny Deacon, Leah King-Smith and Brenda L. Croft.

41 *flyblown* was included in *Beyond the pale: Contemporary Indigenous art* for the Adelaide Biennial of Australian Art, 2000, at the Art Gallery of South Australia, as part of the 2000 Telstra Adelaide Festival of the Arts. *Beyond the pale* showcased the work of 25 of Australia's leading contemporary Indigenous artists. The series was later shown in *By the river* as part of *Message sticks* program at the Sydney Opera House in 2004.

42 Kleinert and Neale (eds), p. 687.

43 This comment was reported to the author by Anthony 'Ace' Bourke, who attended the award ceremony held at the Australian Centre for Photography.

44 Tracey's family is from Moree and she worked closely with Michael during his last years, through her role at Boomalli Aboriginal Artists Co-operative. Boomalli provided extensive support to Michael until his death.

46 Riley, Michael, artist interview in *Guwanyi: Stories of the Redfern Aboriginal community*, exhibition catalogue, Glebe, NSW: Historic Houses Trust of New South Wales, 1996, p. 19.

(above and below) Screen grabs from *Poison* 1991 ABC TV printed with the kind permission of the actors Lydia Miller, Rhoda Roberts, Lillian Crombie, Willurai Kirkbright-Burney and the family of Russell Page

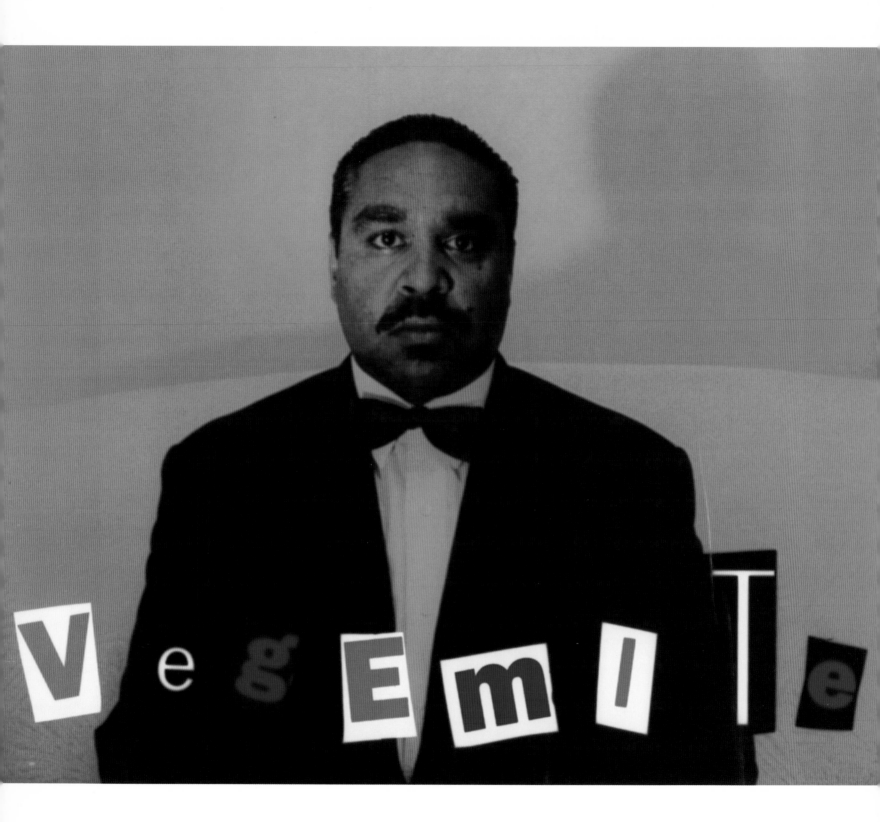

(above and opposite) *They call me niigarr* series 1995 collaged cibachrome photographs Boomalli Aboriginal Artists Co-operative Ltd

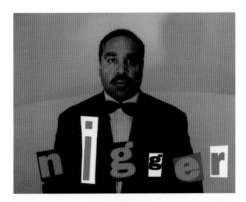

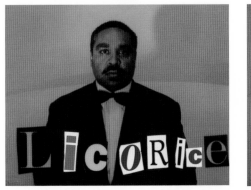

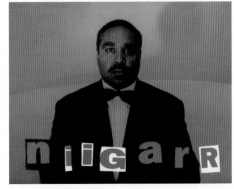

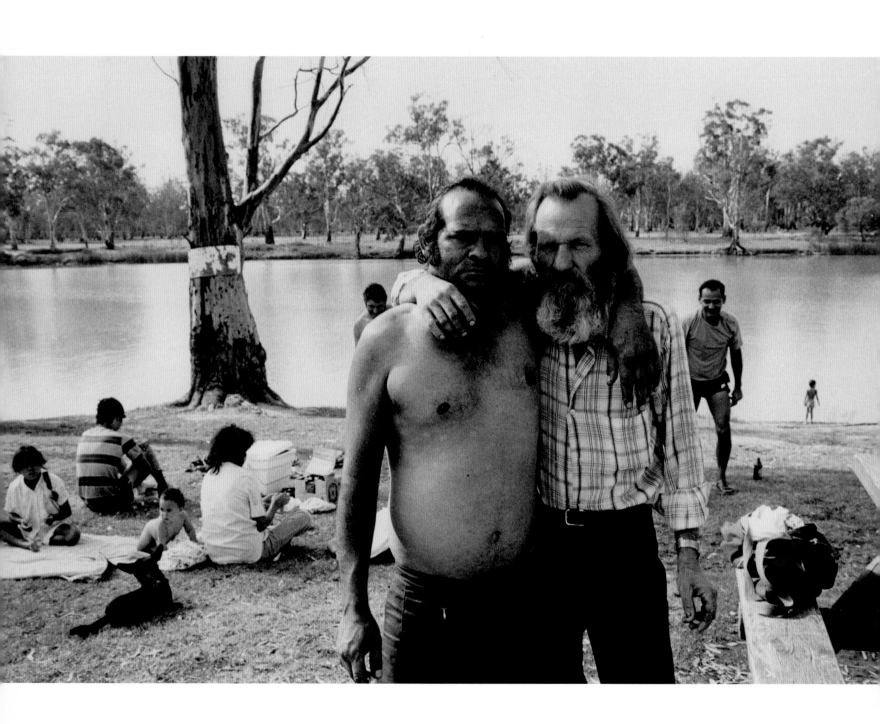

Mark Morgan and Edward Urquhart on the bank of the Murray River, Robinvale 1986 gelatin silver photograph National Gallery of Australia, Canberra

The elders: Indigenous photography in Australia

Gael Newton

The first contemporary art exhibition of work exclusively by Aboriginal and Torres Strait Islander photographers took place in Sydney in September 1986 as part of NADOC '86, a week-long event celebrating the history, culture and achievements of Australia's Indigenous people.[1] Titled *NADOC '86 Exhibition of Aboriginal and Islander photographers*, the exhibition was held at the Aboriginal Artists Gallery in Clarence Street, Sydney and included some 60 photographs by Mervyn Bishop, Brenda L. Croft, Tony Davis, Ellen José, Darren Kemp, Tracey Moffatt, Michael Riley, Christopher Robinson, Ros Sultan, and Terry Shewring.[2] All were influenced by the general excitement in these years about photography as a youthful contemporary artform; one also seen as an accessible and immediately responsive form of witness. As well, these years saw a resurgence of 'the personal is political' activism and liberalism of the 1960s–70s. The embrace in the 1970s of marginalised and diverse cultures also intersected with the pluralism of post-modernism in the 1980s, encouraging borrowings of past imagery and cross-referencing between mediums.

The 1980s were marked by unprecedented consumer affluence for some and protests from others who were excluded or less inclined to accept the status quo. The Brixton race riots in England in 1981 were seen and consumed worldwide through the media, with still photography revealing the power of direct action. In Australia, the effects of a previous decade of government support for more inclusive models of cultural practice had benefits. There was a heightened awareness of Indigenous cultures and communities across Australia in cities, country towns and remote out-stations, largely the result of active campaigning by Indigenous people.[3] In the cities, protests were mounted about Aboriginal deaths in custody but debates also raged around the very definition of 'Aboriginality'.[4] The latter term was diversified beyond anthropological and bureaucratic straitjackets, affirming the legitimacy and role of urban-based Indigenous people. 'Koori', for example, became popular as a term for urban Indigenous people in the south-east of Australia.

The 1988 Bicentenary of the European settlement of Australia was also a catalyst for reconciliation efforts and recognition of Indigenous rights, achievements and new creative endeavours. It provided the impetus, as well, for curatorial projects such as the Australian Institute of Aboriginal and Torres Strait Islander Studies photography commission, *After 200 years*. This massive undertaking documenting Aboriginal Australia commenced in 1985 and aimed for real community engagement. Participating photographers engaged with Aboriginal communities through strict protocols. Of the 21 photographers assigned to the project, only Kathy Fisher, Alana Harris, Ricky Maynard, Polly Sumner, Tess Napaljarri Ross, Helen Napurrula Morton, Peter McKenzie and Riley were Indigenous.[5] Aboriginal poet, activist and photographer Kevin Gilbert, however, mounted a touring photography exhibition called *Inside Black Australia* in protest against the Bicentenary celebrations.

(top) *Mrs Myrtle Clayton outside her home at Euston across the river from Robinvale* 1986 gelatin silver photograph National Gallery of Australia, Canberra (centre) *Michael and Yvonne Hill at home on their block outside Robinvale* 1986 gelatin silver photograph Australian Institute of Aboriginal and Torres Strait Islander Studies (below) *Former dwelling on the original campsite near the bridge, Robinvale* 1986 gelatin silver photograph Australian Institute of Aboriginal and Torres Strait Islander Studies

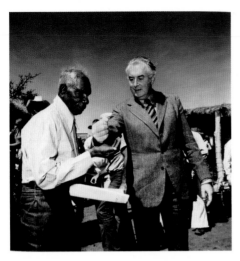

Mervyn BISHOP b.1945 *Prime Minister Gough Whitlam pours soil into hand of traditional landowner Vincent Lingiari, Northern Territory* 1975 gelatin silver photograph 31.0 x 30.4 cm National Gallery of Australia, Canberra © Mervyn Bishop, Licensed by VISCOPY, Australia
(opposite) *Telphia* from *Portraits by a window* 1990 silver gelatin photograph Pat Corrigan

Throughout the 1970s and 1980s, photomedia were acquiring a higher profile in the 'fine arts'. Art schools were increasingly amalgamated with universities – and from 1972, under a free tertiary education scheme, they were energised by a more varied student body. Of the exhibitors in the NADOC '86 show, Moffatt and José were art-school graduates and Riley had recently become an assistant in the photography department at the Sydney College of the Arts. Mervyn Bishop was the only well-established professional photographer among the NADOC '86 Indigenous photographers group. Born in Brewarrina, New South Wales in 1945, he had worked as a photojournalist since the 1960s for *The Sydney Morning Herald* and between 1974 and 1979, he was a photographer at the newly established Department of Aboriginal Affairs.

Photographs at the opening of the NADOC '86 exhibition taken by William Yang, a documentary photographer of Chinese heritage, show some of the exhibitors at what became an historic occasion. The brick walls were not so classy but the event was an art opening with the requisite hip and stylish attendees. While not the product of a tight pre-existing 'group' or movement *per se*, the NADOC '86 exhibition was strategic and savvy, successfully positioning the work in the art gallery scene. Wider issues, the focus of all works, were embodied in a series of individually differentiated, deft, sophisticated or stylish manners. Each exhibitor subtly undermined the deadweight legacy of ethnographic documents and negative media stereotypes.

Mervyn Bishop exhibited his iconic 1975 photograph of Labor Party Prime Minister, the Hon. Gough Whitlam MP, pouring soil into the hand of Gurindji elder Vincent Lingiari, symbolising the return of land rights to the Gurindji people in the Northern Territory. But in 1986 Bishop, too, was on a new journey as bold as that of his younger associates. He had left his job with the Department of Aboriginal Affairs, turned freelance, undertaken further study, and begun teaching at Tranby Aboriginal College in Sydney. Bishop is often described as the first high-profile Indigenous photographer in Australia, but a number of Aboriginal people, including his own mother, had actively taken photographs since the early twentieth century or had a personal practice of compiling albums and having pictures taken.

The 1986 show was preceded by the pioneering show of Indigenous artists, mainly from urban communities, called *Koorie art '84*. This show included the work of several photographers, notably Riley, Shewring and Ian Craigie. The NADOC '86 artists could not begin from a *tabula rasa* in quite the same way that an earlier generation of photographers in the 1970s could imagine themselves taking up a 'new' medium. For these earlier artists, photography seemed 'new', uninflected – the medium had no baggage of history, or so they thought. For this new generation of highly directed Indigenous artist-photographers to begin meant, inevitably, that first there would be some back-tracking, including references to the history of race relations and earlier photography of Indigenous people. The NADOC '86 show, however, marked the beginning of a public profile within the art world for contemporary Indigenous photographers.[6]

The invitation to the exhibition used Michael Riley's moody, Hollywood-style portrait of Kristina Nehm, a student at the Aboriginal and Islander Dance Theatre. Her pose recalled

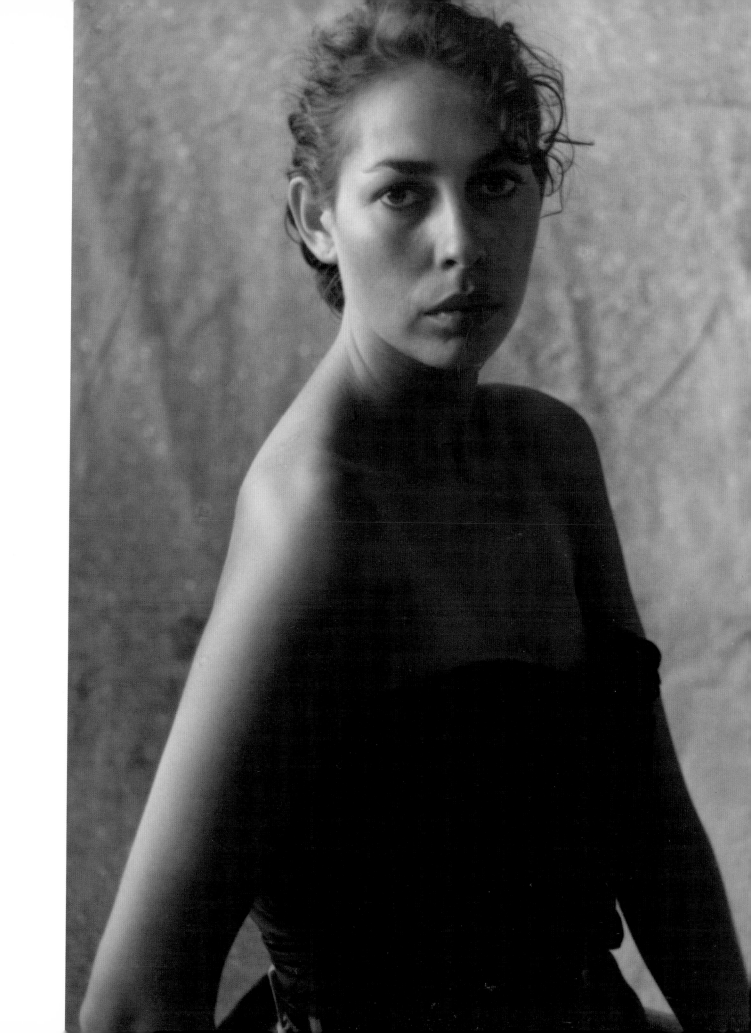

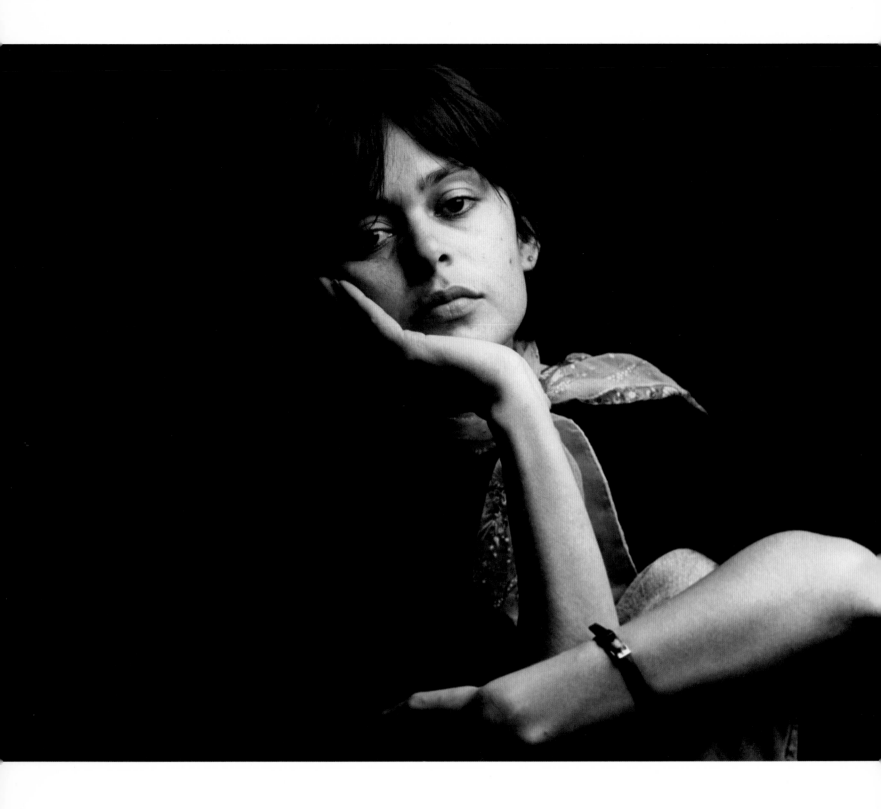

Avril 1986 gelatin silver photograph Avril Quaill

old stereotypes of 'dusky', black beauties languidly acquiescing to the camera's caress yet, as Anthony 'Ace' Bourke, then Director of the Aboriginal Artists Gallery and co-ordinator of the show, recalls, the picture 'was very political, black girls weren't meant to be seriously chic'.[7] Kristina is both revealed by the camera's focus on her but also eludes exposure behind her fashionable sunglasses. Yet no magazine then would have hired her.

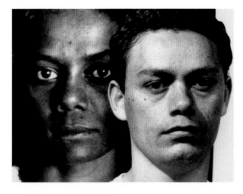

The works on display in the NADOC '86 show ranged from reportage to manipulated images, some with a sharp political edge. Others were remarkable for their lack of bombast. Moffatt's work attracted the only press coverage. Her black-and-white series, *Some lads*, showed dancers from the Aboriginal and Islander Dance Theatre quite nonchalantly, cheekily, passionately playing and posing – anything but the sobriety or anonymity of photographs of corroborees or even classical dancers. Her colour image of dancer and actor David Gulpilil mimicked the sun-baking, beer-drinking Aussies at Bondi Beach. Like Riley's *Kristina*, which claimed a right to be glamorous, Moffatt's images were tuned to the issues of naming rights, identity and dress – an agenda that would be a leitmotiv for many Indigenous photographic artists. Identity, it seems, would be dependent on inserting the unfamiliar dark face in the white scene. Moffatt and Riley grounded their works in the issues of dress and undress which are central to how the 'native' is seen (and not seen). These issues are present in the viewing of photographs of and by Indigenous people. References to self-presentation are also central to the work of Brenda L. Croft and Fiona Foley, both sophisticated artists in several media.

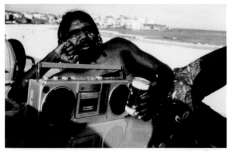

Moffatt's images in the 1986 show were staged but believable fictions. It could be argued that the post-modernism in the contemporary art of the 1980s – with its faith in appropriation and disruption of the notion of an original pure canon, centre or method – greatly favoured the work of those formerly excluded from power and presence: women and ethnic 'others' of all kinds. It allowed for a running commentary on the past and was most effective when tied to a social rather than purely aesthetic agenda. Moffatt has gained considerable international acclaim for her work. Her politics have included the refusal to be categorised as an Aboriginal, a woman and a photographer, suspecting as she did with the NADOC '86 show that attention came from tokenism, not engagement with the work or its normalising within contemporary art.[8]

(top) Michael with 'Maria', *NADOC '86 Exhibition of Aboriginal and Islander photographers* 1986 photograph: Quentin Jones Courtesy of *Sydney Morning Herald*
(centre) **Tracey MOFFATT** b. 1960
The movie star: David Gulpilil on Bondi Beach 1985 direct positive colour photograph 50.3 x 80.2 cm National Gallery of Australia, Canberra Courtesy Roslyn Oxley9 Gallery
(bottom) **Mervyn BISHOP** b. 1945 *Is there an Aboriginal photography?* 1989 gelatin silver photograph 40.3 x 59.7 cm National Gallery of Australia, Canberra © Mervyn Bishop, Licensed by VISCOPY, Australia

A year after the Bicentenary, Mervyn Bishop posed an enigmatic question in a self-portrait called *Is there an Aboriginal photography?* But over the next decade or so, many Indigenous photographers – including Croft, Bishop, Moffatt, Riley and José – would all go on to diverse roles as photomedia artists and leaders of the Indigenous arts revolution, widely recognised both nationally and internationally. Other shows by Indigenous photographers followed in the next five years, aided by the establishment of dedicated venues such as Boomalli Aboriginal Artists Co-operative in 1987, by the national tour of Gilbert's *Inside Black Australia*, and also by the incorporation of Indigenous artists in standard dealer-gallery representation systems. A new generation of Indigenous photo-based artists and curators also appeared. Destiny Deacon, for example, a Kuku–Erub/Mer woman based in Melbourne, began exhibiting in 1990. Appending the term *Blak* to her titles, and employing a kind of creole satirical language throughout her works, she is now among the best-known Indigenous artists from Australia on the international scene.

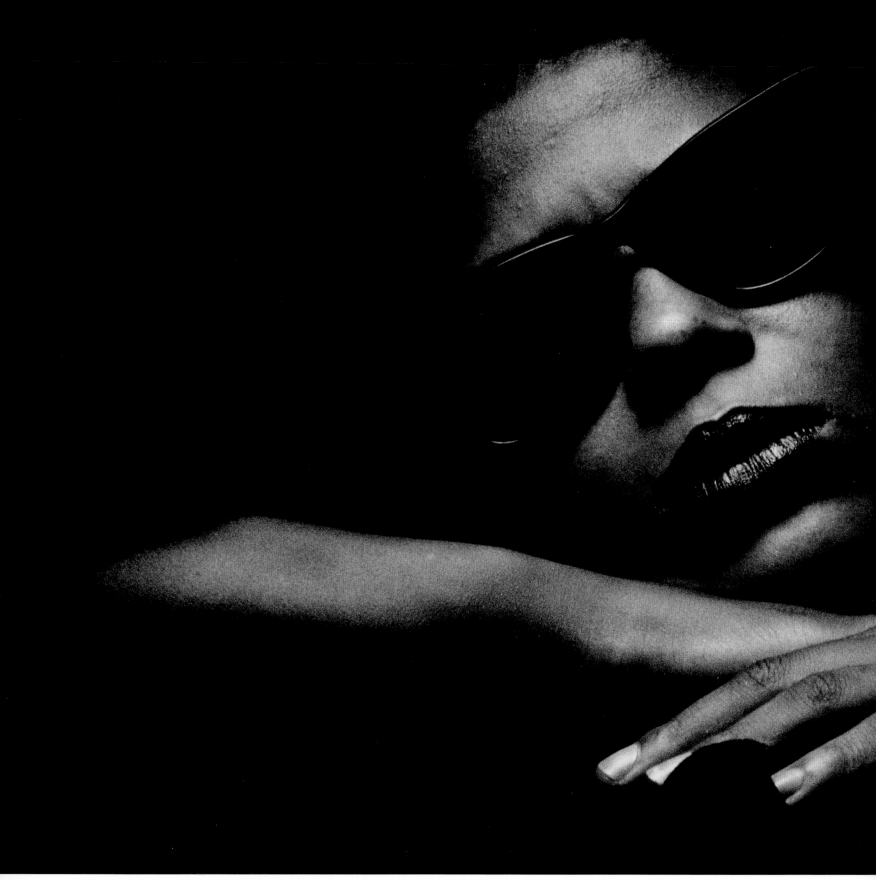

Kristina 1986 gelatin silver photograph National Gallery of Australia, Canberra

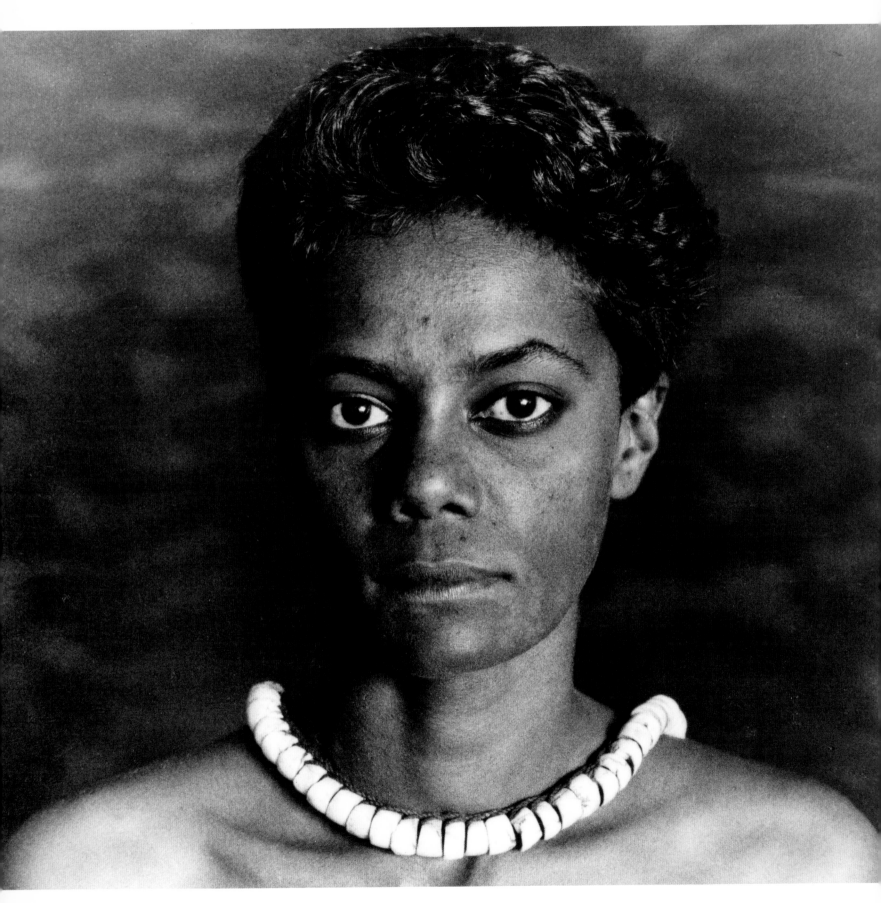

Destiny DEACON b. 1957 *Blak lik mi* 1991/2003
light jet print from Polaroid original 100.0 x 214.5 cm
National Gallery of Australia, Canberra © Destiny
Deacon, Licensed by VISCOPY, Australia
(opposite) *Maria* 1986 gelatin silver photograph
Australian Institute of Aboriginal and Torres Strait
Islander Studies

A number of Indigenous Australian photomedia artists came to international prominence in the 1990s. Arguably, they had higher profiles in the United Kingdom and the United States of America than Indigenous artists from other lands, and they achieved comparable levels of success to ethnic 'artists of colour' within those countries. As in Australia, the United States experienced a surge in the development of young Native American photomedia artists during the mid-1980s and early 1990s.[9] In part, this was in response to the teaching of photography in art schools and the establishment of dedicated, often government supported, art galleries which, like Boomalli in Australia, provided venues for the exhibition of Native American art. But the quincentennial 'celebrations' in 1992 of the discovery of the Americas by Columbus also proved to be a catalyst as people realised photography was the perfect medium to illustrate and confront issues arising from colonisation by Europeans. *Aperture, Views, Afterimage* and other photo-journals all featured Indigenous photographers in that year, and some of the most courageous and intriguing shows of contemporary Native American work to date toured the United States and Canada. Indigenous Australian artists, Riley amongst them, benefited from the increased, although still marginalised, interest.

In 1993, Michael Riley made a key work called *Sacrifice*. It was first shown in black and white at the Hogarth Galleries in Sydney, a dealer-gallery specialising in Aboriginal art and directed by Anthony 'Ace' Bourke, the former Director of the Aboriginal Artists Gallery. *Sacrifice* was an overtly symbolic and ambiguous series of shots of objects and bodies, constructing a complex allegory of sacrifice. Riley interposed a black male torso in place of Christ and turned spoons of the sacraments towards the heroin crisis. Although his works would grow in scale, colour, fantasy and complexity, Riley's subsequent work would never lose the sense of elegy and personal displacement first revealed in this eloquent series. Because of his art's location within an Indigenous politics, it is perhaps Riley's role as an artist to offer the open-ended lack of literality and proscription in his work as an opportunity for art to be open to interpretation and open to all. He was in many ways a traditional western *and* Indigenous artist, addressing the universal through the highly specific and local situation. The majesty and ethereality of his last, large colour series has no barriers at the door for viewers not of colour; they allow for peace and redemption. Offering this quality of topical metaphysics would seem to be Riley's particular role within his generation.

Notes

1. For a history of this event, which evolved from the 1920s and gathered increased profile during the 1970s see <http://www.naidoc.org.au/history/default.aspx>. In 1988, the event became known as NAIDOC Week, reflecting the name change of the management committee to the National Aboriginal and Islander Day Observance Committee. Since 1992, NAIDOC events have been held in the first week of July.

2. The Aboriginal Arts Board of the Australia Council funded the Aboriginal Artists Gallery in Clarence Street, Sydney. The Gallery's first director was Anthony ' Ace' Bourke, later Director of the Hogarth Galleries, Australia's oldest established Aboriginal fine art gallery. The NADOC '86 exhibition was initiated by Brisbane-born Aboriginal photographer and filmmaker, Tracey Moffatt, following an invitation from Ace Bourke.

3. Indigenous people were not counted on the census until 1967, although they had voting rights from the early twentieth century, which were not generally exercised. Native Americans in Canada received voting rights in 1960 and, in the United States of America, indigenous rights were clarified by the 1965 *Voting Rights Act* and subsequent amendments.

4. The Royal Commission into Aboriginal Deaths in Custody was established in 1987. The Commission examined all deaths in custody in each State and Territory which occurred between 1 January 1980 and 31 May 1989, and the actions taken in respect of each death. For more information, see 'Royal Commission into black deaths in custody', Fact Sheet 112, National Archives of Australia, viewed online 11 April 2006, <http://www.naa.gov.au/publications/fact_sheets/fs112.html>,

5. Taylor, Penny (ed.), *After 200 years: Photographic essays of Aboriginal and Islander Australia today*, Canberra: Aboriginal Studies Press, 1988.

6. See Moffatt, Tracey (ed.), *In dreams: Mervyn Bishop – Thirty years of photography 1960–1990*, exhibition catalogue, Sydney: Australian Centre for Photography, 1991. See also Lee, Gary, 'Picturing: Aboriginal social and political photography', *Artlink* vol. 20, no. 1, 2000.

7. Anthony 'Ace' Bourke in conversation with the author, June 1997.

8. Moffatt received considerable criticism for her stance.

9. This discussion is drawn from email correspondence between the author and Veronica Passalqua, Curator, C.N. Gorman Museum, University of California Davis, 19 February 2006. The museum was founded in 1973 by the Department of Native American Studies. See also Carl Nelson Gorman Museum website, <http://gormanmuseum.ucdavis.edu/index.htm>.

Tracey [*head down*] 1986 gelatin silver photograph Anthony Bourke
(opposite) *Kristina* [*no glasses*] 1984 gelatin silver photograph
National Gallery of Australia, Canberra

(clockwise from top left) Ace in front of Michael's poster, Istanbul, Turkey 2003
Jo Holder; Ace Bourke, Michael, Pat Corrigan and Nicola Flamer-Caldera, Australian
Centre for Photography, Sydney 2004 print from colour negative Pat Corrigan;
Ace Bourke in front of Governor Bourke's statue, Mitchell Library print from negative
Museum of Sydney; Michael's work in situ, *NADOC '86 Exhibition of Aboriginal
and Islander photograhers,* Aboriginal Artists Gallery, Sydney, September, 1986
Photographer unknown

In retrospect

Anthony 'Ace' Bourke

I met Michael Riley in 1986. I had seen photographs by Tracey Moffatt and I wrote to her to ask if she wanted to participate in an Aboriginal photographic exhibition. She said she would only participate if the artists included were Indigenous photographers.

I suppose at the time I may have been considering including non-Indigenous photographers like Penny Tweedie, Wes Stacey, Sandy Edwards, Jon Rhodes, Juno Gemes and Jon Lewis.

For *NADOC '86 Exhibition of Aboriginal and Islander photographers*, held at the Aboriginal Artists Gallery in Sydney during NADOC Week in 1986, Tracey produced Michael Riley, Brenda L. Croft, Mervyn Bishop, Tony Davis, Ros Sultan, Ellen José, Christopher Robinson, Darren Kemp and Terry Shewring. It was the first exhibition of Aboriginal photography and, looking back, I wonder why it didn't feel more historic. I was familiar with the work of Trevor Nickolls, Arone Raymond Meeks and Jeffrey Samuels, and I had seen the exhibition *Koorie art '84*, which *did* feel historic. I was aware of just how many talented urban-based Aboriginal artists were emerging, so by 1986 the exhibition was not a surprise.

The photographs of Michael Riley and Tracey Moffatt, however, were exceptionally resolved and assured. Michael, like Robert Mapplethorpe, really understood the power of black-and-white photography, achieved through his rapport with the subject, an instinctive feeling for composition, and expertise with lighting and printing. His portraits of *Kristina* and *Maria* became classics.

Interestingly, I presumed the exhibition was the beginning of many more Aboriginal artists emerging from urban areas, but the next wave didn't happen. This was an extraordinary Indigenous and non-Indigenous generation.

Did the exhibition create the attention it should have? Both photography and 'urban' Aboriginal art were less collected then, and most of the people that came to the exhibition knew how inaccurate the usual stereotypical representation of Aborigines was. The exhibition became famous in retrospect.

As a founding member of Boomalli Aboriginal Artists Co-operative, Michael's heart always lay there, but he exhibited regularly throughout the 1990s with Hogarth Galleries in Paddington, where I was a co-director, and with Gallery Gabrielle Pizzi in Melbourne. His first exhibition, *Portraits by a window* (1990), consisted of beautiful and sensitive photographs of the friends in his life. Once I asked Michael what had been the best periods in his life and he said, 'Oh, meeting you and Hetti Perkins and everyone'. This was the time when his life and work in Sydney was expanding and coming together in the interesting direction he wanted it to go in. People were attractive, well-educated or very bright, interesting and talented. This was being appreciated and utilised, and there were opportunities to be taken. Michael both captured and personified this.

Armed with the trusty Nikon (and the idea of a simple backdrop taken from my copy of Irving Penn's book *Worlds in a small room* (1974), which I was never to see again), Michael photographed his community in Moree (and later in Dubbo). These photographs were less stylised than Penn's, more traditional, and less posed than his early works. He asked people how they wanted to be photographed. *A common place: Portraits of Moree Murries* (1991) is extraordinarily valuable documentation, and was an exhibition of exceptional insight and poignancy.

Michael's work was always fully resolved, distilled, refined. He had an extraordinary aesthetic of elegance and simplicity. It was subtly political rather than overt, and probably more successful for it. It broke the stereotypes, or re-represented Aboriginal people, but in a non-confrontational way. My co-director at the Hogarth Galleries, Helen Hansen, comments, 'I remember he always had trouble with the titles for his exhibitions – words weren't necessary, they were extraneous to the idea, the work said everything'. And she remembers how people 'were drawn into an intimate, silent dialogue with the work, and he was able to convey a wealth of information with ease and a lack of artifice'.

Without fanfare, he quietly, persistently, consistently, built an imposing body of work and a reputation. I saw him as the

Capricorn goat he was, climbing steadily, one step after the other, up and up the mountain. And the view from the top was ... *cloud* in 2000, his final work.

Michael's selection to participate in *Poetic justice: 8th international Istanbul biennial* in 2003, with *cloud* and his film *Empire* (1997), was a career highlight that secured his international reputation. Sadly he was too ill to go to a city he always wanted to visit, and I was fortunate enough to represent him. I arrived to see *feather* from the *cloud* series as the signature image for the Biennial on posters all over the city, from the grand, pedestrianised Istiklal Caddesi to outside the Topkapi Palace.

Sydney curator, writer and gallerist Jo Holder commented:
> This was Michael's global moment. *cloud* was the perfect voice or emblem for the time. It fitted so well into the east/west axis of Istanbul. With the invasion of Iraq and American unilateral foreign policy, the world was in free fall and the work seemed to me to describe a sense of just how wrong it was. It floated above the abyss.

Everyone could relate to the universality of his imagery in *Empire* as well, and the beautiful and haunting music permeated the venue, M.S.U. Tophane-Amire Culture and Arts Centre.

Michael intended to do a body of work about water, a constant theme that ran through his work, and his sister Wendy has described the hours Michael would spend looking at the water in the river. (I was to be a drowning priest, a role Michael gleefully looked forward to my doing.) Recently I visited Dubbo and saw the landscape that inspired him – the water in the two rivers that conjoined at the Talbragar Reserve, the endless blue sky and horizon, the long grasses. Michael reclaimed them and reasserted ownership.

Michael particularly liked the distinctive, moody photoessays on working-class Europeans by Czech-born Magnum photojournalist Joseph Koudleka (born 1938) but he also admired the understated elegance of Anglo-Swedish photographer Axel Poignant who, following his arrival in Sydney in 1926, went on to make pioneering photoessays on the Liverpool River Aboriginal communities in 1952. Michael was especially interested in the photograph of the swaggy and his bike, *Australian swagman* (1953–54), and the long road stretching endlessly to the horizon. Michael wanted to look at the Australian myth of the outback, and deconstruct it and reclaim it as Indigenous.

Michael quietly and assiduously seemed to do a lifetime's work in half the time, but he had so much more he wanted to do and say.

(above and following pages) *Sacrifice* series 1992 gelatin silver photographs National Gallery of Australia, Canberra

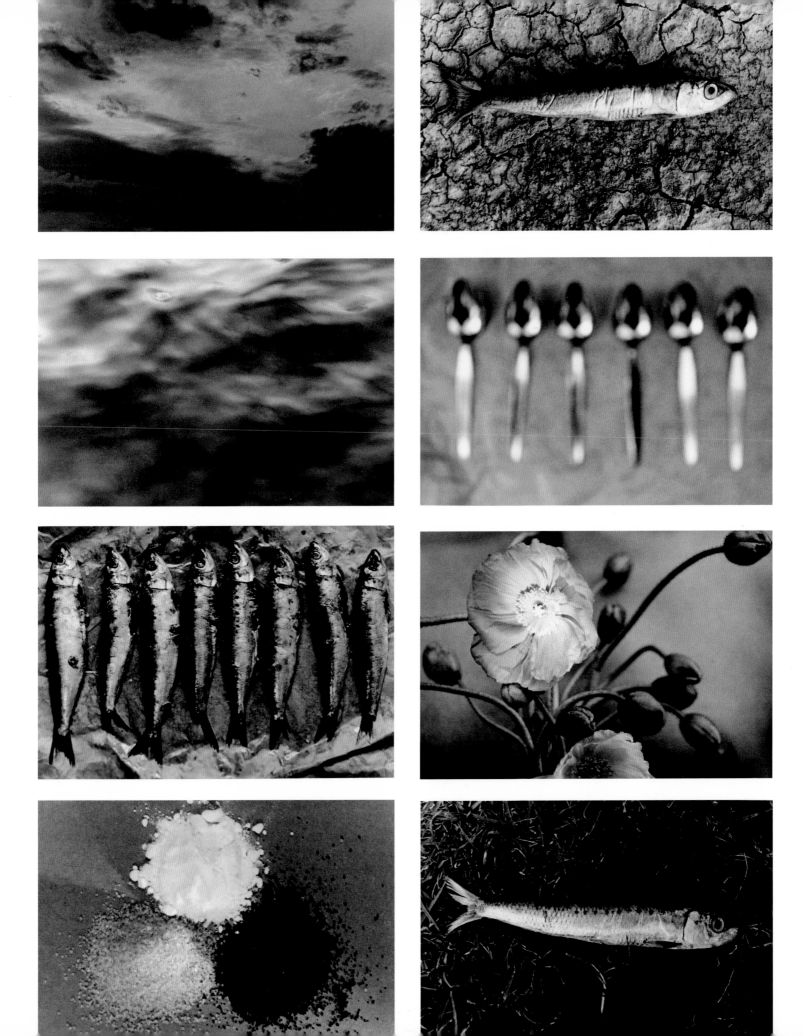

 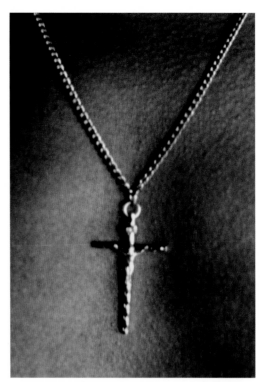

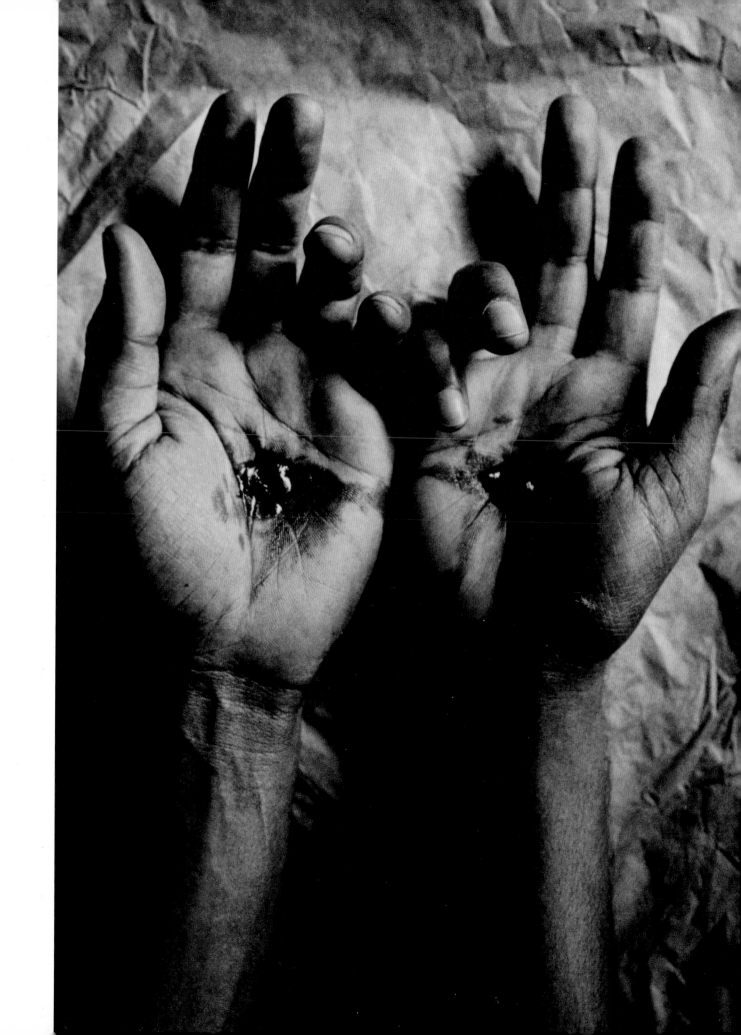

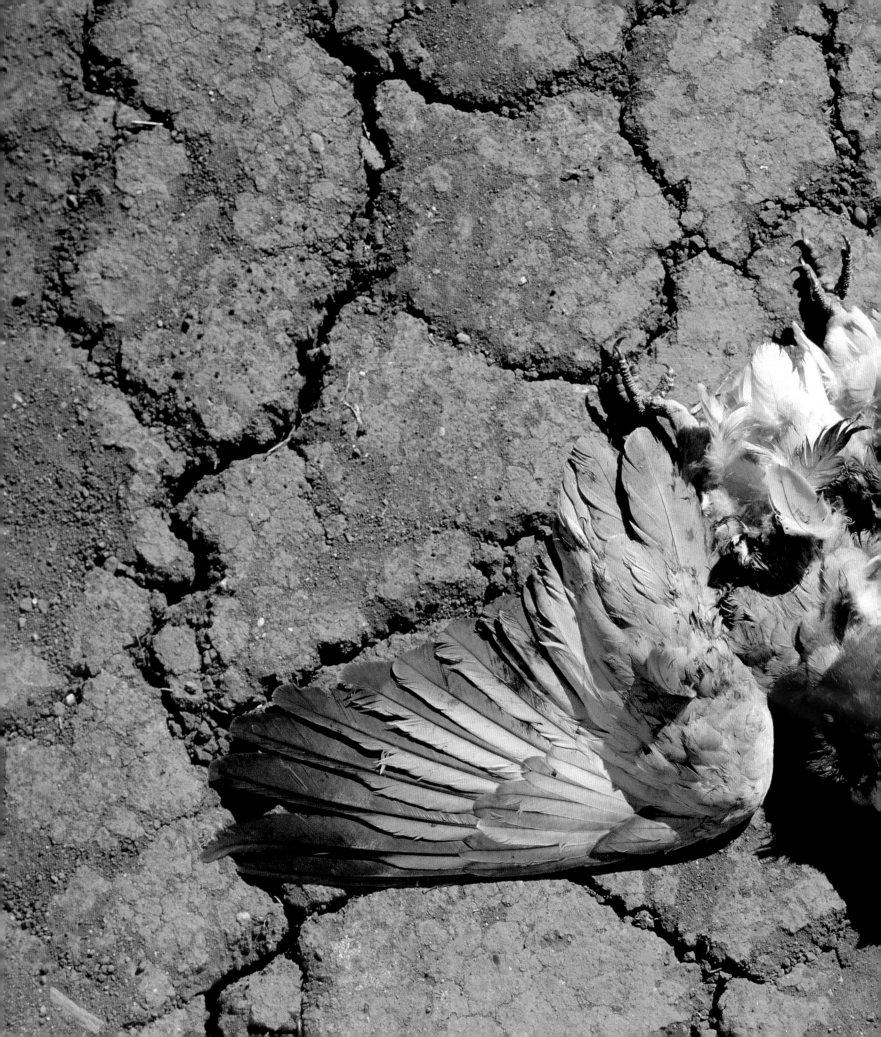

The meek Michael Riley

Nikos Papastergiadis

I met Michael Riley once. The invitation to his exhibition, *A common place: Portraits of Moree Murries,* at the Rebecca Hossack Gallery in London had been sent to the journal *Third Text.* It was the summer of 1991 and it was quite warm. I was working as an assistant editor at the journal and when we received the invitation there was an instant recognition in the office that this was to be an important event. The journal's editors, Jean Fisher and Rasheed Araeen, were intrigued by the card, and even though Rebecca Hossack's gallery was not one of the usual sites for this gang, the word went out and most of the hard-core critics and artists that were associated with the journal came out for the opening.

The opening was packed but in the lower section of the gallery there was a series of photographs that maintained their equanimity. The space had been lit with care, enough to see each work with appreciation but not so as to disturb the quietness that had settled between each work. The photographs were portraits. Most of them were of individuals. Some were of families and friends. Every face was calm. Everyone looked directly at the camera with a warm sense of delight. The photographs had simple names: 'Nana Riley'; 'Nana with grandkids'; 'Two mates'. It was obvious that Michael was at home. But more importantly the gaze and posture of everyone in the photographs was homely. The two mates stood shoulder-to-shoulder, one slightly leaning into the other. The dog at Nana's feet was alert, his tail and ears up and ready – he cares that there might be something around the corner. All the photographs were taken with the same backdrop, a long white canvas sheet that also draped down to cover the floor. The background and foreground merged. It was a simple place of intimacy.

This series of photographs has never left me. They were the most remarkable portraits of a community that I have ever witnessed. Michael took out all the jagged edges of the world in which these people lived but brought in the dignity with which they face that world on a daily basis. The scene is soft, but this does nothing to soften the reality. There is no sense that these people are posing in a fantasy world. They are in a state of repose and respite, but are not oblivious to and apart from their own lives. Their world

Untitled [*galah*] from the series *flyblown* 1998 chromogenic pigment print
National Gallery of Australia, Canberra

is held in their bodies. This can be seen in their small gestures. It is evident in the way the knuckles and fingers in the hands are crossed together. It can also be seen in the fall of the arms from the slightly puffed torso of a younger man. Even the act of tugging of one kid's arm to hold her in the frame is a kind of act of loving co-operation. In this image the gentle wonder and nervous compliance of the kids is counterposed by the proud smile and firm stance of the mother. As we moved along the gallery walls I felt that we were coming closer and closer to a group of people who understood hospitality and hardship.

Michael had created the most relaxed and real photographs of a community. He had not gone into their homes and asked them to be themselves. He had not followed them in the course of their working life or sought to place them in the landscape in a way that might reflect back their struggle and entitlement. On the contrary, he invited them into a space that was abstract. In this neutral setting he created their aura of their belonging through the small gestures of recognition. This effect was startling in its simplicity but also a turning point in the history of photography. It was in direct opposition to the history of colonial and ethnographic photography that sought to capture the noble savage in their primitive setting. It was also a radical departure from the more recent photorealism that sought to sink the subject into a landscape of grim exploitation and alienation. Michael did not set out to challenge these traditions by any overt act. At that time, the critiques of colonial and ethnographic photography were being forcefully argued in the pages of *Third Text*. Many artists were also determined to deconstruct the strategies of the past, appropriate and recontextualise images that had been taken of Indigenous people.

It seemed to me that Michael's aim was more subtle and in a simple way more humble. He knew the people that he wanted to photograph. I also felt that he knew the way these people wanted to be photographed. I have seen numerous exhibitions where photographers have spent extended periods 'in the field'. Where they have clearly worked hard to learn the habits, speak the language and even gain the trust of the people that they wanted to photograph. Many of these photographs have the power to reveal the details of people's everyday lives. At times they hint at articulating a deep secret or creating an iconic moment that evokes a genuine sympathy for the subject. But this does not always translate into the production of photographs that the subjects want to see for themselves. The difference between even a committed photographer and Michael's work is that his images are not just a document of time and place. They are portraits that seem to have

been delivered not just with consent but also through the active collaboration of the subject. How do you get to this phase of co-production?

There are no short cuts in this art practice. To convey this intimacy requires profound familiarity. It comes through the way one lives with one's family and friends. It emerges from a lifetime of having noticed what makes people happy and what causes them pain. I imagine that Michael was able to ask people to stand in a way that was not simply posing for the camera and they would know what he meant. They would know that he would know when they were putting on a pose. But more importantly he also knew that they wanted to look well and to feel pride and pleasure in the final image. The power of their relationship is in how they work together to create this positive image. Most recently I have come to think that this relationship has nothing to do with the history of documentation but a great deal to do with the process of mediation. The photographer is working with these people for them to create the image of themselves that does not just reflect back a fixed identity, but also presents a sense of who they are and who they are becoming. It shifts the act of representation from recovering the past, to conveying the possibility of being in the present and the future.

In the late 1970s John Berger and Jean Mohr made a book of photographs about the lives of mountain peasants. The writer and photographer knew their subjects intimately. John Berger lived in the village for many years and Jean Mohr originated from a similar place. They had both understood the challenge of making a book of photographs. Mohr noted that the point of intersection between the photographer, the subject of a photograph and the viewer were often contradictory. Each person approaches the image from a different perspective, with different assumptions and unique sets of references. Their concern was to produce photographs in which the fundamental questions – 'who is being represented?' and 'what use is being made of the image?' – could be asked in such a way that everyone felt empowered to answer. There is a chapter in this book called 'Marcel or the right to choose', in which Mohr photographs a shepherd in the mountains with his cows, dog and grandson. After having shown Marcel dozens of photographs, he requested the right to be photographed as he wished:

> The next Sunday, early in the morning, Marcel knocked at the door. He was wearing a clean, freshly ironed, black shirt. His hair was carefully combed. He had shaved. 'The moment has come,' he told me, 'to take the bust. Down to there!' He indicated his waist with one hand. Below this chosen line he was wearing his working trousers and his boots covered with

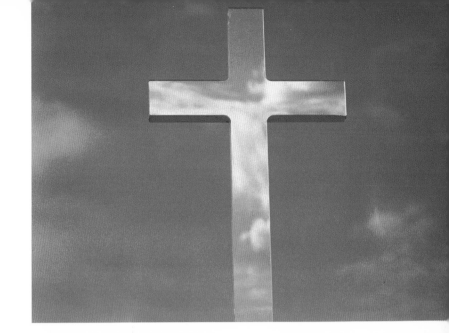

cowshit. Sunday or not, he still had fifty cows to look after. He stood in the middle of the kitchen and concentrated on the camera which was going to take his portrait.

When he saw this portrait, in which he had chosen everything for himself, he said with a kind of relief: 'And now my great grandchildren will know what sort of man I was.'[1]

A few years later I met Marcel's grandson. He was on holidays from his science course and was about to assist in the delivery of a calf. After he cleaned the barn he came next door and had a drink with us. He had the same smiling expression of satisfaction as his grandfather. The image of Marcel and the presence of his grandson seem to come from the same place. The co-presence between the photograph of Marcel and the smile on the face of his grandson might be another way of thinking about posterity. Michael, I suspect, would have understood this claim that photography has the power to convey the inter-generational passage of traits. I am guessing, as there is now no way to check, that he felt he was photographing his family for the sake of the future.

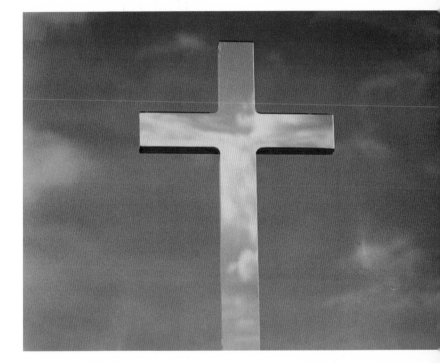

We did have the chance to check some of these impressions and reflections. At the opening in London, Jean Fisher, Rasheed Araeen and I asked to be introduced to Michael. The heat of the day had not lifted and so we took our beers and stepped out into the shady footpath. Michael came outside to say hello and shook our hands. He was extremely shy and modest. Rasheed was quick to commend him for the technique of blurring the horizon line through the curve of the sheet. Jean was most moved by the deep humanism that was evoked by his subjects. Michael was appreciative but he shuffled nervously and his eyes floated off towards some other kind of horizon. Jean asked him if we could record an interview with him that might be published in the journal. He agreed, and so on the next day we went out to Brixton to have lunch and discuss the politics of representation and the use of photography in redeeming the subjectivity of Indigenous people. We asked questions about his technique for developing a trusting relationship with his subjects, and the development of a mode that we called 'critical intimacy'. We also asked him if there were parallels in the laws on and conditions for representing the art of the Indigenous peoples in the Americas and Australia. Throughout the interview Michael replied slowly and mostly from a personal perspective. He was uncomfortable with being in a dark basement flat, the slowly turning reels of the

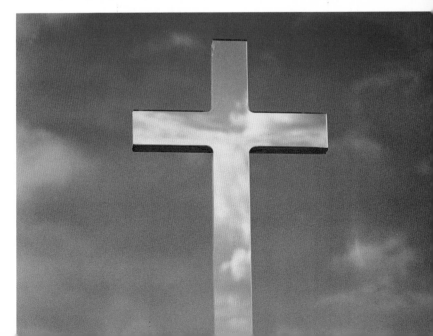

(top to bottom) *Untitled* [*red cross*]; *Untitled* [*gold cross*]; *Untitled* [*blue cross*] from the series *flyblown* 1998 chromogenic pigment prints National Gallery of Australia, Canberra

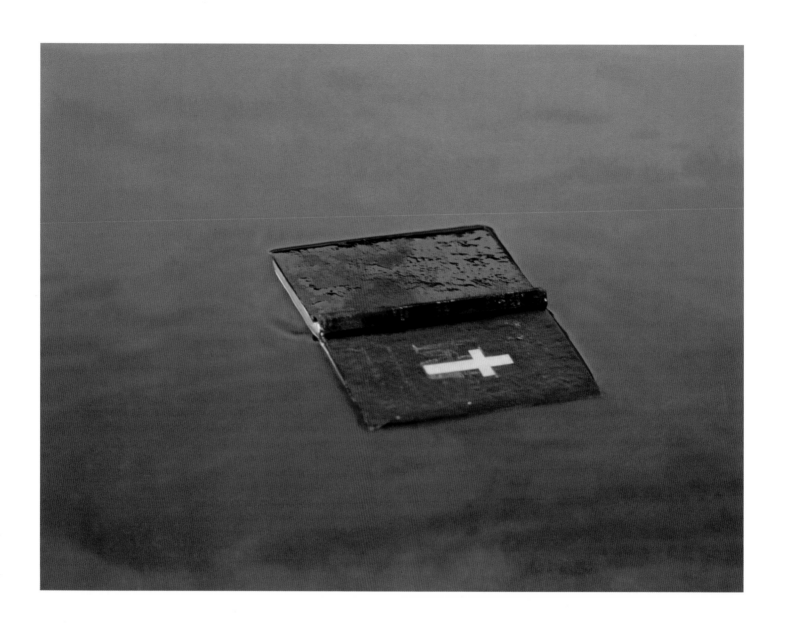

Untitled [*bible*] from the series *flyblown* 1998 chromogenic pigment prints National Gallery of Australia, Canberra

Walkman, and with some of our more strident questions. We turned off the machine and went to a nearby restaurant to eat Mexican food on the terrace, because to everyone's surprise it was still warm.

When I returned to Australia in 1998, Alasdair Foster from the Australian Centre for Photography invited me to edit a special issue of the journal *Photofile*. I was interested in exploring the concept of the 'strange'.[2] During my time away I had often pondered on the vast levels of complexity in the social and historical landscape of Australia. How do we make sense of all the different histories that have jostled for attention? How do we even begin to grasp the multiple layers and diverse fragments that are dispersed in our everyday surroundings? My aim was not to seek to find photographic testimonies of the strange, or marginal and unfamiliar images, in order to then validate them as worthy of closer attention and public appreciation. The focus was more directed towards an encounter with the strange that expanded the frameworks of hospitality towards the other, enabled a recognition of the uncanny, and provided a space in which ruined forms might emit a new and different perspective on the otherwise over-confident claims on progress. I was particularly interested in how an urban or rural landscape may evoke tender reflections on the vulnerability of the human condition. In my discussions with Alasdair Foster he introduced me to a recent body of work by Michael called *flyblown* (1998).

This installation involves five panels, each composed of pairs of images that conjure up the gaping extremes of the Australian landscape. A dead galah on a dusty and cracked track; boundless skies with murky waters; hybrid wheat fields rustling in the wind; blood red, gold and blue crosses dominating the foregrounds; and a Bible floating, as if in the position of a dead man, on a shallow riverbed – these haunting images arrest all sense of time. The landscape hovers somewhere between life and death. The story of colonisation is being told from a different perspective in these panels. They have the elegiac qualities that inspire a sense of reflection and humility that is common in much religious iconography. This calm note of destruction is the opposite of the alarmed shrill of protest, but the resonance is more reaching. I found these gentle and sombre images to have a haunted quality. They did not thrust themselves into our consciousness by making any aggressive or confrontational claim. Like his video *Empire* (1997), these images manage to touch, ever so lightly, the landscape that seems both parched and scarred. The harshness of this environment is multiple. At one level it must contend with the extremes of nature: the ease with which fire spreads through the bush, or the tendency for drought to be followed by flood. Overlaying the signs of natural tension in the landscape are the scars that have followed the paths of western colonisation. Michael picks up these traces of colonisation by identifying both the agricultural seed and the word of the Bible as two of the dominant means that have led to the desacralisation of the landscape and culture of Aboriginal communities. Polluted rivers, over-farmed valleys, deforestation and rising salt beds are paired off with the ominous Christian crosses that dominate the foreground.

By focusing on the ecological damage that went hand-in-hand with the frontier myth of settlement and which was paralleled by the drive to civilise and convert the Indigenous peoples to Christianity, Michael was able to highlight the stunning contradictions of contemporary Aboriginal experience. After the acknowledged failure of conversion and the near genocide that is coyly referred to as 'cultural contact', there is now a perverse relationship maintained by mainstream Australian society – on a political and social level Aboriginal communities are being subjected to increasing marginalisation and exclusion, while culturally and aesthetically they are everybody's darling. Aboriginal art is the marketing success story of the 1990s. However, behind the celebrations and beneath the symbols of Dreamtime are the realities of an increasing gap between the health and welfare of Indigenous and mainstream Australian communities. At a time when Aboriginal art and culture is being promoted to celebrate the timelessness of this continent, Michael returns us to the land with all its physical and political needs.

Michael's images disturb the cosy assumptions that we have gained control over the environment. His subtle juxtapositions between the ruins of the land and fragments of both Christian and Indigenous cultures suggest the need for a new way of thinking about reconciliation. Michael is not making easy condemnations against the complicity between the church and colonialism. Rather than rejecting Christianity, he makes us think about the gap between Christian values and the legacy it produced, or rather, in the social and political whirlwind in which it was embroiled. I got the feeling that Michael was not trying to reject the principles of the Christian faith but rather asking us to consider the consequences of its imposition in the Australian context. The complexity of Michael's approach is made more evident when you consider the relationship between the music and the images in his video *Empire*. The images of the landscape range between intense close-ups and wide, open horizon shots that seem to be taken from the sky. We go from an insect's perspective to the bird's-eye view. This gives the video a sublime and an omniscient gaze. The music is also a contemporary variation of elegiac church music. Together they lift

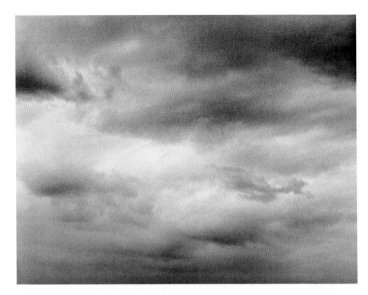

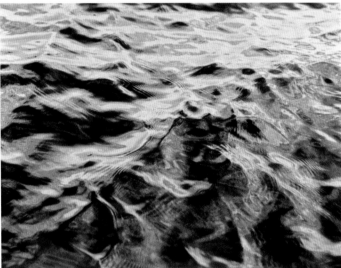

us into the realm of the gods but also drop us into the despair of mortal tragedy. This combination is telling. Michael is taking us inside the world of a believer. At no stage do you feel that he is casting judgment upon other people, or that he is somehow claiming to occupy a transcendental viewpoint from which he can look down on others, or look back at the past. The perspective that Michael offers is of someone who began with genuine and good intentions. It would be simple to find an example of a malicious, rapacious and brutal coloniser. However, Michael's approach is not drawn towards moral condemnations of individuals but is a testimony to the flaws and contradictions in a system that sought to deliver progress, enlightenment and solidarity.

The images in the series *flyblown* had a deep effect in me. They made me think of the ways in which the problems of colonialism persist in our contemporary landscapes. The evidence of failure is not just in the burial sites of massacres, or even in the ongoing ecological damage, but rather that we still have no answers to the question of how can we all live together in this place. We may think that we are not as evil as the colonial masters, but we are not as innocent as we may often like to think. Our presence in this place has consequences. Even when walking in the landscape I often feel how strange it is to be in land in which my knowledge of its history is still so thin. I struggle to find my own bearings, partly because I have yet to map out a genealogy that can link me deeper into this history. When my Auntie died she wanted to be buried in Greece next to her mother. When her husband died he chose to be buried in Australia so that he could be near his sons. The images in *flyblown* remind me of the uncanny effect of the Australian sun and heat. I have grown up with classical myths about the piercing effects of nature. Whether it involves people who risked flying too high or talking too much, these myths are ways of striking a balance with nature. The myths help familiarise and domesticate the landscape. Such stories are always out of place in Australia. They don't quite make the same kind of sense. And so when I stare into the horizon there is an uncanny stillness that is burnt into my consciousness. The flameless summer light can become an all-consuming yellow. At night the only witness is the distant but ever-present cicada whose restless chorus offers little redemption. It feels as if our desire for reconciliation will not find a footing until we discover new myths for our own place under this sun. I selected one of Michael's images of a shining cross that is set against an open sky saturated in red for the front cover of the special issue 'Strange'.

Walter Benjamin, one of the most melancholic figures in philosophy, once said that there is no better starting point for serious thinking

Untitled [grey sky]; Untitled [water] from the series *flyblown* 1998 chromogenic pigment prints National Gallery of Australia, Canberra

than laughter. At the time that the issue of *Photofile* that I edited was in press, I also attended the 1999 exhibition *Living here now: Art and politics – Australian perspecta* at the Art Gallery of New South Wales. As I approached an installation I noticed some very unusual behaviour. People seemed to be gathering around a video monitor with a kind of nervous excitement and homely relief that you do not often encounter in an art gallery. From a distance I gazed at this phenomenon. Viewers were actually stopping to let the video have its time. They were slowly opening themselves up to the experience of viewing, rather than simply glancing at something as they passed by on their way to the coffee shop or some other destination. I also began to notice that they were at first giggling to themselves. The gallery was starting to feel like it was being occupied by schoolboys and schoolgirls who were uncertain as to whether they could laugh out aloud or whether they should tuck their grins under their jumpers. Eventually the atmosphere broke and there was open laughter. The space of the gallery had finally, albeit rather briefly, become what it should be: a social space. As I entered the space I also joined in and found to my great pleasure that it was a video by Michael and Destiny Deacon called *I don't wanna be a bludger* (1999).

Watching this video again is a more complicated experience. Destiny's bitter-sweet jokes and her incredulous undermining of bureaucratic authorities are still as funny and as breathtakingly audacious as they were the first time I saw the video. The stereotypes that she manages to unpick have not disappeared and the pathos of the aspirations that she expresses have not lost any of their vitality. It is this tragicomic balancing act that brings these two great artists together. Throughout the video one is uncertain about one's own response – tears and laughter seem equally appropriate to each scene. However, what remains almost unbearable is Michael's cameo performance. In a scene where Destiny puts on a party for the kids in her family, Michael appears as a disabled uncle. He enters in a wheelchair wearing a short-sleeved shirt and dicky bowtie, broken glasses with lenses as thick as a Coke bottle and a triangular party hat. This is an archetypical image of the clown. Michael also plays a helpless mute that is unable to feed himself and who also falls from his wheelchair as Destiny is trying to drag him up the stairs. After Michael's unfair death it is impossible to see this scene as anything other than life's cruelest joke.

Now that Michael has gone, how to remember him? Looking back at the photographs and videos that he produced in such a short career it is almost impossible to separate the tragic qualities in his work from the tragic circumstances of his death. It is as if one element foretells the next. However, it is also crucial to celebrate the other passions that

radiate from his work. Michael's portrait photography challenged the conventions of representing the history of Aboriginal communities. In his collaborative portraits he captured an active self-presence that was distinctly absent in the traditional ethnographic displays and documents that set out to capture 'types' and effectively objectified the very subject of their investigations. This tendency to objectify and exoticise is consistent with the colonising mission. While the formal structures for colonising Australia have been dismantled, we have, to paraphrase Ngugi Wa Thiongo, not yet found ways to decolonise our imagination.[3] Michael's work not only reveals the scars and ruins that mark our landscape, but he also positions us as the inheritors of this land and its history. We cannot stand outside or above this strange land.

The way I wish to remember Michael is as the most affirmative embodiment of the qualities of meekness. I take my image of meekness in part from my brief meeting with him in London and in part from the Italian philosopher Norberto Bobbio. The meek, according to Bobbio, always find hope in the fragments of the past and in the fleeting hints of recognition with the other. Bobbio claims that meekness must not be confused with the sadness of humility, or compared to other passive states such as modesty, submission or resignation. On the contrary, he asserts that meekness revels in its capacity to survive and remain calm in the face of adversity, and is untouched by the tendrils of vengeance and fury. Meekness, he insists, is a unilateral social virtue: it does not expect reciprocity. A meek person does not brighten their kindness, curiosity and concern in proportion to the other's power. Bobbio praises the meek not for their display of a superior form of goodwill, but for the way that they behave as if their generosity simply exists, like a constant pulse. It continues even when every gesture goes unnoticed. For, as Bobbio states: 'The meek are cheerful because they are inwardly convinced that the world to which they aspire is better than the one they are forced to inhabit.'[4] When an artist like Michael Riley comes into this world, you only have to meet him once to have him with you for the rest of your life.

Notes

1 Berger, John and Mohr, Jean, *Another way of telling*, London: Writers and Readers, 1982, pp. 36–37.
2 Papastergiadis, Nikos (ed.), *Strange: Photofile*, no. 57, October 1999.
3 See Wa Thiongo, Ngugi, *Decolonising the mind: The politics of language in African literature*, New Hampshire: Heinemann, 1986.
4 Bobbio, Norberto, *In praise of meekness*, translated by Teresa Chataway, Cambridge: Polity Press, 2000, p. 31.

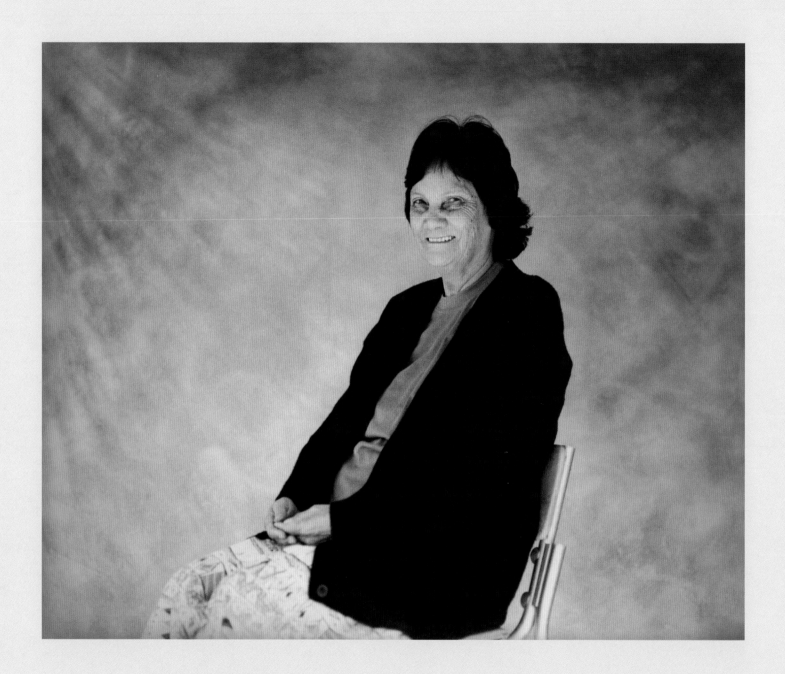

Ruby McGuinness from the series *Yarns from the Talbragar Reserve* 1998 gelatin silver photograph Gift of the Artist – Guardianship Dubbo Regional Art Gallery

Auntie Ruby McGuinness[1]

Auntie Ruby McGuinness: Well, I was just thinking, you know, his father, Rocko, would have been very proud of Mike. But he always was, you know, with Michael. He used to go down there to Michael when he was – you know, when he first started out. And he was living down there … And he had that little boy, Ben …

Oh, listen, I'd better tell you about my grandmother, my mum's mum … And she was a very little lady, she was. Always smiling and never complaining about nothing. I used to go over there and play around and she used to come home. Always had black stockings on, black shoes, doesn't matter how hot it was. Black skirt and white blouse. Always dressed up like that. You know, in real hot weather …

Brenda L. Croft: What was her name?

Auntie Ruby: Janey. But she – she was a very quiet little – you know, on her own and that … But mum's – mum's grandmother and grandfather – that's where this tale has come from – mum and them was only bits of kids and the police come out there to take them because they couldn't work and they were getting a ration. And mum was telling us about the rations for tea, sugar, flour and tobacco. That's all they got … They said the government couldn't keep two old people. They worked all their lives, you know, both of them on the station. They used to go every morning across the river, mum said. And anyway they just come and picked them up and took them. They said they had to go to Sydney. And they had a big old thing, you know, the car. Then the poor old things, they were real old. They must have been sitting up there stiff. Anyways, they got word back a week after, mum said – their

mother, you know – got word back to say that the old lady, the old woman died. Then he died two days after. It's funny, isn't it? They could have thrown him over the mountains going along. No-one knows things …

But they did things like that, probably, you know. Because my mum – my mum and her cousin, Esther Smith, they were going to Brocklehurst School [at a small village, eight kilometres from Dubbo]. Mum said they were only around about eight or nine. They wouldn't have been that, she said, and they just come out there and said, 'Your mother, your mother's said we can take youse out.' They took them out to the station. They worked like that for 12 months. They'd bring them home for the day …

That's it. But Michael – you know, Dot must, she could be really proud of him. Everybody in Dubbo knew him and was proud of what he did anyways, you know. It was marvellous what he did and that. Made himself – got in. When he first started out, it was real hard too, you know.

Note

[1] This is an edited extract of a conversation between Brenda L. Croft and Auntie Ruby McGuinness, recorded in Dubbo, New South Wales, on 11 February 2006.

Screen grabs from *Quest for country* 1993
SBS Television

Ron Riley, Deborah Ryan, Auntie Dot Riley and Diane McNaboe[1]

Ron Riley: It was sort of like just over there where their old, where their grandfather used to live in. We used to come at Christmas and so when we were all teenagers, we'd just sit around and you'd have all this great big pot of chicken broth and plenty of barley. He knew that we'd been out in town all night and he'd come out with all this big pot of barley. The thing about it was that the homestead was the old poachers' cottage, but the kitchen was a corrugated-iron shed, probably from here to the take-away, see, 20 feet away. That's where they used to do most of their cooking. It was over an open fire, and they just had a big bench running sort of just about the length of the shed. So we'd all just sit up there and we'd have our breakfast and so on … Granny Riley was a big woman.

Bernadette Riley: And she was your grandma?

Ron: Yes. And she'd be, after the kids had been washed up – there was just a great big galvanised tub, and they'd have all the water, they used to have a pulley down to the river and pull the water up for it and then tip it in and they'd have a couple of drums of hot water hanging on hooks over the fire, and then they'd put that into the tubs like a bath.

Bernadette: And put all the kids in?

Ron: Yeah. It would be half full of water, not quite enough to wash all the kids. After the kids had been washed and then Gran would get into it and water would just splash out over the –

Bernadette: Because she was so big! … So how many families would have been out here at that time?

Ron: They were all scattered. There were families who had been over the back here

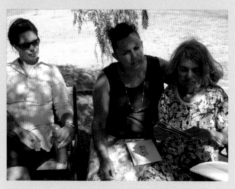

(top to bottom) Deborah Ryan and Ron Riley; Diane McNaboe, Dot Riley, Ace Bourke; Diane and Auntie Dot; Bernadette Yhi Riley, Diane, Auntie Dot, Talbragar 2006 digital images Brenda L. Croft

and my grandfather had a pigpen out the back here. You used to get wild pigs, little suckers. We'd just fatten them up and we'd have pork and that for Christmas. There were chooks and that around the house and that, and a few ducks … There was Malcolm Burns [Will Burns' older brother], who is a bit older, you know, like five years older than I am. He used to have sort of flippers and goggles and a spear gun and go down looking under the logs for the cod, you know, like. And he reckons the cod down there, their eyes were that far apart and you thought, 'You know, I'm getting out of here!' *(laughs)* …

And the old bloke [Tracker Riley] used to, when we become teenagers, he used to pull out his photo albums and just sit there. Everybody would be silent and he'd be sitting there talking about, you know, 'This is when blah, blah, blah, blah.' He'd sit there … Out would come the photo albums and we'd sit there for a good two hours or something. There was probably like – like, being the baby boomers, there'd be probably 25, 30 of us sitting around. Grandpa had everyone's complete attention. And he'd point out all these things to you …

Deborah Ryan: And that's why Tracker's so significant too – having him work here as an Indigenous person and be revered as an Indigenous person. And the people had values. Like you could no more – like, there was people drinking but you weren't allowed to come out here and drink.

Ron: Oh, no.

Deborah: So the drinkers went up the track around the bend there. If you drank, you lived up around the bend …

Bernadette: So how old would Michael have been when he was out here? When did his family leave?

Ron: When they were kids and that they were always out here …

Deborah: When we were younger – not that I had as much time as some other people – but his [Michael's] focus was always different. What I'm trying to say is: if we thought this way, he'd look at it from a different way. That was always prevalent …

Auntie Dot Riley: He used to come home from the school and straight in the river. It used to be beautiful, that river. Nice and clean. You can't swim in it now …

Bernadette: He was different to the other kids too, wasn't he? He was interested in something that a lot of Koori kids in Dubbo and Moree weren't really into, like photography and art. He would have been quite different to a lot of other kids, too. Did they pick on him?

Diane McNaboe: No, he was well liked because he was real quiet, see? So he didn't go tormenting anybody or anything like that.

Auntie Dot: I don't think he had an enemy in his life.

Diane: He just sat back and watched everybody else and had a good laugh at everybody. Even as a young fella, he'd sit back observing everything … Even when he was little, he'd sit there observing everybody and listening to what was going on between different parties, and he'd be taking it all in.

Auntie Dot: Yeah, we'd be talking, Carol and I and another friend, in the room, and he had the thing [tape recorder] under the bed. He was taping us. I felt like killing him.

Bernadette: Why did he do that, Auntie Dot?

Auntie Dot: He was a terrible sticky beak.

Diane: Listening. He liked yarns. Mm.

Bernadette: Oh, he liked yarns.

Diane: He wasn't allowed in the room to listen to what they had to say, so he taped it on the sly so he could find out what was going on.

Auntie Dot: Under the bed.

Diane: Then he'd pull it out and have a laugh at everybody. Play it back to them and have a laugh …

He was natural in it, because if you are a photographer, the best thing you can do is be able to observe how things are put together and then try to place things in your perspective as you look through the camera …

Bernadette: Look at these eagles up here. We're talking about Michael Riley and look, there's four wedge-tailed eagles. That's really significant. We don't see them all the time. That's really special …

Deborah: He never lost his identity. He didn't want to be better than anybody else. He wanted to stay how he was. Proud of his colour.

Auntie Dot: Proud of his race …

Diane: We hope that from Michael's achievement, other young fellas will think, 'Maybe I can do what Michael did,' or 'I can do what Uncle did,' and find a sense of achievement for themselves. There are still people that say, 'You're not going to get anywhere, you're not going to do anything, you're not going to achieve nothing.' Hopefully, they can see from Michael's achievements that 'Hey, maybe I can get out and do what I want to do.'

Note

1 This is an edited extract of a conversation between Ron Riley, Deborah Ryan, Auntie Dot Riley, Diane McNaboe (née Riley), Bernadette Riley and Anthony 'Ace' Bourke recorded at Talbragar Aboriginal Reserve, Dubbo, New South Wales, on 10 February 2006.

Ronald Riley from the series *Yarns from the Talbragar Reserve* 1998 gelatin silver photograph Gift of the Artist – Guardianship Dubbo Regional Art Gallery

Will Burns and his mother, Dorothy (Dot) Burns[1]

Will Burns: The biggest thing that I remember or that has always stuck with me, was just being here and how it felt to be here … You could go anywhere, you know … We'd walk from North Dubbo over to West Dubbo, for instance, and we'd go to … oh, well, Uncle Bernie Ryan was a prime example. You'd go to the Ryan place and they had – what'd they have? – 14 kids anyway of their own, and there'd be five of us and a couple of other cousins. We'd all roll in, and it was no problem. Everyone would sit up at the table and get a feed and a cup of tea and then you'd go again. That's what I remember, we used to just knock around like that and all play together and all look after each other together. As you were going, one of the old aunts or uncles or someone, mothers, would yell out, 'You old ones look after them little ones'. So we always stuck together, yes.

Brenda L. Croft: And when Michael came back and people realised what he was doing, obviously there was a huge amount of pride.

Will: Oh, absolutely, especially – well, when he first came through and he was doing that film *Quest for country*, you know. People were just proud of him, you know … I suppose that was one of the things, he was inspirational in a way … and when he came back, as I started to say before, and he was filming, people started to realise what sort of credentials he had, you know, and what sort of work he was trying to do. But I found that he was inspirational, he was like a role

Dotty Burns; Will Burns from the series *Yarns from the Talbragar Reserve* 1998 gelatin silver photographs Gift of the Artist – Guardianship Dubbo Regional Art Gallery

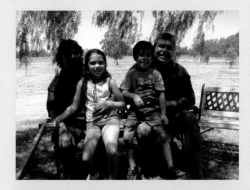

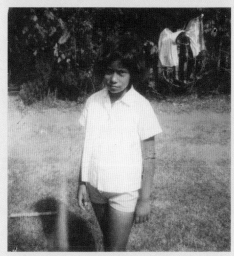

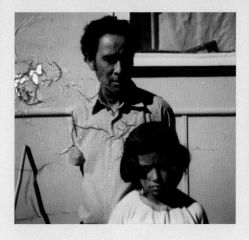

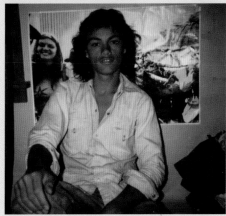

(clockwise from top left) Will Burns and family,
Talbragar 2006 digital image Brenda L. Croft;
Michael's class photo 1972, top row, third from left
1972 black-and-white photograph Wendy Hockley;
Michael at home in Dubbo c.1975 Wendy Hockley;
Allen (Rocko) Riley and his daughter Carol, early 1970s
colour polaroid Wendy Hockley; One of Michael's first
photographs on his Box Brownie, younger sister Carol,
Dubbo early 1970s black-and-white photograph
Wendy Hockley

model for people … 'Don't believe them whitefellas when they say you're nothing but a lazy, dirty black bastard. If you want to do it, do it'. It wasn't long after that that I started my building company and that was something else …

Brenda: How did he set up for taking the photographs for *Yarns from the Talbragar Reserve*? Where were they taken?

Dorothy Burns: I think he went around to each person, because he came to my house on his own and he took photos out the back. He put a backdrop down … And I had dogs and he put the dogs there. He had me standing up – he had me sitting down first and the dogs in front of me and then he stood me up … and then he stayed … I think he had a cup of tea before he left.

Will: That's what he did, he went to all the old people wherever they were, instead of putting them out, and he brought me out here. That photo of me is taken in front of this amenities block just after we first got it built through the Land Council, and we were so proud because all the years we grew up living here, there was no power, no plumbing, nothing, you know …

I think he especially wanted to come out here with me, because we were close as kids, you know. I can't even remember why but it just seemed like we were always together. It might have been our age, I don't know. It might have been just that we got on better than some of the other kids, because I had three brothers and three sisters and Michael had a brother and a couple of sisters and we all sort of hung around together. We were like one family anyway, just like one family …

And the way he was, the way he loved, the way he respected … it was like more than, say, a counsellor, more than a confidant, more than a mentor, the way he drew people out and got them to talk. And his own people and his old people and the way he treated them with the utmost respect and acknowledged that and treated them as honourable people no matter what their station in life or what life had dealt them, you know. And by that attitude of his, it just drew people to him, and he did that with me while we were out here together reminiscing about our involvement. I found myself remembering things with him and stories that I wouldn't have thought of at any other time …

That's what I remember about the time that he took that photo here, because I didn't want to … he had to convince me to sit for him … I knew who he was taking photos of. These were all old people, elders of our community, people who I held in high regard, and I didn't see that I had the right to be in the same exhibition as them. But he convinced me that I'd been running the Land Council here for a while, trying to get things happening and stuff …

Well, Michael had that ability to inspire people and bring that out in them and I think people very quickly recognised that about him when they met him. I'm saying that, not ever having socialised with him as an adult. Like we never had a beer in a pub, you know what I mean? We never went to a Rock Against Racism concert or anything together. We never did any of those things together, but I just know that of him because of how he was …

Like I said, it's hard to remember specific stuff but when I remember anyone, and anyone I do remember in my life, I may not remember specific things, conversations or things we might have done together. I just remember how I felt when I was with them and I think with Michael I felt very calm. I still feel his vibe and I still miss him, even though we probably never spent a lot of time together once we left this place, but you miss special people like that, you know.

Note

1 This is an edited extract of a conversation between Brenda L. Croft, Will Burns and his mother, Dorothy Burns, recorded at Talbragar Aboriginal Reserve, Dubbo, New South Wales, on 11 February 2006.

Wendy Hockley[1]

Wendy Hockley: I remember living with him at Haberfield. With his clothes, you'd walk into his room and his clothes were like a mountain. He'd go and get, you know, something from the top of the mountain to pull on and then he'd go out the door. He had this wardrobe completely empty and he just had his clothes like that. We were amazed how he had his clothes in a mountain. We said, 'Why don't you use the wardrobe?' 'Oh, no, it's fine'. Never very tidy in his room. But he'd come, we'd be all sitting there talking and he was the type of person that he'd come in and he'd say, 'I'm going'. He'd put his clothes in a duffle bag. 'Where you going, Michael?' 'Oh, chill', you know, and off he'd go and we'd be yelling out, 'Grab us a T-shirt as you go', you know. Like it was just amazing how carefree he was. If that was me, I'd be going, 'I'm going to New York', you know. But he was sort of – he'd come in, put everything in a duffle bag, off he'd go. Like when he went to England he did exactly the same thing … those days like to go overseas was a big thing. It's not so much these days but them days when he used to go over and he was always travelling. You know, I'm really just amazed at how much he travelled around. He'd just hop in a train, you know, when he went to England and go from one place to the other, you know …

Matthew Poll: Now, look, when he was young, did he like reading magazines and things?

Wendy: Loved reading, read a lot. I mean, yes, he did read a lot … Yes, anything. Yes, even the *Women's Weekly* because we were amazed how he used to like reading the *Women's Weekly* because not many men do like reading it. But, no, he did …

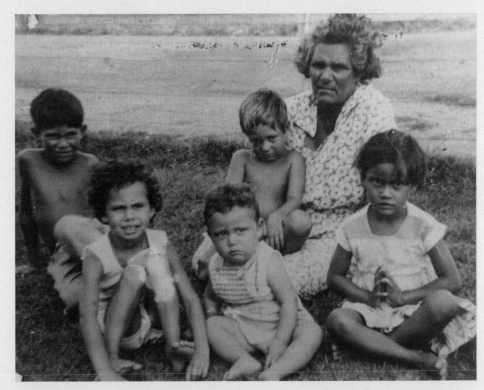

Nanny Wright with grandchildren, left to right: David Riley, Lynette Riley, Michael, Mark Wright (on Nanny's lap), Wendy Riley mid-1960s black-and-white photograph Wendy Hockley

Yes, it's true, and he loved reading *Women's Weekly* and all this, probably because of the gossip that was in it, I suppose …

Matthew: When you were with him, in fact, while he loved the gossip, he wasn't very chatty …

Wendy: No, he just loved hearing about scandal. You should've seen him the time that the lady across the road had an affair with the bloke across the road and Michael was out in the street. I reckon if he had a camera and a piece of paper he'd be like a reporter and he'd go around and interview everyone. That's what he was like then. 'Got some scandal', you know. Just write it all down, you know … Yes, because he was very … like I never knew half the stuff because he's very secretive. He never bragged, never bragged.

Note
[1] This is an edited extract of a conversation between Wendy Hockley (née Riley) and Matthew Poll, recorded at Boomalli Aboriginal Artists Co-operative, Leichhardt, Sydney, on 20 December 2005.

Michael will always be to me the little, chubby, shy cousin, who made it big.

When we were growing up, Michael was the quiet kid who said very little. But when something pricked his sense of humour, we always knew that laugh anywhere.

Michael was one of those kids who went through school without his talent being recognised. He was not really considered unusual – many Aboriginal kids, during the 1960s and 1970s found themselves placed in OA classes (that is, classes for mildly, intellectually handicapped children – we referred to them as 'Only Aboriginal' classes) because cultural and language differences were not recognised. In fact, Aboriginal kids were often judged against 'white middle-class Australia' and found to be deficient in intelligence, language and ability. So it is not very surprising that Michael's talents were not recognised, picked up or nurtured until he left school and his home community.

Michael really spent a long time searching for who he was: that is a 'black' person who was considered by many Australians as not being really Aboriginal. It was that non-existence and non-recognition which Michael sought to destroy.

Michael drew on the strengths of his extended family and his culture. When Michael found his talent, photography and then film-making, it was astounding to watch the transformation.

Gone was the introverted person who could sit with you for three hours and not say a word. He became a person who expressed not only who he was, but also the depths of his people's history, life experiences, and how they viewed themselves in today's society.

The pride felt by Michael's extended family, friends and the public who saw his works was something he never quite understood. I think it even embarrassed him. He was most happy listening to the family gossip, who was doing what and why. And if we could poke fun at anyone that was the greatest treasure – we all aimed to see if we could get Michael laughing. Even better was laughing at Michael. One story I remember was Michael trying to order a cab on an automatic phone-line that would not recognise his accent. The anger, the frustration (and the swearing) by Michael … yes, good memories.

Then there is his talent. What did he give us? For the first time we saw our family, our people, not being portrayed as savages, as the missing links, but as people with real pride and history.

When the photos of our Nan (Maude Wright) and aunts and uncles and cousins from Moree and then Dubbo, Talbragar Reserve, were produced, we gasped. Michael gave us our public pride back.

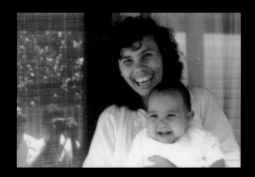

Lynette Riley-Mundine with child early 1980s
print from negative Michael Riley Foundation;
Nanny Wright, Lynette Riley-Mundine and family,
Moree mid-1980s print from negative Michael Riley
Foundation

Then he transformed our history into films. There was the story of our Uncle Alec, when he was a 'tracker' with the police force and Michael's portrayal of where racism and hatred could lead people. But what was also fantastic was that Michael made all the family feel involved and feel that we also owned those portrayals. We were all asked to contribute and family members and friends were asked to play roles in the film. Again the pride in seeing a story about our family and seeing our family members in the film is really something almost indescribable.

Michael, through his works, gave us our public identity back. No longer invisible, no longer the hidden people. We existed, but not only did we exist – we were proud. One of the greatest images I have showing this is a photo taken of one of our cousins, Polly Wright. Michael was able to pull out her hidden identity and place it before all of us.

This was a rare talent, a gift that could so easily have been missed. It speaks of Michael's innate strengths that he didn't let the trials of being an Aboriginal person in Australia weigh him down so much that he could easily have sunk under the mire, and become the negative stereotype so often used to portray Aboriginal people in Australia.

No. Michael pursued his gift and left us all a legacy that says: 'I was here, I saw and I want you to see what I see.'

He has had those images taken beyond Australia to the world of all people. They are images all people seem to be able to relate to. That is one of the greatest gifts any person can give to us all – the ability to communicate to our minds, hearts and souls.

As his extended family and as Aboriginal people, we thank Michael for sharing his gift. We are proud he was one of us.

Talbragar exhibition opening at Art Gallery of New South Wales, 1999. Top: Hetti Perkins, Rachel Perkins. Bottom: Michael, Bernadette Yhi Riley 1999 digital image Bernadette Yhi Riley; Bernadette Yhi Riley with scar tree on road to Talbragar Reserve 2006 digital image Brenda L. Croft

■ Bernadette Yhi Riley

Michael and I both had the same dream – to tell the story of our grandfather (my great-grandfather), 'Tracker' Alexander Riley. We wanted to tell his story because he was such a great man, an inspiration, and of course we were proud of him. But neither of us knew what the other was doing until 1995, when we both returned to Dubbo. We just both ended up back home in Dubbo to tell his story.

Of course, it's not until now that I have even realised this. I'm not sure if Michael did because we never discussed it. We just discussed our grandfather and that we wanted his story told because he wasn't a political figure and yet his presence had more impact than any other Aboriginal leader in Dubbo at that time, and even until this day.

Michael and I would often yarn about the social paradigms of the early 1900s and their impacts on our mob in a country town – what was happening at that time with the Depression, the two World Wars and our mob going off to fight, and all the issues of living on the Talbragar Reserve under the control of the New South Wales Aborigines Protection Board, which became the Aborigines Welfare Board in the 1940s, and so on.

However we both held Tracker in such reverence and knew of his presence within the community – both the Aboriginal and broader community. He was highly respected and accepted by everyone. We understood his position within the community was quite powerful – in that era. We wanted to capture that in the documentary, *Blacktracker* (1996). I think we did. Michael often said, 'It's hard to capture an entire man's life and limit it to a half-hour documentary'. But I know he was happy with the documentary because it did capture Tracker's skills, his presence and integrity, the era and, of course, the racial intolerance of that time and they were the main themes Michael wanted to get across.

(We would often have a giggle about the non-Aboriginal people who worked with Tracker. One old fella said, 'Tracker would light up cow dung, when the sun went down – you know to keep the spirits away.' We laughed and laughed at that statement because Grandfather lit that cow dung to keep the mozzies away!)

Our next project began in 1997, the photographic exhibition *Yarns from the Talbragar Reserve*. Michael wanted to ensure that all the families that lived on the reserve, not just us traditional owners, were not displaced because of the Native title claims that had been lodged. Some of our mob were feeling displaced and we, as Aboriginal people, don't displace anyone – that's what whitefellas do. So we yarned about this and the impacts of Native title and that is why and how *Yarns* came about.

You see, Michael was a man of integrity himself. He was also very caring and, even from Sydney, he was concerned about his mob out here in the Central West. Michael was able to travel back and forth between Dubbo, Moree and Sydney and it was like he never left. He would just turn up at home here, come in, go to the fridge, have a feed, have a nap and then go off in the car to see his mob, before driving back to Sydney.

Bernadette, Ruby McGuinness, Shirley Matthews, Michael, *Talbragar* exhibition opening, Dubbo 1999
colour photo Bernadette Yhi Riley

I think that because Michael did live in Sydney throughout his adult life, he was able to see the black-and-whiteness of rural communities. For me, coming back to Dubbo and being immersed here for the last decade, I can no longer see this as clearly as I used to. There are more shades of grey now. Before, I could yarn with Michael about things and he would validate my perceptions – he had a very analytical mind.

I have often thought about Michael and what he had that gave him his uncanny ability to blend in. He was never aggressive or rushed. He always had this inner stillness about him. He was a very calming person, Michael. He was sophisticated and had good taste – Michael liked fine things (look at all his deadly 'sista' girlfriends!).

I'm so proud that he was my cousin, my countryman and my friend.

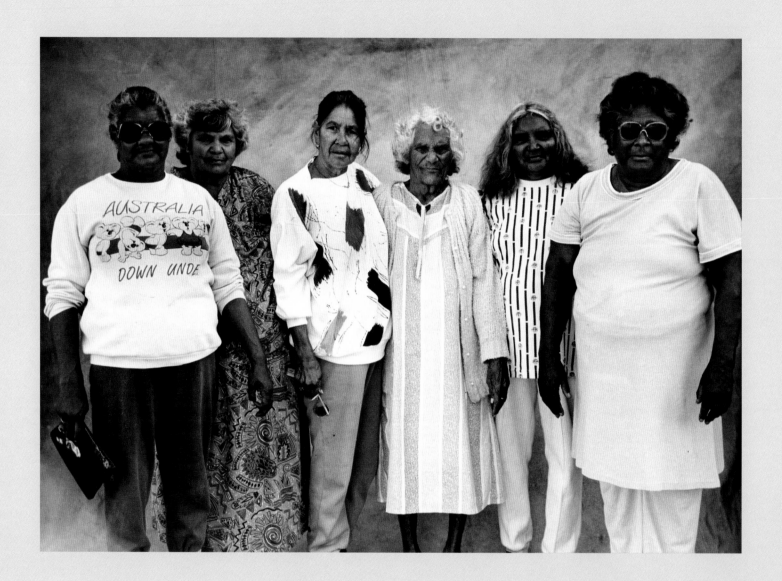

Moree women from the series *A common place: Portraits of Moree Murries* 1991 gelatin silver photograph Moree Plains Gallery

Edna Craigie, Reena Fernando and Cathy Craigie[1]

Edna Craigie: Oh, Nanny Wright was a great – she was a great worker in the community. Nanny Wright, like if anybody needed something or there was something needed, she was always there to help. She was that sort of woman. She used to sell iceblocks and things. If somebody needed something, she always had those iceblocks or little cakes and things she'd sell around the mission … She was always there and she was also one of the founders of the funeral fund with mum … Well, Nanny Wright, they were always there to help people … Pop Wright was really the first one to have a car there on the mission and he used to do messages and things, you know. Well, like if somebody wanted a loaf of bread or something, he'd do that … He used to take us to the pictures, see, Monday nights or Tuesday nights, and he used to charge us five cents a taxi ride, or sixpence, see, to go up and back in that car.

Cathy Craigie: They used to have an Aboriginal ball and we always celebrated Aboriginal Week here in July and this is before it became a public thing. It was always celebrated, hey. Blacks and whites would march down that street. I remember coming out of second class or something. We had to march down the street with our schools on National Aborigines Week. They'd have speech day in the education centre …

Reena Fernando: They didn't have it the last two years, hey, the march?

Edna: They've changed, they've changed for the worse. At the real old mission, like before them houses were built there, they used to have sports days of a Sunday. The people from the Top and the Row, whatever ones came down, they'd

come down and compete. We'd have foot running and we'd have all those athletic things, you know. They used to have the horse races. Different men used to own the horses and they'd race from, say, where Nanny Wright used to live, from there … But the other thing you talked about earlier about Nanny Wright and Pop – they went away to Dubbo and then they came back. He went over there. I don't know if he went over tracking.

Cathy: Yes, he was tracking.

Edna: He went to Dubbo. When he came back, the manager gave him a house. You know where Clarkes used to live? That big old house, near the school it was. Him and his family shared the front part of it. Let me think. The loungeroom when they walked in, kitchen, one bedroom out the back, that was the girls' bedroom, and they had two in the front and the big veranda. Then you walk out through, like if you went straight up it, there was another entrance around the side and there was two bedrooms, a bathroom and a laundry together and a big kitchen. That was for … women that came in to have babies or anyone was sick. It was like a transit hospital … This is where they stayed unless they had relatives. If they didn't have relatives, they stayed at the back of Nanny Wright's place … Yes, that's how we met a lot of the Boggabilla people, otherwise we wouldn't have known them. That was one thing that they were in but they were always there to help, you know.

Cathy: He was a kind old man, wasn't he?

Edna: He was a gentle, he was a beautiful person … Nanny Wright worked as the domestic there [at the hospital] … She worked there for many years. What else can I tell you about it? It was good. Like, you know, we had all those dances what we talked about. Every Friday night there'd

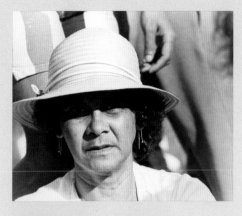

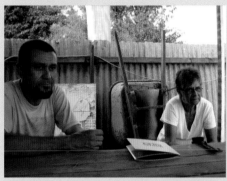

Edna Craigie, NSW Aboriginal Football Knockout, Sydney early 1980s black-and-white photograph Cathy Craigie; Ian 'Yurry' Craigie and Edna Craigie, Moree 2006 digital image Brenda L. Croft

be a dance, right. It was just a dance in general. Then next minute usually there's a fancy dress ball on. So everybody would come dressed up. It was beautiful, you know. The kids, and then you'd put something on for the kids, a fancy dress ball or something.

Note

1 This is an edited extract of a conversation between Brenda L. Croft, Cathy Craigie, Edna Craigie and Reena Fernando, recorded in Moree, New South Wales, on 18 March 2006.

P.J. Swan, Lyall Munro Jnr and Cathy Craigie[1]

Cathy Craigie: So with Michael, P.J. and Lyall, was there any interaction there? What did you have?

Lyall Munro Jnr: Well, I remember Michael coming to me many years ago and saying, 'Cus, I want to be a photographer', and he said, 'I want to take photographs in a way that depicts what the image is', you know, like he wanted to –

Cathy: Like what was really happening in our lives.

Lyall: He wanted to, you know, in reality, he wanted the photos to represent so much, like Nanny Wright's photo, you know.

Cathy: Like the real life, instead of the protests and all the things like that, the real life.

Lyall: But if you look at Nanny Wright, you can see her whole history in that photo. If you look at mum and dad, the way they're standing … I've got them, Michael gave me the first copies … and I've still got them, and his effort to bring about this dream, hey, was pretty full-on … Look, it was his art. It was his way of expressing his understanding of art, you know, and then he got sick – that fucked us all up …

P.J. Swan: Yes, he was a serious fella. When he did do the exhibition over here, he was fully focused and knew what he wanted to do. I guess his completed works reflect that now …

Lyall: He was one of the first young Murri Kooris that come from Dubbo, particularly from Dubbo. Like Dubbo was basically fucking in the whole struggle and didn't sort of do much, and then little cus here, you know, he came out of that atmosphere and like his politics was as strong as mine like, you know, land rights and justice …

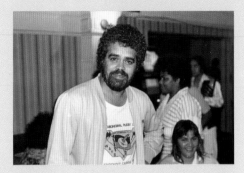

Lyall Munro Jnr early 1990s print from negative
Michael Riley Foundation

Cathy: His stuff was getting so strong. But I loved all his old social stuff of the footballers. He's got this great photo from a knockout in Sydney at Redfern oval and it's Kempsey – he must have been going around shooting all the teams. Dave Fernando – and they're getting ready to run on, and Dave Fernando's stretching and then there's this … I don't know who it is, this big fella next to him and he's got the leg up to stretch, cigarette out the mouth, and it's a classic photo. He used to capture a lot of stuff like that …

Lyall: He wanted to put our struggle, you know, before everyone else. He wanted to bring our struggle out in his photography … Yes, and it didn't take Michael long to progress from whoa to go, you know, a very short period of time. Like photographers, you know, they take years and years to perfect their art, but young Michael, he just went from whoa to go with three or four years. He was up there with the best of them in the world of photography, particularly his black-and-white stuff.

Note

1 This is an edited extract of a conversation between P.J. Swan, Lyall Munro Jnr and Cathy Craigie, recorded in Moree, New South Wales, on 18 March 2006.

Brent Beale and Cathy Craigie[1]

Brent Beale: We wanted to get an exhibition to come out of Moree to take to Sydney and we had the chance to do that at Boomalli [Aboriginal Artists Co-operative], where Michael was a member …

Cathy Craigie: What was happening in Moree at that time, like with all your mob starting to work on your art and that, because before that there was nothing, hey? I mean, Yurandiali [Printmakers Co-operative] came and then it started creating other things. What were you doing at that time, because Michael came up here and wanted to stay here and be here around all that because there was so much work being done?

Brent: It was hard because there wasn't many people, you know, you could sort of associate with.

Cathy: With art and that?

Brent: That were interested in the same things that you wanted to pursue. Michael was one of those guys that was always out on his own but in amongst it all, you know, at the same time …

Brenda L. Croft: Moree was being put on the map basically, the art map, because people were saying, 'There's a thriving art …'?

Brent: That's right. They called it the renaissance that was happening and a lot of other things … Yes, I think it was a time when everyone was coming out of the woodwork, you know. It was just so many people that were just really fresh to the art scene and they were just, like I say, coming out of the woodwork …
I think since 1988, since the Moree Plains Regional Gallery was set up in 1988 it opened the doors for a lot of talent to get through there and show their artwork through the gallery. I think it just drew the people in at that time …

Cathy: Yes. When that Yurandiali stuff and that was happening, because like that was what attracted Michael to come up here and then he set up that Moree mob series and he worked, he did workshops and stuff there, but he had a lot of mob come in. Like Aunty Ida Waters and, you know, portraits of people that were … it was like a picture of the Aboriginal community that hadn't been seen … Nanny Wright with the dog, you know, and there was Mum Maude with her [hand]bag …[2]

Brenda: You were saying before he was one of those people you could talk to about things you were interested in, where you couldn't always do that? What do you remember him talking about?

Brent: You name it, everything and anything. You know, he was that easy to get along with. Just working with Michael, to me it seemed to be so technically difficult, he'd just breeze through it and still have time to joke about things and still have time to ring his mum on the phone. You know, he still had time to just be Michael, you know.

Cathy: What about when youse went on the trips, when youse were driving around and that, what were youse talking about, you and him?

Brent: Talking about what it would've been like before, before Cook, you know. All the time he'd always mention things like that. 'I wonder what it was like in this part of the country' or, you know, going to Mount Kaputar, you know … Yes, he's a very patient man, you know, that way. You know, always back it in. He'd have something happening there …

Brenda: What will it mean with his exhibition coming up here to local people?

Brent: I think it'd be a recognition of Michael, you know, a recognition. I think it'll open a lot of people's eyes up to the fact that

he is a local fellow, you know, that's been all around the world with his artwork and still has time to come home and, you know, exhibit his work here …

You know, because the gallery was set up from 1988 onwards, because it was set up in 1988, a lot of people wouldn't come anywhere near the place and Michael, you know, sort of broke down the door for a lot of people to come in and feel comfortable, you know …

Cathy: So when was the last time you saw Michael?

Brent: I think the last time would've been, would've been about 1997 … He was working on a film, *Empire* … We went to a few places where we maybe shouldn't have been. But it worked out well that day because we had people, Michael's people were behind the binoculars making sure that, you know, everything went down okay. That was a good day, that one … Michael spotted these two tanks and he had to have that shot. He said, 'They've gotta be in this', these tanks. So we got through the gate and everyone set up. The sun was okay. Michael was happy with the sun for a short time but he prefers it at night, in the evenings, sundown. But he still put up with the shot anyway because it was the only chance he had to, you know. So, yes, we were there for about an hour or so but he was happy.

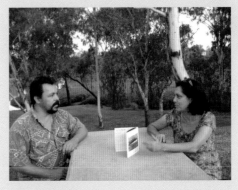

Brent Beale and Cathy Craigie, Moree 2006 digital image Brenda L. Croft

Notes

1 Cathy Craigie and Brent Beale in conversation with Brenda L. Croft, Moree, New South Wales, 18 March 2006.

2 Cathy Craigie's grandmothers were Nanny Wright (her paternal grandmother and Michael Riley's maternal grandmother) and Mum Maude (Cathy's maternal grandmother).

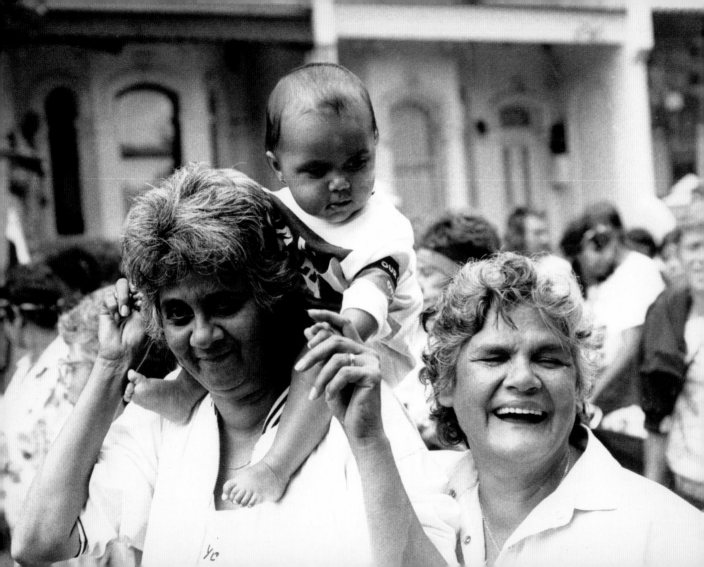

I first met Michael at the University of Sydney Art Workshops on City Road, Darlington, or the 'Tin Sheds' as it was best known, where I was teaching photography. I cannot remember why it was there or how we came to meet. It could well have been through Linda Burney, who introduced me to colleagues who eventually helped me set up the National Education Strategy for Aborigines (NESA) scheme at Sydney College of the Arts. And Michael became the first of my trainees to participate in that program.

Michael was a perfect student. He observed and listened and quietly went about doing what he wanted to do. My approach to teaching was to explain what I knew about photography and to encourage students to find their own eye and method. That seemed to suit Michael perfectly. And Michael did not let any opportunity pass to use the studio or to sit in on classes when it suited him. He was always welcome. I was not the only person who helped Michael: photographer Geoff McGeachin, who also taught at the Sydney College of the Arts, gave Michael a lot of his time and encouragement.

Michael could be hilariously funny at times and his sense of humour was very strange. I remember that we had been on summer vacation and when the students returned to college they were, of course, always bright-eyed and bushy-tailed. On this particular occasion one of the students said very innocently, 'Gee, you've got a great suntan, Michael. You must have been on the beach.' Michael thought that was a huge joke, and he milked that line for months.

Michael and I kept in touch after he finished his training and he became a part of Rapport Photo Agency which, along with Robert Walls, I helped set up. One Saturday afternoon there was a knock at my door and, on opening it, there was Michael standing sheepishly with some pastries in a bag. I invited him in for a cup of tea and proceeded to chat with him. Michael sat there staring into space and nodded and grinned occasionally and drank his tea. He seemed to be thinking about something and my chitchat could not penetrate this focus that he had. And then he said 'Thank you' quietly and was gone.

One of the last times I saw Michael, he was in hospital. I had been told that he was in intensive care as the kidney problems that he suffered from demanded that he be on a life support system. I took a bunch of flowers expecting to be able to speak to him but he was lying there alone with those necessary tubes everywhere. I sat there for a while trying to remain composed until I could no longer see for tears and the nursing sister encouraged me to leave.

Once I was passing Boomalli Aboriginal Artists Co-operative in Parramatta Road and we bumped into each other and had coffee together in a nearby café. He hastened to fetch a magazine for me that had published some of his images with his accompanying text. Later I discovered that he had mentioned me as being an important influence on his work.

And this was Michael to a tee. A beautiful man, kind and thoughtful and loved by

■ Hetti Perkins

Meeting Michael for the first time was quite intimidating. At an informal lunch, organised by our mutual friend 'Ace' Bourke – who continues to be a stalwart champion of Michael's work – he sat silently, refusing to be drawn into conversation, or even to make eye contact! Sitting for one of his portraits was pretty much the same experience.

My family and I – father Charlie, brother Adam and mother Eileen (who was originally there just out of curiosity) – arrived at the Aboriginal Dance Theatre, Redfern, which he'd booked for the shoot, with some trepidation. Adam and I nervous about having our 'photo taken' and Dad a bit suspicious about all the fuss, still having not made the leap to how a family snapshot can be considered 'art'. We were met by Michael in a typically reserved manner and I proceeded to get the full make-over treatment from celebrated Oxford Street Koori drag queen Eric Renshaw, and Gary Lang, a moonlighting hairdresser who was one of the principal dancers with the National Aboriginal and Islander Dance Theatre. It was not until I read a later interview with Michael in Andrew Dewdney's *Racism, representation and photography* (1993), that I understood why he had even bothered to take my photograph.

In the print chosen from the shoot that day, I appear with freshly fluffed hair swinging my head away from the camera, probably responding to very discreet direction. Michael's tactic was to set the scene and patiently wait for the image to appear, allowing the subject to eventually relax into a natural pose. In retrospect I think the only way he could take the picture without my nerves being plainly written on my face was to get me to look away. Despite my reservations about my suitability as a subject, I believed that Michael's work was very important and my anxieties over my small role were irrelevant in the context of his much bigger agenda. My father and Adam were much more able to adopt their 'suit and tie' manner, and being portrayed with his son brought a smile to Dad's face. Michael then obligingly took a photo of all of us together which we treasure, only regretting that my sister Rachel was not there on the day.

Most of Michael's formal portraits of friends and colleagues were of women, a precedent set by his first suite of five works exhibited in 1986. Some of these portraits were given a footnote in later years with the addition of children. In his disarmingly modest way, Michael achieved what he had set out to do as an impressionable young man with enough drive to get himself to Sydney, abandon a trade apprenticeship, enrol in a photography course and establish himself as an artist. He expressed a desire to overturn the negative stereotypes foisted upon his people, and his portraits, like the artist himself, sit quietly as testimony to the endurance of his singular vision.

Over the years, I grew to appreciate that Michael was always the quiet eye of the storm around him. Michael once said, 'The every day is more surreal than the surreal'. And really that's what his work captures, a pause in our lives that, like silence, often speaks louder than words. It is a measure of the respect Michael's subjects had for him that they trusted him to capture the unguarded moment.

Perkins family from *Portraits by a window* photo shoot 1990 proof strip, print from negative Michael Riley Foundation
(opposite) *Hetti* from the series *Portraits by a window* 1990 gelatin silver photograph Pat Corrigan

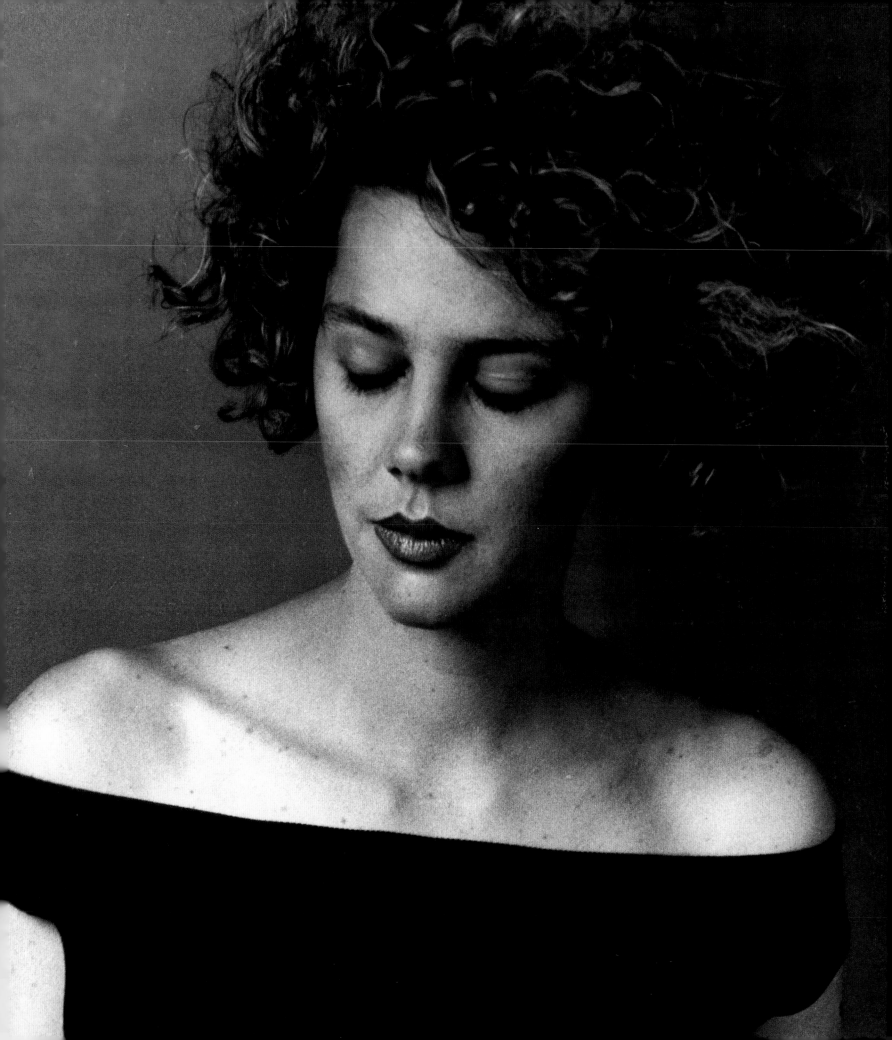

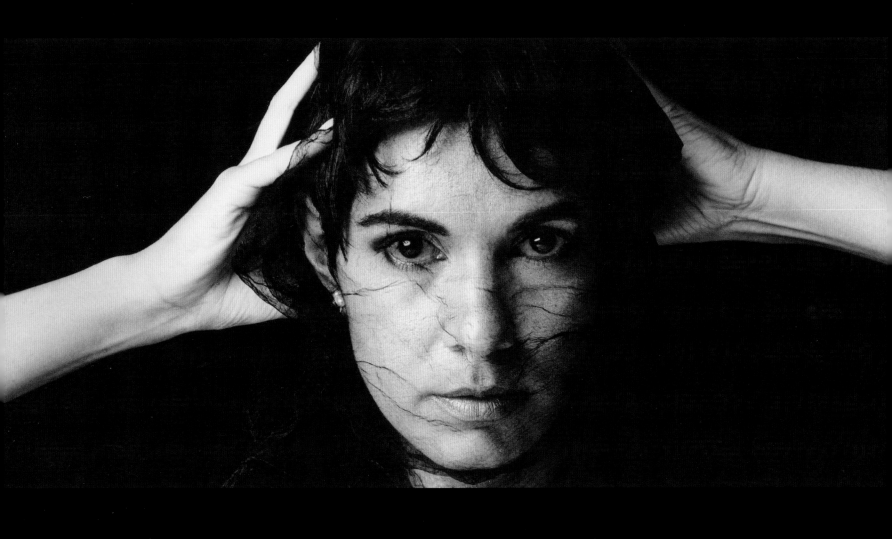

In 1986 in Sydney, Anthony 'Ace' Bourke wrote me a nice letter saying how much he liked my photograph of actor David Gulpilil that he saw hanging in the foyer at Sydney's Belvoir Street Theatre. When I met Ace, at what was then called Aboriginal Arts Australia, we immediately hit it off, talking not of art but of comedian Barry Humphries' creation, Dame Edna Everage. Between laughs, Ace proposed his 'Aboriginal photography exhibition', and I told him that I would only exhibit my work in his gallery if he dropped all the European/White Australian photographers and only displayed the work of Aboriginal artists.

I clearly remember him not batting an eyelid and saying 'Well, who then?' He still challenges me like this. I told him to leave it to me. I then ran around gathering every photographer I knew.

I remember going to Brenda Croft's crowded party in a terrace house in Redfern. The party was full of punky drunkie art student kids. I asked Brenda to exhibit work in the show and she said 'Yes', as she watched me back out the door.

Michael Riley was an obvious choice to be in the show. We had worked together at Sydney College of the Arts. In fact, Michael sweetly got me a job there in 1985 (he saw that I was broke at the time and feeling sorry for myself). My job was to keep the darkroom running and replenish the photochemical trays. Michael's job was more technical. He worked mainly with students in the studio, setting up lights and such.

Over time Michael developed a wonderful technical knowledge of photography, something I could never grasp and to this day never have.

In 2003, I wrote in support of Michael's nomination for the Red Ochre award. The award was established by the Aboriginal and Torres Strait Islander Arts Board of the Australia Council of the Arts to honour an artist who, throughout their life, has made an outstanding contribution to the recognition of Aboriginal and Torres Strait Islander arts. This is what I wrote:

In 1999, Michael Riley made a very funny, seemingly amateurish video drama called *I don't wanna be a bludger*, starring Melbourne artist Destiny Deacon. In the video, Destiny plays a 'loser' who is 'trying to make something of herself'. She is filmed in her house and in other makeshift sets. Destiny acts really badly and forgets her lines and makes them up – in fact, the whole video seems made up on the spot and that was its marvellous appeal.

I stood in horror in the Art Gallery of New South Wales watching the video, thinking that Michael Riley and Destiny Deacon were mad. Did they really think that they were going to get away with presenting *I don't wanna be a bludger* as an 'art video' in the serious contemporary art world? A world where comedy is rarely found? Around me, non-Aboriginal people stood watching the video in amazement and some younger people thought that it was really funny.

It's hard to pinpoint humour and what makes us laugh. Some people, like Destiny, have natural comic timing and Riley knew this and let the camera roll. He was mature enough to not interfere and let Destiny be irreverent about everything including Aboriginal culture, and behave like Australia's own Roseanne Barr.

This is one of many works that sum up Michael Riley's ability as an artist – that is of 'allowing'. In his vast bank of images in film and photography Riley allows us to feel and interrupt without obvious control and interference. This is pure bravery and this is how artists should be.

There is another image in my head, one that I have never forgotten, an image Riley made around the early 1980s and I don't believe that he has presented it as art. It is a black-and-white photograph of his grandmother's house in rural New South Wales, photographed at a low angle with a storm cloud brewing behind. The house is ramshackle, with bits of junk in the yard. At the time I didn't understand what Riley was saying with the image. A seemingly straightforward shot with no people. The photograph works on many levels. It has a haunting, lonely quality yet is so matter-of-fact and it is taken with such affection. Again Riley wasn't interfering, wasn't passing judgement. He wasn't documenting, he wasn't directing us how to think, just merely 'allowing' us to feel the image.

Twenty years later I can see Riley's grandmother's house – it is still a mystery and I wish that I made this photograph.

Tracey proof sheet mid-1980s print from negative
Michael Riley Foundation
(opposite) *Tracey* [*hands up*] 1986 gelatin silver photograph Black Follar Dreaming Museum

John Delaney and David Riley[1]

Brenda L. Croft: When did Michael start showing an interest in making photographs do you think?

John Delaney: Oh, when he bought a camera.

David Riley [Michael's older brother]: He was only a young boy and he'd walk around with a camera, he had a camera, a box camera with him all the time … taking photos of anything. He had a camera and he was walking around with it all the time …

Brenda: Do you remember when you first saw some of Michael's work in an exhibition, John?

John: Yeah, it would have been over in Balmain where he studied [at Sydney College of the Arts, White Bay Campus] … Yeah. He had a few exhibitions and things. I remember black-and-white photographs with Dallas [Clayton] with a jean coat on, and it was black and white, everything was black and white in the photograph but the jean coat was blue …

Brenda: Did he ever talk much with you about the kind of work that he was doing?

John: He did, yeah. Like his ideas and that, to me it was, 'What makes you think like that?' … Yeah, but after explaining it to me and the way he wanted to do things, it was really, you know, put down to the brilliant stuff … Most of my life he spoke to me about, he always wanted to do *Blacktracker*.

Brenda: About your granddad [to David].

John: Yeah, and to see that kind of film and like before he spoke to me about it, how he wanted to do it and all this, and then seeing it on film, it was brilliant … Yeah. We were just like brothers, he was my big brother, and we were just the same as any other brothers in my family.

We had fights and disagreements …
I helped on a few exhibitions, like just putting frames, going to certain galleries and helping hang them and that. But the film, I helped him on that, what was the name of it?

Ace Bourke: *Empire*?

John: Yeah … He asked me to build a cross for him … The day before we did the film we got the cross together and soaked it in petrol … This was up north in – I think the dam was called Copeland Dam. It's in between Moree and Inverell. I was in Inverell at the time when he came up there doing the *Empire* film and he asked me to put this cross together so I did it the day before he wanted to shoot it. I soaked it in petrol and everything, and he bought these waders for me to walk out in the water, and the water was freezing cold. I was out in the dam, I've got this big cross in my hand and a big hammer in my hand walking out. I had to walk out

so far because he wanted it so far out in the water, but as soon as you started walking out in the water, like it started dropping, and I had these waders on and they started falling off. So I had to rush back, like drop the cross and try to get back up onto the bank. Got the cross up on the bank, tried to get out of these waders so I wouldn't end up drowning. Then eventually I just walked out in my shorts, freezing cold water, got the cross out there and tapped it in. Then I had to light this big like matchstick, so I had to reach out and … set the cross alight, because he wanted still water all around it. So I had to reach out and try and light it and get it going, and he wanted the water to be nice and calm and still, and I was standing there beside him on the bank and we were looking around the dam, and the dam's huge, you could see for miles across the water and that and see these little campfires, individual

areas around the dam. I said to Michael, 'You know we're way out north here at the moment and this is all KKK territory and we're standing here burning a cross'. He said, 'Yeah, what if they turn up with their hoods on'. He said, 'I'm gone. You definitely won't see me' …

Brenda: David, how much older than Michael are you?

John: Michael would be 46 today.

David: Six years, I'm 52 this year, 53.

Brenda: Did he talk with you much about what he was doing?

David: No, not really, no, but I wasn't here all the time. Most of the time I lived in Moree and he was back at Moree, Dubbo, Sydney.

Brenda: Were you aware of what he was doing?

David: Oh, yeah.

Brenda: And did people in Dubbo talk about the kind of work he was doing, they were proud of it?

David: Oh, yeah, especially teachers anyway. They were saying, 'Where's Michael? Where's your brother Michael? I want to see him when he comes back now and again', or if you had to go and see the teacher, you know, the teachers always asked about him all the time … They'd heard about his work, wanted to find out how he was doing …

John: I love the way Sydney supported him, like took his artwork up on several occasions. That was amazing – like on the railway and that. Then another time I was working over at Bondi and I was on my way home and here he is at the bus stop …[2]

He asked me to travel with him, like going overseas and that with him, but I had a family too at the same time, two children. So I spent a lot of time there too, and my own business and things like that so I couldn't go with him, but

(above) John Delaney and David Riley, Glebe, Sydney 2006 digital image Brenda L. Croft
(opposite) *avid Riley* from the series *Yarns from the Talbragar Reserve* 1998 gelatin silver photograph Gift of the Artist – Guardianship Dubbo Regional Art Gallery

he always asked me to go with him. 'Free accommodation, brother. New York, Paris. Just come. All you got to do is buy your own plane ticket and have money in your pocket to spend'. He always asked me, and I regret not going with him now.

Notes

1 This is an edited extract of a conversation between John Delaney, David Riley, Brenda L. Croft and Anthony 'Ace' Bourke, recorded in Glebe, Sydney on 6 January 2006.
2 Michael's image, *Maria* (1986), was reproduced on posters in Sydney bus stops as a public art project in 2004.

Darrell Sibosado and Cathy Craigie[1]

Darrell Sibosado: What I get from Michael's work, and I guess from talking to him before he'd done stuff, he'd have an idea … even with the portraits and stuff he did, everything I got from Michael in talking to him, it was actually the idea behind it and the story, the theme, that he just captured the image. Like the photos of the Moree mob, when I look at that, it's telling me, someone who's not been to Moree, about Moree.

Cathy Craigie: But I think in many ways the social commentary didn't stop, I mean, he's always had social commentary. I think what he did was start to refine it more into an artistic view of things. His early work, especially the one of Maria (Polly) … That sort of stuff, the one with Polly and her sister Toni, those sorts of things – you could see what he was experimenting with at that time and he wanted to move towards other things.

I think the thing about Michael is he loved beautiful things. He was a label man. He was a person who really … yeah, anything beautiful, he had to have or be part of it, and that included people, so he'd have to capture that … I think Michael's work was always very – people responded to him, to the camera when he was behind it, and I've seen that in Moree Mob and other things like the Dubbo series and that.[2] People responded and they knew if it was Michael doing it, that it was okay to be sitting there. I'm not being critical of other photographers but I think that's something he had that I didn't see in other photographers' earlier work was the same level of intimacy that he had with the people who were sitting. It was capturing what I would call 'community'. I think a lot of other photos and even

photographers that I've seen, they didn't capture community in the same sense … For him to be able to do that, that intimacy, the relationship between him and the people who were sitting for him, that intimacy was a lot stronger because of that.

Darrell: And I guess with Michael, we all knew him and we felt there was a lot of integrity and honesty in what he did. Nothing was really contrived it seemed, you know. He'd have an idea and he'd want to show a certain aspect of Indigenous life or culture and stuff like that, so maybe in that way he set some things up – do you know what I mean? – or photographed certain things or certain people because there was a similarity between them. But basically I just saw, with most of his portraits anyway of people, it was just a really honest look at that person which involved all these other ideas that that person might have.

Cathy: Yeah, that intimacy was showing. He picked up things that you could see in those photographs. In many ways, like things like Moree Mob and the Dubbo ones, the catalyst for that was old ethnographic photos and he was interested in capturing those in another way and showing, you know – if you look at those old photos, the eyes just tend to be dead, there's no soul and stuff. Whereas in these, as Darrell said, there's so much more you can see … there's another story to tell apart from what was there, what's portrayed in the image …

Darrell: I don't remember meeting Michael, like that first moment, because I think I met him in a gang. I think I met them altogether and Michael was part of it and then I just became part of it. It just happened along the way. Like it was just us sitting round and him, sort of mucking around really, you know, just taking photos and then he'd go, 'Let's do this properly', and then we'd go away and do it and stuff like that. I remember with the hands and all that stuff, when that happened, like he just …

Brenda L. Croft: The *Sacrifice* series?

Darrell: Yeah. He just rocked up to my house. I was living in East Sydney at that time, in Bourke Street in this huge old terrace, and he had told me something about wanting to do this sort of series, but it was just an idea, nothing quite solid, not saying, 'This is how I'm going to do it', or whatever. Then he just rocked up that day and said, 'Let's take photos', and we went and bought the fish and all that sort of thing from down the local fish shop or whatever and then he just took photos. I just let him do whatever he wanted because I just trusted him anyway. I was like, 'Whatever, I'll just do whatever you want me to do', and then all of a sudden it'd be an exhibition, do you know what I mean? That's how it happened.

Cathy: I think too with him, I don't know if anyone else found this with him but he was very … I mean, most of us when we go into work, we're quite prepared or we'll do the research and we're

continuously looking for things that will connect with what we're trying to – you know, the outcome. But I never saw that with Michael, and I know he must have done it but I never saw him sit down and try to read books or go and do things. The ideas sort of came from whatever he was living at the time. Like it could have been he was doing a trip somewhere and he spotted something, or he met somebody. So it was all those sorts of things that were catalysts. It wasn't where the rest of us sort of think up the thematic stuff and that and then try to do a lot of work around that to get it right, I just never saw that. I just saw him come out and he'd go, 'Yeah, I'm going to do it', and then he would.

Darrell: Yeah, and he seemed really disorganised.

Cathy: Always.

Darrell: That's what I thought anyway.

Cathy: Always.

Darrell: Always leaving things, couldn't find anything, blah, blah, blah, but then something would happen out of it. I think that's what we all sort of knew and we had faith in anyway, that he'd do it anyway.

Cathy: You used to think, yeah, like, 'What are you doing?'

Darrell: Yeah, 'Shouldn't you write all this down?'

Cathy: 'Shouldn't you have something documented?', or 'What about this?', and it just never … yeah.

Darrell: Yeah …

Brenda: Were they shot at your place?

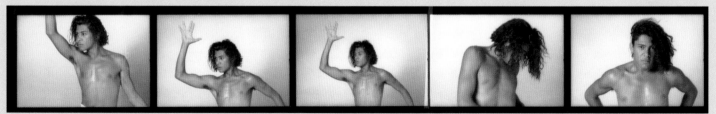

Darrell proof sheet mid-1980s print from negative Michael Riley Foundation

Darrell: Yeah, just in the backyard and in the garage and stuff like that. You know when you see photographers getting all set up and …

Cathy: That's right, everyone else you know does all this work and so on. He never did, or things were never working, you know, like he'd have to prop things up and that.

Darrell: Or he'd forgotten the film or whatever. The only thing he did set up with me was the one with the eyes shut and we did it in Redfern, just up the road from the Aboriginal Dance Theatre at Redfern in someone's house or studio or whatever …

Cathy: And his car – because I remember he had an old stationwagon and it was just full of everything. So he'd go, 'Hang on', and he'd go search through and he'd come up with a piece of paper with something on it, like notes and stuff … and that was all his research and all his ideas and everything in the back of the car mixed in with his clothes and whatever he had, you know, to travel with. He was very disorganised, but there was an order.

Darrell: Yeah, and I think a lot of the ideas he'd had for years, you know what I mean? He just wasn't satisfied with how he was going to present them, you know what I mean? And I think then as … I think things just fell into place eventually. A lot of the photographs he took or different series that he'd done, like it was something he'd thought about a while ago and it was just one shove, you know, waiting for the right time.

Notes
[1] This is an edited extract of a conversation between Cathy Craigie, Darrell Sibosado and Brenda L. Croft, recorded in Marrickville, Sydney on 15 January 2006.
[2] *A common place: Portraits of Moree Murries* (1990) and *Yarns from the Talbragar Reserve* (1998).

Joe Hurst, Jeffrey Samuels, Melissa Abraham and Joyce (Dooki) Abraham[1]

Joe Hurst: I remember when he was working in Balmain. Remember where he won the school trophy from Balmain and he done all these mad photographs? He took Dallas' photograph and it was nine feet high, you know, and took Dallas' and Polly's and all that kind of thing.

Jeffrey Samuels: Like we can reflect on the people who are still alive now and we can look back through Michael's photographs on that period. We see, you know, when we were all young and that and we were all vibrant and students and artists and doing things. But Michael's black and whites in the beginning … Well, they showed a different perspective, I think, to what was perceived to be done by Aboriginal artists. He was one of the forerunners in that. You could say an experiment but Aboriginal artists didn't always have to paint. The mastery of the camera and film was an avenue that Michael, like I've heard before, always wanted to do it. I must've came in just after that when he knew how to, you know, go into a studio and everything.

Joyce Abraham: It was all professional …

Jeffrey: He knew people in the Aboriginal creative community and the political arena that wanted to do things, that Aboriginal artists could manage their own affairs, manage their own art and the distribution of the money from the Australia Council, from the Federal Government. He worked with such people as … Gary Foley … What I remember was that him and Gary always discussed the issue about Aboriginal people presenting Aboriginal art, instead of non-Aboriginal people presenting Aboriginal art …

Melissa Abraham: What first inspired me to do anything in life full stop … was the day

Jeffrey Samuels, James Simon and Michael, Boomalli Aboriginal Artists Co-operative exhibition opening, 1994 photographer unknown

that I saw a film that my cousin, Michael Riley, made called *Tent boxers*. In that film I saw my aunty – I couldn't make it to her funeral but I saw her still alive and well on camera. He made the dead live. That's why it meant more than anything could in my whole life because I just thought, 'I'm a historian'. I like history and I like culture, family … I just want to say that I don't think I'd be as much of a good person as I am today if it wasn't for Michael Riley.

Note
[1] This is an edited extract of a conversation between Joe Hurst, Jeffrey Samuels, Melissa Abraham, Joyce (Dooki) Abraham and Anthony 'Ace' Bourke, recorded at Boomalli Aboriginal Artists Co-operative, Leichhardt, Sydney in January 2006.

Jeffrey 1990 proof sheet, print from negative Michael Riley Foundation

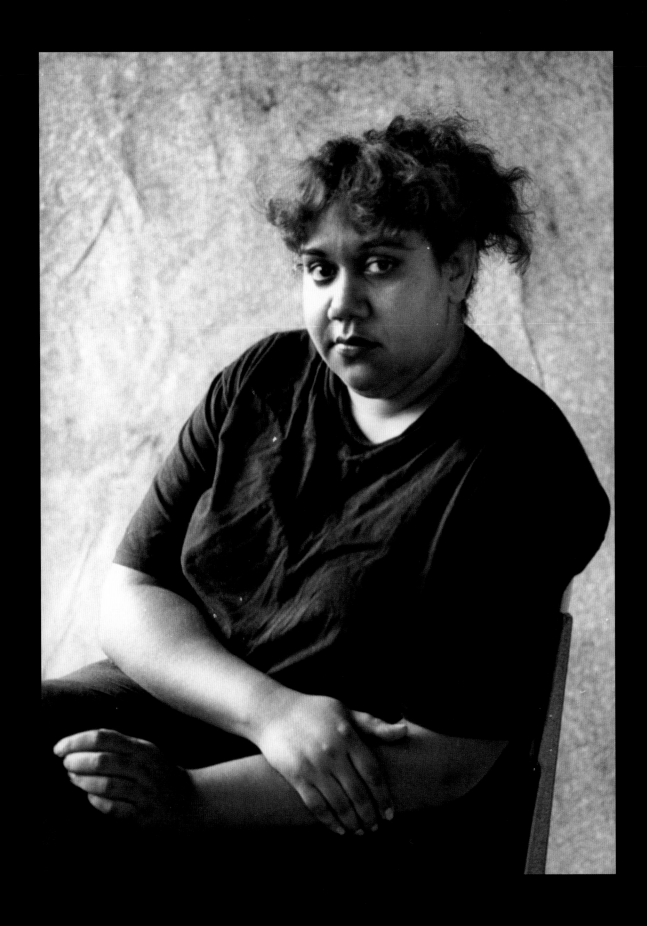

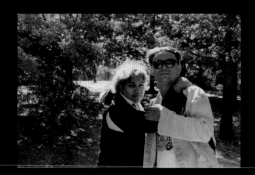

(above) Frances Peters-Little and Michael, Canberra
early 1990s colour print Michael Riley Foundation
photo: David Sandy; *Frances* Screen grab 1990 ABC
TV
(opposite) *Frances* from *Portraits by a window* shoot
1990 proof sheet, print from negative
Michael Riley Foundation

■ Frances Peters-Little

Why should it be that so many people expect that the most extraordinary things in life only emerge from the mysterious and intangible, when, in fact, most great things and people come from an ordinary life?

Michael Riley did not come from an exotic background. Instead, he grew up on an Aboriginal mission outside Dubbo in central-western New South Wales where he would spend most of his childhood until he came to Sydney in the late 1970s.

During his early years at school Michael began questioning the boundaries of his and other people's imagination. A source of amusement was the time he asked his high-school teacher in Dubbo how one went about becoming an astrophysicist. Michael recalled being told that he should enrol in the woodwork class as a substitute for the time being.

Notwithstanding the circumstances of his early environment, Michael quickly developed a keen attraction for the peculiar and unpredictable, refusing to be pigeon-holed – from his fondness for David Lynch films and music by nineteenth-century French composer Gabriel Fauré to his intense curiosity for Professor Stephen W. Hawking's bestseller, *A brief history of time* (1988).

In addition to the long and private friendship we shared, I have also had the honour of working with Michael on two of his films: as a researcher on *Malangi* (1991), a 30-minute documentary film about celebrated traditional artist David Malangi; and as a sound assistant on *Poison* (1991), a short drama about four Aboriginal youths whose narcotic-addicted lives are underpinned by the aftermath of years of assimilation, adoption and sexual abuse. I was also one of the subjects included in Michael's 1990 *Portraits by a window* exhibition at the Hogarth Galleries in Sydney and the music video *Frances*, which he made at the Australian Film, Television and Radio School in Sydney in 1990.

Admiringly supported by his family and friends to take risks and challenges in life, nothing that Michael did would be anything less than remarkable. And he would pay back the compliment to all those who loved him by including them in his films and his photography, allowing us to share in the everlasting extraordinariness of his life.

■ **Avril Quaill**

1987 saw the formation of Boomalli Aboriginal Artists Co-operative. Michael was responsible for getting the group incorporated, as well as getting the funding from the newly revamped Aboriginal Arts Board of the Australia Council for the Arts. His time was mostly dedicated to getting a building with good studio and exhibition space and obtaining support to keep artists interested and producing work. Month after month, we met outside various dilapidated buildings around the inner city of Sydney, including Newtown, Alexandria, Chippendale and Redfern. It was looking like the group would remain working out of their bedsits, flats and shared rented terraces. So many times we were almost assured of a building, only to lose it at the last minute. A space in Chippendale became available to us after a long search. As secretary of the group, I had to go with Michael to a meeting at the Arts Board offices in its then premises in North Sydney, to lobby for money to rent the gallery space in Chippendale. Gary Foley, then Director of the Aboriginal Arts Board, pretty much organised the funds that day.

Michael was constantly getting in touch with members, keeping the group focused on issues and aims. He introduced artists to each other, talked about differing arts practices, about people, about artists – famous and the infamous. Mostly we would talk about Boomalli projects and what the collective might achieve.

For the 1989 Artspace exhibition, *A Koori perspective*, I needed help to hang the works at the gallery in Sydney's Woolloomooloo. Together we worked through the night into the early hours to get everything done. Michael physically hung all the works, leaving his own photographs until the last minute, actually just pinning them up. They were stunning, large format black-and-white portraits. I was gobsmacked he could just tack them up on the walls but he was very 'un-precious' about the display of his own work. He just wanted the images out there.

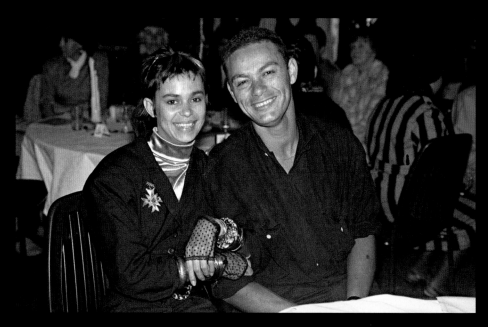

Avril Quaill and Michael, Aboriginal Medical Service Ball c. 1984 print from negative Michael Riley Foundation
(opposite) *Avril and Miya* from the series *Portraits by a window* 1990 gelatin silver photograph National Gallery of Australia, Canberra

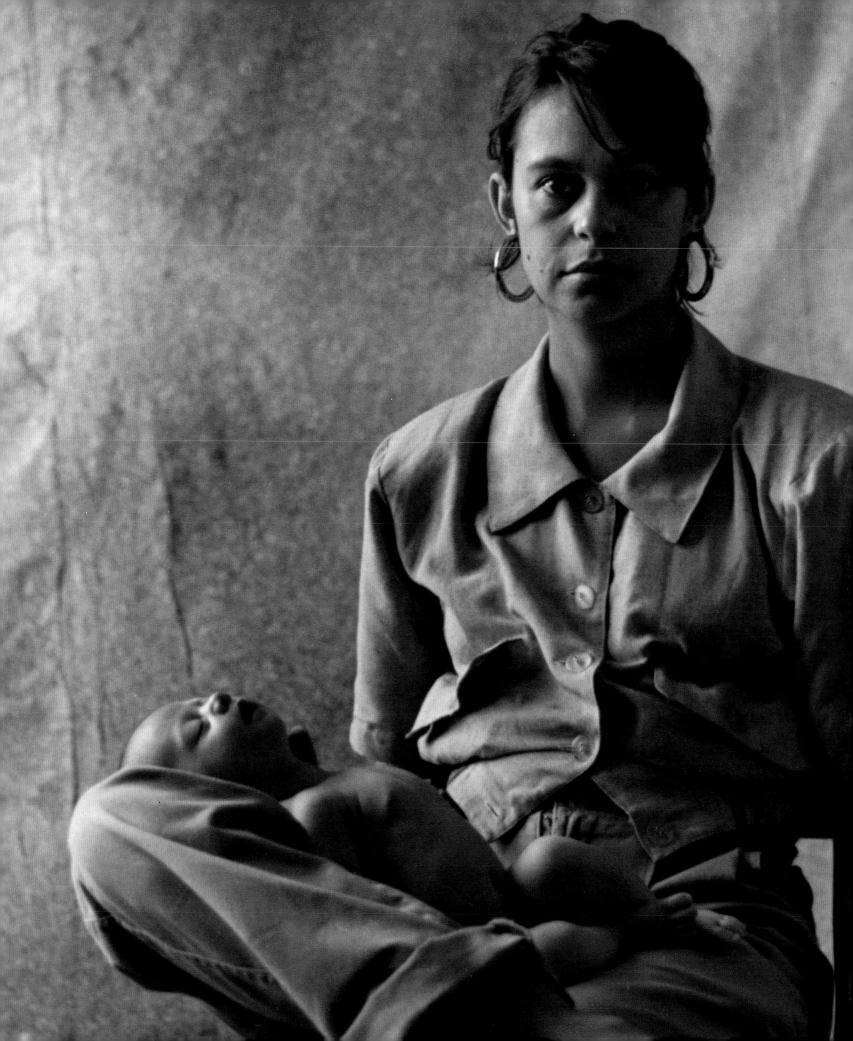

Poison cast and crew group shot black and white print
Michael Riley Foundation
(below) Screen grab from *Poison* 1991 ABC TV

■ Lydia Miller

The heady days of the 1980s gave rise to a generation of young Aboriginal artists who blazed a trail through the Australian cultural landscape with their exuberance, vitality and creativity, all of which continues to resonate today. Michael Riley was part of that generation.

I first met Michael at the Boomalli Aboriginal Artists Co-operative in Chippendale around 1987 when he and other visual artists decided to set up an Indigenous artspace and I and people such as Rhoda Roberts, Vivian Walker, Justine Saunders, Brian Syron, Suzanne Butt (née Ingram) and Michael Johnson were starting the Aboriginal National Theatre Trust (ANTT) in Newtown. At the opening event of Boomalli, the room was crowded with Indigenous actors, dancers, writers, musicians, politicos, representatives from various sectors such as health and education, and others from the Sydney community. It was an amazing time and place for Indigenous arts and culture. The collective debates raged about urban-based Indigenous art and culture and this new wave of extraordinary artists articulated passionately and creatively that the renaissance of urban Indigenous culture had arrived. Michael captured all this in the documentary *Boomalli: Five Koorie artists* (1988). This period was also notable for the collaborations between artists and there were many occasions when we all were involved in each other's creative works.

Michael had the ability to engage with artists, quietly observing that creative space to see what emerged and then shaping it into a series of poignant and disturbing images. In 1987, Michael directed the documentary *Dreamings: The art of Aboriginal Australia* for an exhibition of Aboriginal art at the Asia Society Galleries, New York, and I had the opportunity to work with him as narrator.

In 1989, ANTT organised the Second National Black Playwrights' Conference at Macquarie University and Michael was involved in the documentation of this historic conference with participants such as Oodgeroo Noonuccal, Brian Syron, Justine Saunders, Jimmy Everett and Jimmy Chi to name a few. This was echoed in the 1991 film *Poison* with the late Russell Page, Rhoda Roberts, Lillian Crombie and myself as actors exploring the issue of substance abuse and spirituality in a highly stylised drama which won awards at foreign film festivals.

As a director, Michael was respectful of the artist's creative space and his gentle humour would pervade that creative environment. We could experiment and break with convention and, in doing so, were loyal to his vision because he trusted us in that sacred space of creativity. I would watch him from afar during the film shoot, deep in

Second National Black Playwrights' C
shot Sydney 1989 Brenda L. Croft

concentration as he wove the story in his mind, and then we would catch each other's eye
and laugh at catching each other out. In 1993, Michael agreed to be interviewed for Diana
Plater's book *Other boundaries: Inner-city Aboriginal stories* (1993) and he explored what was
happening in Sydney in the 1980s and his own personal journey:

I just want to look at our history, look at – not so much the black versus white
thing – I just want to look at the intricacies within the Aboriginal community
itself, whereas white people wouldn't be able to get into the community to
find out how the black community works. Black people have got to look at
themselves now, really examine themselves and really criticise themselves I
think … and really question whether we have done the right things or their
parents' generation have done the right thing by us or not, or whether we're
going in the right direction … we've really got to analyse those things I think
before we get anywhere else, and those are the types of things I want to start
looking at in film.

His artistic legacy is testimony to not only the depth of his creative vision but also the
integrity and beauty of the man.

Rachel Perkins, Lisa Bellear, Destiny Deacon and
Michael at Message Sticks Festival, Sydney 2001 print
from negative Brenda L. Croft
(opposite) Destiny Deacon and Michael at *flyblown*
opening, Gallery Gabrielle Pizzi, Melbourne 1998
print from negative Michael Riley Foundation

■ Destiny Deacon

There seemed a kind of blak mystery-man thing about Michael. And since he's been gone,
I'm none the wiser about him, other than what I already think I know.

I hope Michael enjoyed working with me. Looking back, I remember he laughed a lot
while we were filming and I hope I'm a bit wiser for doing something with him. We never
consulted or talked much about the projects we made. He would give me some notice
from Sydney and, before I knew it, he and his camera would be in Melbourne, rolling in my
kitchen.

We both come from the same old school of blak family, politics and community service.
Our chuckles and mumbles come from a not-so-distant place and time that most people
prefer to forget or regret. Goodness knows what he had in mind, by wanting to work
with me.

Rather than acting as a director in his work with me, it was more a matter of him setting
a situation in which I could perform. Michael trusted my rough-draft scenario outlines,
which meant all those involved had to improvise and adlib their way about. Michael was
strict and no-nonsense. He chose the scenes he wanted, getting the attitudes he wanted.
Plus he had the editorial control. I would have changed and edited heaps.

Anyway, I don't consider myself an actor, maybe a storyteller. Michael put a tight
schedule on us to come up with the stories we made. Once, I got him to give me a break
and got him to try some 'acting'.

In *I don't wanna be a bludger* (1999), Michael chose to play an 'uncle' character. He named
himself 'Harold' and did his own styling and wardrobe with help from Virginia Fraser, who
also helped with lights, props and filmed his birthday-party segment. It is a strange and
interesting performance. Michael had regrets that he may have overacted. And I had
qualms about playing the fool … but he made me do it.

It's funny, but I can't remember where I first met Michael, nearly two decades ago. It
seems I've always known him enough to trust him. Enough to know where he was coming
from. A puzzle with some pieces.

(above and opposite) Screen grabs from *I don't wanna be a bludger* 1999 Art Gallery of New South Wales and Roslyn Oxley9 Gallery

■ Virginia Fraser

I met Michael through Destiny Deacon and her siblings. We were on friendly terms, though never friends. I worked on three projects with him and Destiny, and also cooked quite a few roast pork dinners he ate. In fact, for a while, every time a pork roast went into the oven at Destiny's, Michael seemed to arrive at the door, as though he and the meal summoned each other up.

On these three collaborations – two series of mini-soaps (the second of which never made it to air) for the ABC's *Blackout*, and *I don't wanna be a bludger*, commissioned for *Living here now: Art and politics – Australian perspecta* (1999) – I worked as usual with Destiny, producing props, sets and costumes at short notice on low or no budget.

During the shoots, Michael had a mild, permissive, low-resistance, low-conflict way of working, directing by close observation and small interventions rather than by trying to outline and control the action. He was so low-conflict, in fact, that though one of the camera crews on a *Blackout* set proved less congenial than was functional, he didn't challenge them, but on *Bludger* solved this problem by doing most of the camera work himself. His only remark to me when I shot the scenes where he played Uncle Harold was to make it look like a home video.

Bludger took about a week to shoot, in living rooms and other locations provided by the cast, working around the days Michael had to spend on dialysis, about which he was completely matter-of-fact and uninformative.

He was cautious with the budget. Madame Zora's fortune-telling robe and Uncle Harold's outfit, which he chose himself, were probably the biggest single expenditure and he cleaned the jelly stains off Harold's hired purple golf shirt and clip-on bow tie to get the deposit back. The whole cost of the props and costumes for *Bludger* couldn't have gone very far into triple figures and I ended up paying for some myself.

The work Michael did with Destiny is obviously formally and stylistically very different from his art films and photography with their sonorous, sublime skies, resonant objects and restraint, so apt for sadness that when some of those images were shown at his funeral, it was as if they had been made for that purpose.

Michael was a conversational minimalist and I never heard him say a word about why he wanted to work with Destiny or what he was aiming at in their collaborations. But I guess you can work it out. I'd see him chuckling and sometimes his whole body shaking with silent laughter at Destiny's performances. The shoots, partly planned and partly improvised, had a kind of purposeful playfulness connected to the awkward banalities and excesses of daily life. The tragedy that *Poison* (1991) attempted as highly stylised melodrama, *Bludger* approached as slightly sinister farce. I think Destiny herself, plus an ad-hoc quality in her working methods, gave Michael a home for something otherwise inexpressible through his normal mode of production – naughtiness, unpredictability, and the sort of unsettling humour that comes from crossing the line.

Imagination: The moving image in the work of Michael Riley

Victoria Lynn

In the video *I don't wanna be a bludger* (1999), Michael Riley plays the part of Harold, a disabled cousin of Delores (Destiny Deacon), who visits her house in Brunswick where Delores is throwing him a birthday party. Michael has thick black-rimmed glasses, wears a pink shirt and bow tie, trembles in his wheelchair, and is generally at the mercy of this afternoon escapade in Delores' Koori world. In the video, Riley's camera lovingly envelops the character of Delores, allowing her the freedom to dig herself into more and more strife as she attempts a career in fortune telling, has an excruciating interview with a social worker, applies for a study grant and babysits three children at the end of a long day trying to make something of her life. Riley's camera stays with Delores' improvisatory humour, sometimes almost daring Destiny Deacon to go further. As a collaborative team of writer and director, Deacon and Riley find in this work an exquisite balance between excess and narrative; satire and kitsch; improvisation and script.

The key themes of this video are how we treat the 'outsider' or 'other' and how we respond to difference. The larger-than-life Delores meets her match with the silent, helpless Harold. Delores' humour depends on reaction: as an audience, we wait in anticipation for what she will say or do next, and how her chosen foe will respond. A typical conversation with the social worker goes:

> Social Worker: How far did you go in school?
> Delores: Far enough.
> Social Worker: What is your date of birth?
> Delores: Old enough to know better.

Harold is, however, Delores' foil: all he can do is dribble. As she spoons green jelly into a quivering mouth, gives him a box of

magic tricks with which he clearly can't play, and dances with him around the lounge room, her slapstick humour is met with pathos. The 'troublemaker' comes face-to-face with the 'hapless victim' in a sequence that has audiences laughing aloud.

The media frequently depicts Indigenous people in perpetually negative circumstances, often as either 'making trouble' or being 'bludgers'. Aboriginals are regularly referred to in terms of types, in dehumanised and degrading language. Deacon and Riley's characters use the devices of satire and humour, through the conventions of the soap opera and reality television, to utterly unravel what it means to be an Indigenous person in the Australian suburbs. We are faced with a complex and varied scenario, one that makes fun of stereotypes in the most politically incorrect way possible. In this video, everyone is 'mistreated' to one degree or another. Delores has no empathy for anyone, including cousin Harold or the youngsters she is babysitting. She views the welfare system with a wry and cynical attitude, almost revelling in the tap dance she has with the welfare officers. Deacon and Riley reclaim 'politically incorrect', archival cultural forms in order to forge a larger and more complex understanding of black identity.

Michael Riley and Destiny Deacon had worked together before, in the early 1990s, on a sequence of videos known as *Welcome to my Koori world*. Delores first appeared in these five short vignettes – only four of which were screened as part of ABC TV's *Blackout* series – in her Brunswick kitchen. We see Delores pining for the boyfriend who abandoned her, Gary – who is represented by a Rastafarian statue on top of the fridge. She compares him with the great Dr Charles Perkins AO, Aboriginal activist, whose photograph she keeps by her side. She feeds her children, in the form of black dolls, in a high chair and almost chokes one of them on popcorn. She devises a poem

Screen grabs from *Welcome to my Koori world* 1992 SBS Television

for a NAIDOC Week talent quest to win a trip for two on the Murray River:

> they still call us Abos, Coons, Gins and Dags
> and there you are, lighting up my fags …

The final section presents Delores as chef, wearing an Aboriginal Australia T-shirt, and instructing us on how to make meatballs in a microwave oven. Delores wishes that we could sleep in microwave ovens, so that in three minutes you could get eight hours.

Michael Riley's videos with Destiny Deacon find a way to go to the heart of Aboriginal Australia by cutting through any expectations we might have over what Aboriginal people look like, how they behave, what their dreams are made of, what they eat, drink and listen to. In *Welcome to my Koori world* and in *I don't wanna be a bludger*, Deacon takes on various roles – cook, poet, wife, mother, bludger – in order to reveal the inadequacy of categorisation.

In Riley's films and videos there is an accumulative, unforced style of editing that slowly and deliberately builds a picture. He can switch from short fragments to long sequences, in order to build up a momentum. The short sequences have as much power and meaning as the longer ones. In this, we see the photographer at work within the structure of the moving image. As such, one comes to love the characters in Michael Riley's films, whether they are real or fictional, because we are encouraged to share their stories, and their journeys, past and present. This is as true for comic Delores, as it is for the men and women interviewed in the documentary, *Tent boxers* (1997).

In the much more abstract film *Empire* (1997), Riley's camera focuses on the detail of the Australian landscape with a similar structural format. The film opens with an eye inside a cloud. It moves through a montage of images from the Australian landscape: ants, a carcass, a lizard, drought-stricken clumps of earth that barely soak up the rain, a dead parrot. In these troubled sequences, life has been squeezed out of the earth. Such elegiac imagery is juxtaposed with scenes of a hawk freely soaring through the blue sky and time-lapse imagery of clouds, light and shadow shifting across enduring desert boulders. This is an Aboriginal landscape that propels us into a deep past. The camera roams over black and white rocks, along the crevices of dead trees and then zooms out to reveal a majestic sunrise or sunset. The play between an abstract stillness in the landscape and an endlessly shifting symphony of weather signals a continual shuttling between symbolic image and narrative sequence.

The tone of *Empire* encompasses a love of the landscape, a respect for its harshness, a mistrust of colonial influences and an ambivalence towards Christianity. With an image of two hands, in water, with stigmata, the film meditates upon the missionary infiltration into the Aboriginal landscape. As in the photographic series, *flyblown* (1998), the Christian cross is depicted as a mirror, reflecting the sky and clouds around it to the extent that they become one and the same – God is everywhere. In another scene, the cross has been lit up in flames. These sequences are followed by an image of a very old British flag and, further on, a sign that says 'Slaughterhouse Ck'. With this slow montage, *Empire* suggests that with the introduction of Christianity came destruction of both the landscape and its Indigenous people. There is, however, a decaying beauty, as if the British hopes for the urban and rural landscapes of Australia have fallen into a languid and languishing dream.

Thirty years before *Empire* was made, the British filmmaker Nicholas Roeg made *Walkabout* (1971), a feature film that has become an 'Australian' classic. There are some stylistic similarities between the two films. In *Walkabout*, there are moments of parched brightness in the desert, passages of intense light and dark, scenes where the desert offers up hallucinations of past explorers riding camels across the sand, and imagery of deserted mines and abandoned housing that depict a strange, angular, inhospitable environment. At times the soundtrack mixes radio frequencies with the voices of absent people and the sound of ants scratching in the sand. The photography alternates between close-ups of lizards, snakes and ants in the bush, quick shots of a butcher at work in the city, and long sequences depicting the majestic vastness of the Australian

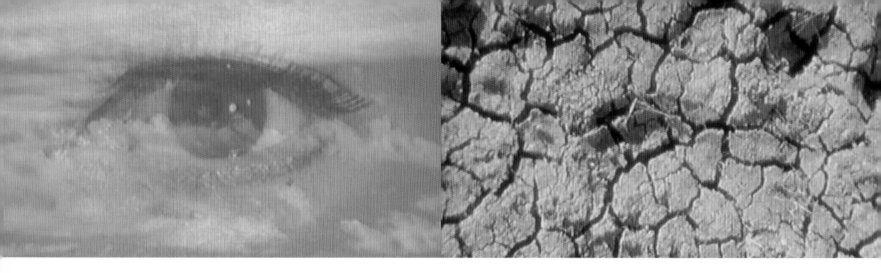

bush. Though underpinned by this fragmented imagery, the film is not in itself fragmentary (unlike Riley's *Empire*). Rather, there is a strong narrative which takes the disorientated characters through a series of spatial thresholds, often marked by blazing light and intense darkness – from city to desert to bush to farmland to an abandoned mine and, finally, to the bitumen road that leads back to the city.

Walkabout relies on binary symbols as it traces the journey of an English teenage girl and her younger brother lost in the Australian desert after their father shoots himself. The young Aboriginal man (played by David Gulpilil) who helps them find their way back to the bitumen road is depicted as 'primitive' – silent, ritualistic and dangerous. The Australian landscape is revealed as tormenting and harsh. During the film, the Aboriginal man makes advances to the girl. Rejected, he kills himself, echoing the death of the father at the beginning of the drama.

In comparison, Michael Riley's *Empire* has no narrative. Rather than relying on binary opposites to paint a picture of Aboriginal Australia as the 'other', Riley's film folds in and through references to colonisation, British values, Christian symbols, the Australian landscape and the Aboriginal relationship with 'country'. Through

Riley, the viewer 'reads' the Australian landscape with subtlety, tenderness, circumspection and ambivalence.

The reason why Riley was able to structure *Empire* in the way that he has is at least twofold. First, his training as a photographer meant that he had facility with both still and moving imagery. As such, he did not need to rely on narrative to tell a story, but could do so through iconic visual forms. Second, Riley's freedom with editing was no doubt informed by changes in the moving image itself. The moving image has interpenetrated the worlds of art and popular culture. Once confined to the houses of cinema, moving images can be found in galleries, museums, and metro stations, on street screens, the Internet and mobile phones. As a result, the ways in which the moving image is treated by artists and filmmakers have also changed. For example, the advent of the multi-screen video installation has meant that parallel sequences are simultaneously screened. Narrative is thereby broken and, instead, meaning emerges from the recombinant poetic connections between the screens. Although it is a single channel film, *Empire*'s structure works in a similar way: it is composed of sequences that connect over other sequences. In the larger context, cinema and art are cohabitating. In Riley's films/videos, they are equally at home with one another.

Watching *I don't wanna be a bludger* is haunting for those of us who knew Michael Riley, because the image of him disabled in a

(above and below) Screen grabs from *Empire* 1997 ABC TV

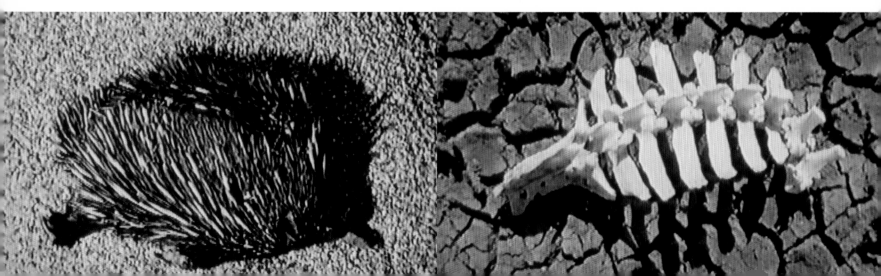

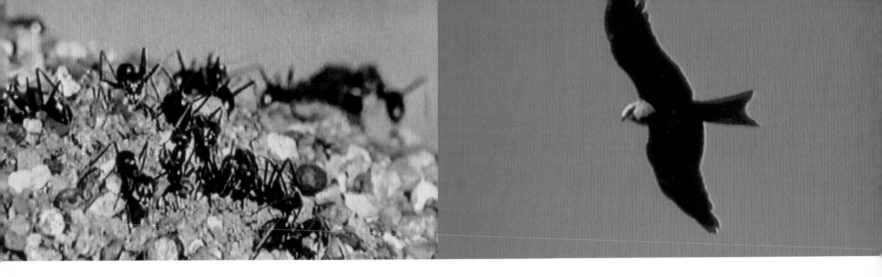

wheelchair predicts his own failing health a few years later. Equally haunting is the film *Poison* (1991) which features a young Russell Page, whose untimely death in 2002 also rocked the visual and performing arts worlds. A gifted dancer, Russell Page performed with Bangarra Dance Theatre, and was at the opening of Australia's pavilion at the 1997 Venice Biennale. His body was painted by the artist Judy Watson and he trailed through the streets of Venice much to the dismay of passing Venetians, tourists and the art cognoscenti. For them, he represented a completely unknown world – one where dance, art, belief, custom and landscape combine in the body of the performer.

The 'poison' referred to in the title of Riley's film is not only the consequence of drug and alcohol abuse, but also the ways in which western society has failed Aboriginal people. *Poison* has no dialogue: the entire film relies on sound, movement and a shift between black and white and colour for meaning. The film oscillates between a high-key colour stage set, where Aboriginal men, women and children sit by a lagoon, in harmony and visual symmetry, and black-and-white sequences in a bar and its urban, gritty surrounds. The same characters occupy both places. There is a contrast between an atmosphere of celebration and joyousness in the Indigenous landscape, and the sense of loss, lack of control, and hopelessness in the urban environment. In this place of confusion and substance abuse, there is no guidance from the elders,

no familial connections, no love, no belief. The Christian cross and Bible appear in momentary flashes throughout the film.

The relationship between the urban and desert worlds is complex. The Indigenous landscape simultaneously represents memories of the characters, dreams that they might have had, and fragments of a parallel life in the desert. At the end of the film, the two worlds become entangled as the main character, Raylene, stumbles through both the streets of the city, unaided, and through the desert, assisted by her friends. In the city environment, she arrives at a telephone booth in order to call her mother for help, but collapses and dies as the phone rings unanswered. Her slumped body encapsulates the tragedy of Aboriginal Australia. Yet the final scene of the film shows a presumably young Raylene embracing her mother on the edge of the lagoon. In this sequence, the Indigenous landscape takes on the form of an afterlife – there is redemption and hope.

Michael Riley forged a unique and independent Indigenous voice through his films and videos. These works are not only visually imaginative and captivating, they are also testaments to the turbulence and beauty of a contemporary Aboriginal Australia. They conjure a mixture of wonder, allure and comedy along with heartbreak, frustration and anger that, I hope, we all feel when faced with the triumphs and plights of Indigenous people in this country.

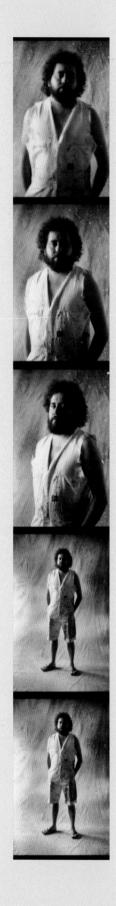

Joe Hurst[1]

Joe Hurst: He'd come up to Dangar Island [on the Hawkesbury River, north of Sydney] and he'd talk about, he'd be working on some thing. He'd say, 'Oh, I'm working on this thing', you know. 'What is it?' 'I can't tell you', which means he doesn't know yet. Anyhow, he came up and he goes, 'I've got it, I've written it, I've got this thing'. I said, 'Show me the script'. 'Oh, it's not written'. 'What is it?' 'Oh, it's this thing. Just come, turn up, Joe'. I had to design this thing for him and it was *Poison*.

So we rocked up and he got me in as the assistant designer to the designer, to the in-house design team of ABC. There's this old guy who died – I can't remember his name now – he was beautiful. So he was the designer but I was the assistant designer to him. So we were share designers. He was in-house and I was brought in. I said, 'What do you want me to do?' He said, 'Just paint me some pictures … So I just painted some pictures … Me and Michael, we'd fire off each other … We'd go to rehearsals with the actors and he'd just choose, I don't know, people who had … worked with him. 'Why'd you choose these people for?' He goes, 'Oh'. He had this thing about choosing friends to act for him. Like I suppose like there's iconic photographs and a lot of iconic faces in his movies. I went, 'Oh, look, I can't work with them people' …

Michael would be there and I remember the DAP [Director of Art Photography] and the assistant director would come up to me and they'd go – because the film industry was just riddled with cocaine 10 years prior, you know – they'd come up to me and they'd go, 'What's he on?' Because they wanted to know what he was on so they could modify their language or their brain to be able to work with him. I said, 'Panadol'. They thought he was like on smack or coke or something. He wasn't, he was on Panadol. They couldn't figure out how to adjust the lighting crew and the camera crew and the special effects because they hadn't worked with a Panadol junkie … He expected everybody to do their job without him telling them. He thought it was intuitive but they wanted a director to direct them. So they had to figure out that he was a non-directing director. He thought that he was an intuitive director. But he's like Elvis, a real faker, you know, and he was faking it.

Matthew Poll: This is why he wanted to work with people he knew …?

Joe: Yes, so he could be intuitive with them. He'd talk to them and then go, 'What do you think the character is from the script?' and they'd say, 'Oh, this is what I think it is' and he'd go, 'Oh, right'. Even though he couldn't say, 'Tone it down, become this person'. He'd say to the actor, 'What do you think the character should be and should do?' 'Oh, she should have a really nice dress and my hair should be beautiful and have big red lips and go "That's life"'. Because it was easier for him to say yes than to say no …

Alternatives, he never had an alternative because he didn't direct people. He directed the image as a photographer. Then he said to me one day, 'Oh, I wish I could direct people'. I go, 'Look, these photographs, why don't you make moving pictures?' 'Oh, yeah, all right'. Because he sort of had this dilemma of Tracey Moffatt. You know, he'd come up to Dangar Island and she rang him up and abused him that the sets … she thought that we'd ripped her off. I said to him, 'Look, I ripped off *Star Trek*,

114

I didn't rip off Tracey Moffatt' … His had a story directly related to the heroin and the drug abuse of Sydney Aboriginal people … His was a direct relationship to people he knew and a situation that was happening about heroin abuse in Sydney at the time. Also the film was a futuristic view of what he … I don't know if he's seen what happened years later as the heroin got really bad and a lot of people died. I don't know if he could see it but he sensed it, he sensed that he had to make a film about heroin abuse right there and then …

I moved back to Sydney and he turns up and he turns up with 50 lines of words on a page and 50 numbers on it, 52 numbers or 55 numbers, and he goes, 'Here, Joe, here's the script. I want you to draw this and this'll be a storyboard to my new film'. I went, 'Alright'. Because he used to come around, I used to make him lunch every now and then because I don't know how he ever eats. I used to make nice big salads and pasta salads and stuff and he'd come round. Anyhow, one day he turns up for one of my salads with this 50, 52 line, 52 numbers with words saying 'mountain', 'fish', 'dead cat' or something. He said, 'This is my script to my new film *Empire*'. I went, 'Oh, yeah, all right'. He didn't even have a name, he sort of went something like *Empire* or *Britannia* or something. So I had this really nice Stonehenge paper, so I drew up these things I call flashcards. Once I painted them all … I really love it because what you can do is you can shuffle up like a deck of tarot cards and you can make different movies because of the different order you watch them in … So a year or two went by and he rings me up and he says, 'Look, you've got to come to the Dendy Theatre, my film's on tonight at the Festival of the Dreaming', the film festival back then. I went, 'Alright'.

So we turn up and there's all this film mob there and we sort of avoid the ones we want to avoid, which Michael's good at too, he's good at avoiding people, which I like because if he was avoiding them then I'm avoiding them too, you know. So we go and we sit down and we sit next to each other and we're sitting in the middle of the theatre, in the middle, in the middle of the picture theatre by ourselves and all these other people all around. This movie comes on and I just go, 'Oh'. He goes, 'What do you reckon?' It was fantastic on two points. It was fantastic as a film, it's fantastic that he didn't direct any people, it was iconic images, but I really like the DAP and Michael. Some of my flashcards were identical to the shots in the film. So if I did 52 drawings, there could've been 12, 15, 18 shots in the film that were driven from my drawings, which I love. So I went, 'Great'. So he'd actually taken notice of my pictures. That's what I like about him. But I like it because it brought in everything … not what he talked about. He didn't talk about art, he talked about people, about what they did. So all the exhibitions that I never went to or have seen is what *Empire* was. Then from the still photos that he took on location, then that became the next exhibition … *flyblown*. So *flyblown* grew out of *Empire*. So that's Michael with his 120 Bronica on set. So when the DAP sets up a shot with the 16 millimetre camera, Michael's there with his Bronica taking the shot. So *Empire* comes out and *flyblown* comes out. It's the same thing. Well, to me it's the same thing because they come out in 1997–98.

Note
1 This is an edited extract of a conversation between Joe Hurst and Matthew Poll, recorded at Boomalli Aboriginal Artists Co-operative, Leichhardt, Sydney, on 20 December 2005.

(opposite) *Joe Hurst* from *Portraits by a window* shoot 1990 proof sheet, print from negative Michael Riley Foundation

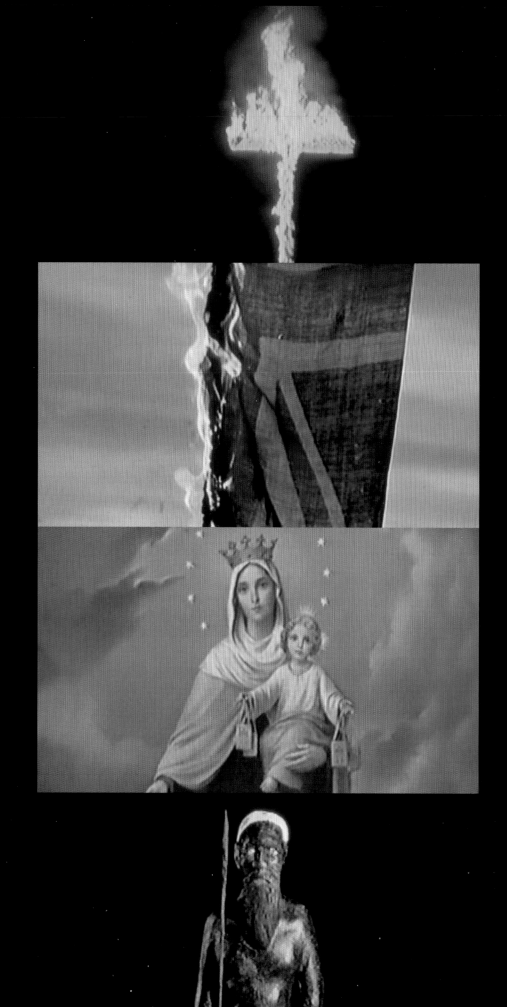

Michael and Lisa Reihana, Sydney 1988 print from negative Brenda L. Croft
(opposite) Screen grabs from *Empire* 1997 ABC TV

Michael Riley revealed his world using cameras, an urban brother whose significant contribution to Aboriginal film and photography began during the 1980s. Riley's idiosyncratic poetic style is evident in the works directed for SBS and ABC TV's Indigenous Arts Unit, where he produced documentaries and experimental films.

In 1997, the film *Empire* was produced and broadcast as part of ABC TV's contribution to the Festival of the Dreaming, the first in the Sydney 2000 Olympic Arts Festival series. It incorporates iconography also found in the elegiac photographic series': *Sacrifice* (1992), *flyblown* (1998) and *cloud* (2000). These works use multiple images, precise moments collectively presented to tell a bigger story.

EMPIRE

Opening Shot: blend 50 per cent extreme close up of an eye [perfect mascara lashes] with blue sky and white clouds – a heavenly location! This 'Gods-eye' view stares us down, closes. Dry?

Fade to: ants going about their busy business. Cut. A hawk [territorial and carrion] surveys its domain from up high in a bright blue sky. Close-up of sharp needles; a wide shot reveals these are the shriveled spikes on an echidna carcass surrounded by ants. Life and death. Up high, down low. Quick and slow.

The key images are clouds of all descriptions; sweeping vistas that crawl across frame and hold *Empire* together. Smooth transitions, lingering pans, cuts and frame-rate changes alter our sense of time, while the lens confounds scale. Luscious sunsets deepen, become night. The sound of rumbling thunder perceptually darkens our view. Soprano Cinzia Montresor performs a melancholic composition. The original score for violin and horns, composed by Supersonic and performed by the Tasmanian Symphony Orchestra, transforms these fleeting moments into epic proportions.

A crane shot [the gaze of a surveyor] looks down upon a cracked brown earth and bleached white bones. Where are we? What is this country? And where are the people? Minimal traces reveal human occupation – the occasional road; a fence disappearing into the distance; a livestock water pump. These interventions are western and territorial, leaving indelible marks on the land.

Riley instinctively directs our thoughts [*terra nullius*]. A black man's hand hovers above the land. No shadow, no residue. A Union Jack fills the screen, obscures the heavens and is replaced by … a mirrored cross reflecting clouds moving retrograde to its sky background [camouflage] – an antipodean vision. Raindrops fall to the ground, disperse ochre dust into the ether, become a muddy pool. Stigmata hands, an open Bible floats on water, provides no salvation [you have blood on your hands]. A road sign 'SLAUGHTERHOUSE CK' jolts us into a colonial reality.

A burning cross in a black void, its yellow and red flames, establishes a clear connection with the Aboriginal flag. Contrasts with a half-burned Union Jack. Cut to Virgin Mary and Christ.

Empire ends with an Aboriginal-man souvenir statuette – a trebly, BBC voiceover:
… keeping untouched natives away from white settlements, where they would quickly perish like moths in the light. Replacing their faith, which their ancient beliefs gave them, by a higher faith – the Christian faith. Training them in a benevolent segregation, in crafts, gradually to make them fit into an Australian community. No one wins.

Michael stood on a rocky outcrop on top of a hill. Silhouetted by the sun, he looks out towards the distant horizon. The film crew and I wait patiently at the bottom of the hill. All he needs to do is lift one foot up and perch it on his knee, then he'd look like the quintessential blackfella from those old Australian films. I entertain this thought privately.

Knowingly, he looks out searching for something in the bush. Time passes. Slowly.

'Hey, Michael … what are we doin'?' I ask.

Michael's eyes are fixed ahead. 'I don't know,' he quietly replies.

The crew, who have been poised for some time now, start to relax. Their conversations turn from 'what's the next shot?' to 'when's lunch?'. We wait a while longer.

Jokingly I ask, 'Are we lost, bruz?'

Silence fills the valley as the crew focus on Michael's reply.

After a while, he responds, 'I don't know.'

A silent panic floods through the crew. They look at each other with concern. The conversation quickly turns again from 'when's lunch?' to 'survival in the bush' and even 'how to make a fire with one match'.

Michael, who is oblivious to the growing hysteria, slowly turns and points towards a hill up ahead. He says, 'Ummm.'

The crew stare up at him, trying desperately to catch his eye, but Michael expertly avoids this.

He looks out to where he is pointing. 'I want a shot of that mountain, then we'll move over there and shoot that tree … the one with the axe mark.'

The crew look into the valley, unable to see the trees for the forest.

'After that, we'll go over there, to that cliff. There's a waterhole there – we'll shoot that. Then we'll eat, the road will be close to that ridge.'

Months later, in an edit suite in Sydney, I saw the images we captured that day.

Michael did know.

The sequence he created, for that valley, was a songline. The mountains, the trees, the cliffs and the water.

He reminded me of an elder seeing country for the first time and working out where to travel, where to rest and where to eat. Michael never said much to me, but I soon realised that by watching and listening, you would learn a lot from him.

(opposite) Screen grabs from *Quest for country* 1993
SBS Television

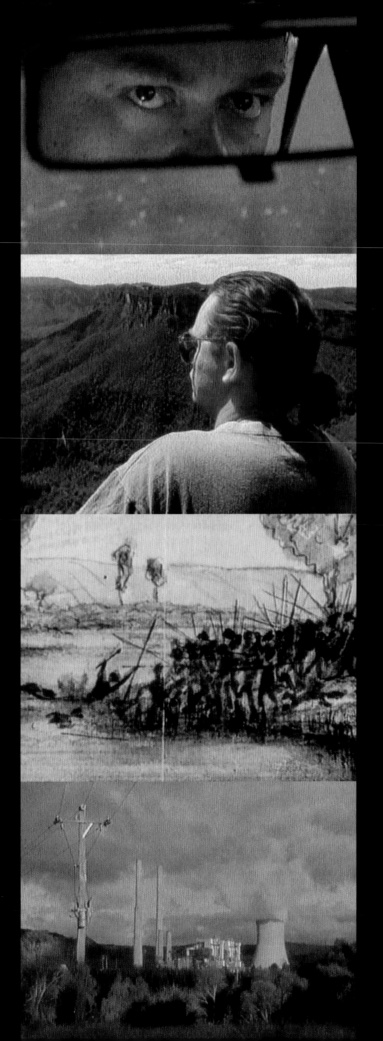

■ Troy J. Russell

I knew of Michael during most of my early preparative years as an artist. I was studying photography at the Eora Centre in Sydney in the late 1980s and I probably only ever said two words to him. I'm a quiet sort of bloke. I'd always see him at one of the Boomalli Aboriginal Artists Co-operative buildings, either supporting others or exhibiting his own works, but I never worked with him closely until I started making my documentary, *The foundation 1963–1975* (2002).

Our collaborations on the film were brief but intense. Not the intensity that comes from panic or anger – I don't think I ever saw him angry or panicky – but it came from an artistic point-of-view that only comes from a respect for each other's schema. We'd sit around in his flat at Glebe and discuss different approaches we could take to make the film not only interesting but also informative. We'd talk of images that might set some sort of surreal prologue for the interviewees and their retrospective roles within *The foundation* or something else that would introduce another segment. That would always set my own mind off, thinking of the surreal.

When it came time to shoot, he was always in the background, never up front, and he would always make photographs of those interesting people that we'd have to interview but I never saw those pictures. I don't know if he ever realised how much I respected him for his mentorship on that film. I never got a chance to tell him.

A couple of years before we had our collaboration on the doco, I was living above him in that block of flats called *Wahgunyah* in Glebe – on Glebe Point Road across from the Valhalla Cinemas. Sydney had a really big hailstorm that smashed everything up. I went downstairs to have a look at the hail hitting things and there was Michael, just standing there in the building's very small porch, watching the hail hitting the ground at our feet. We just stood there, in silence, watching.

(opposite) Screen grabs from *Quest for country* 1993
SBS Television

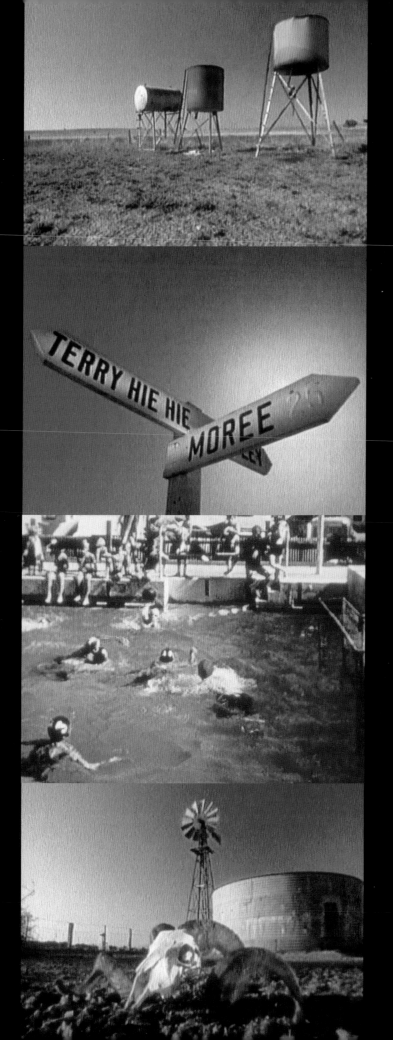

■ Rachel Perkins

From the moment Michael explored the moving image, he made exceptional and innovative films. Even in the most mundane production environments, Michael created ideas that pushed the boundaries of form and the depiction of the Indigenous experience. With the National Gallery of Australia's retrospective, those films now have the opportunity to be examined as a distinctive legacy, created at the birth of Indigenous filmmaking in Australia.

I first met Michael in Alice Springs in the Northern Territory as he was passing though town on his way to film Michael Nelson Jakamarra at Papunya for his first documentary *Dreamings: The art of Aboriginal Australia*. We were both starting out as filmmakers. Michael was at Film Australia and I was at the Central Australian Aboriginal Media Association (CAAMA). The year was 1989 and the Bicentenary and extensive lobbying had created an awareness of Indigenous culture which influenced the Australian film industry and government bodies to recognise the need for an Indigenous voice in the Australian screen industries. An injection of government support assisted the ABC and SBS to establish Indigenous Units, CAAMA to begin its video unit in earnest and Film Australia to offer opportunities to Indigenous filmmakers, of which Michael was one of the first. When I moved to Sydney from Alice to work at SBS, Michael and I immediately became friends. So began our filmmaking collaboration that continued on and off over the next 15 years or so. But Michael always remained, in a creative sense, one step ahead.

Michael's passion for visual expression began with photography. His filmmaking evolved as an extension of this passion. The genesis from the still image to the moving image meant Michael's films, although created for television, were never really TV; they were artworks.

The still images he created spoke to his films. This can most clearly be seen in the photographic series *flyblown* (1998) and *cloud* (2000) and their reflection in the sumptuous experimental film, *Empire* (1997). The film *Quest for country* (1993) is a further meditation on the abuse of settler culture on the environment, also captured in the photographic series *flyblown* (1998). The images in the exhibitions *Yarns from the Talbragar Reserve* (1998) and *A common place: Portraits of Moree Murries* (1991) are reflected in the people and the places in the films *Blacktracker* (1996) and *Tent boxers* (1997). These are Michael's mob and his films are about their world.

Filmmaking, as opposed to photography, necessitates a more collaborative process and many Indigenous filmmakers had the privilege to assist Michael in making his films. I was one of them and in many ways we grew up together making films. I recall we seemed to spend a lot of time on the road, thinking up new ideas for films. In this context Michael continually impressed me with his sureness of vision. From the first moment he articulated an idea for a film, he always had the complete concept determined. Even more so than photography, to get the money to make a film the idea would need to be expressed convincingly on paper. With great tolerance Michael would scrawl out pages of indecipherable text and whoever was working with him at the time would type it all into a computer as he dictated from his notes. The dictation was, from start to finish, a complete work. No redrafting or rethinking.

As much as Michael was true to his creative vision, he was equally true to his personal style. Michael had no regard for television hierarchy and the flashy two-minute TV idea 'pitch'. He would just arrive in his shorts, outline the idea to the executive with the power to make it happen and then curl his hair around his finger, look at the floor and wait for their response, which was always 'yes'. Everyone understood that Michael was a true artist and no-one assumed they could turn him down or, worse, tell him about his art.

In 1993 Michael and I established an independent production company together called Blackfella Films. We were both tired of all the debate about the rejection or acceptance of the term 'Aboriginal filmmaker' and wanted to make it clear where we stood. Our first production through Blackfella Films was an international co-production by Indigenous filmmakers from Australia as well as Maori, Sami people and Native Canadians. Michael's film was called *Quest for country* (1993). Blackfella Films is still operating, currently shooting the largest documentary series to be undertaken in Australia and employing Indigenous people throughout the production.

Michael was universally loved by all his work mates and particularly by his family. His films, in a way, are testimonies of his love for these people. If you review most of the films he has made and also his still images, they are people close to him; made with or about family, friends and fellow artists. He had an exceptionally independent vision as an artist and a true and loyal heart as a friend.

(opposite top to bottom) *Untitled* [*ocean*]; *Untitled* [*clouds*]; *Untitled* [*storm and grasslands*]; *Untitled* [*brown grass*] from the series *Fence sitting* 1994 gelatin silver photographs Rachel Perkins

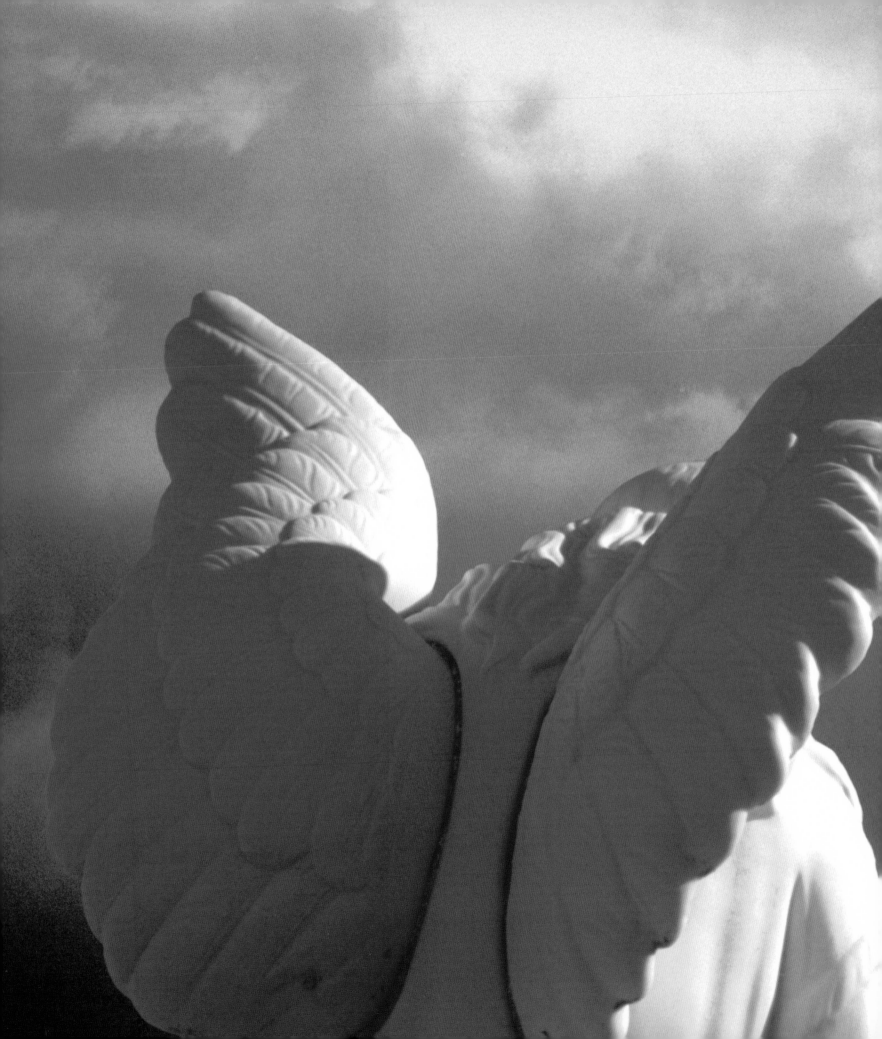

CLOUD

Wungguli – Shadow: Photographing the spirit and Michael Riley[1]

Djon Mundine

Feathers float – so do clouds – and dreams.

Feather – a Wiradjuri word for feather and wing are the same, *Gawuurra*. Probably Cowra, the name of a town to the south, comes from this. In contemporary Aboriginal practices of other groups, feather-appendage is extended in meaning to string tassel, sacred string marking a journey, connecting landscapes, people, family lineages, and, importantly, the embryo cord linking child and mother.

A wing of the eagle hawk, *Malyan*, a skin name, a scary dream-being overhead. Is it guardian angel or assassin? In the south-east, a feather left behind is often evidence of such a spiritual visit.

At the funeral of actor and activist Bob Maza in 2000, his son held his father's Bible and recollected his words, 'to dare to dream your dreams'. It's interesting that Michael Riley chose to avoid the word 'dream' in naming his final photographic work *cloud* (2000), avoiding glib connections to 'Dreamtime'. What rolls past our eyes and through our senses is the culmination of self-examination. In a series of poetic photographic texts made increasingly poignant through events in his personal life, these are dreams of childhood memories in Dubbo, New South Wales: dreams of floating, of release.

Untitled [*angel back, full wings*] from the series *cloud* 2000/2005 chromogenic pigment print National Gallery of Australia, Canberra

You talk of conservation
Keep the forest pristine green
Yet in 200 years your materialism
Has stripped the forests clean
A racist's a contradiction
That's understood by none
Mostly their left hand holds a Bible
Their right hand holds a gun[2]

Michael Riley's earlier photographic essays, *Sacrifice* (1992), *flyblown* (1998), and the evocative short film *Empire* (1997) deal with the broad but brutal issues of the 'black armband' – true facts – of Australian history. This is the history of a colonialism beginning with cursory sightings, then violent exchanges, wars, and massacres, followed by the saving and assimilation of the Aboriginal survivors by Christian missionaries. The history of 'clearing the land', to wipe clean and rewrite. A history of Aboriginal people being murdered or forced from the land and onto missions and reserves. The gun or the crucifix. Crosses, prayers, stigmata, dark fishes, Bibles, water, cracked earth. The death of the environment in Christian overtones. Of biblical plagues – drought, locusts – a poisoning of the water. As rural industry takes over the physical land, Christian missionary zeal takes the soul of the people.

cloud appears as more personal and free. A floating feather; a sweeping wing; a vigilant angel; the cows from 'the mission' farm; a single Australian Plague Locust in flight, referring to the cyclical swarms of locusts; a comforting Bible; and a graceful emblematic returning boomerang. The boomerang is really the only overtly Aboriginal image in the series and the locust is one of the few native species left that is visible and cannot be swept aside. It persists.

Dubbo, on the Macquarie River in central-western New South Wales, is named from a Wiradjuri Aboriginal language word meaning red earth and net cap, as in the clay cap worn by Wiradjuri women in mourning. On a Dubbo website in 2000, a timeline of linear white history contained only one mention of Aboriginal people (what they called the Macquarie mob), despite a long history of Aboriginal settlement in the area. That mention was the hanging of Jacky Underwood (aka Charlie Brown) at the Dubbo Gaol in January 1901, the year of the Federation of Australia as a nation. Jacky Underwood and the Governor brothers from the Talbragar River were declared outlaws (outside the law) when they reacted to insults by white neighbours and overseers by brutally murdering them in what was called the Breelong Massacre. This event was mythologised by

Thomas Keneally in his 1972 novel, *The chant of Jimmie Blacksmith*, which was itself transformed in 1978 into a film by Fred Schepisi.

Resistance fighter Windradyne was already leading the Wiradjuri people in a war with colonists before explorer John Oxley passed through the present site of Dubbo in 1817–18 in search of the inland sea. Oxley saw the area's rich potential for grazing and agricultural industry without understanding that an Indigenous form of this was there already. The abundant wildlife – kangaroos, emus – and other plant life that provided for the Wiradjuri quickly came into competition with the ever-growing numbers of colonial sheep and beef cattle. The warfare continued when the Surveyor-General of New South Wales, Major Thomas Mitchell, arrived in the area in the early 1830s. By 1865, when Dubbo was declared a village, open physical warfare had fallen off, with white infrastructures being set up such that, by 1872, Dubbo had grown to a municipality.

In 1883, the Aborigines Protection Board was established and an ongoing legal battle over the control of Aboriginal reserves commenced between the white authorities and Aboriginal people. Talbragar Reserve, on the junction of the Talbragar and Macquarie Rivers, was established in 1898 as one of these self-sufficient properties in the centre of what had become beef and dairy country. In 1905, of 114 reserves gazetted in New South Wales, 63 per cent (73) were declared over to Aboriginal farmers already working crops on that land or Aboriginal farmers who were ready to take up the land.

A sophisticated Aboriginal population developed from the Dubbo and the Talbragar Reserve area who, despite losing their land, being disempowered, and disenfranchised, were never really displaced in their own hearts and minds. A line of sophisticated people who fall between, in Michael Riley's words, the 'Rad Ab' and the 'Trad Ab'; between those politically active marchers of the streets and the spiritual people sought out by new-agers and visiting backpackers. It was these sophisticated Aboriginal people that Michael strove to highlight. He would count himself among this group. His male relatives and friends nicknamed him 'Elvis' because of his slicked-back hair and stylish dress.

> The Aborigines are semi-nomadic, hunters, fishermen and plant-food collectors who employ their art in the décor of their rituals and in the decoration of their everyday weapons and utensils … The aesthetic sense of the Aborigines is a much debated question … Much of Aboriginal art is crude technically.[3]

In an historic event in 1960, the State Galleries of Australia had organised the largest ever, national touring exhibition of Aboriginal art. Of over 100 objects, bark paintings from northern Australia dominated. Also included were several painted skulls and a number of restricted sacred ceremonial objects from central Australia. This was the image of Aboriginal art when Michael Riley was born the same year in Dubbo. In the following year, 1961, amid concerns about the perceived end of the 'authentic traditional Aboriginal', the Australian Institute of Aboriginal Studies opened in Canberra. However, in 1962, Mervyn Bishop became Australia's first Aboriginal press photographer working for *The Sydney Morning Herald*.

Michael went to school in Dubbo. His parents were religious (Christian) and went to church on Sunday regularly like average good suburbanites. They sent the kids to Sunday school – the right thing to do, but it also meant they got a break from them. Michael, however, seems to have found the Christian experience very 'creepy'.

> I hated it, I thought they [church] were creepy, I'm not a Christian, I'm not really against Christians. I just don't like hypocrites.[4]

For him, it was a sort of inversion of Christian missionaries denouncing Dreaming stories and beliefs as primitive and evil. An image of the Bible, a recurring theme throughout his autobiographical work, comes out of this time. He always wanted a Bible but 'they wouldn't give me one; all the other kids had one'.[5] The Bible image, which appears in both the *Sacrifice* and *cloud* series, contains an ambiguity, being depicted as both discarded and floating vision-like, although upside down, in the sky. Is it the sign of a true spiritual believer struggling with his belief, possibly a metaphor for the struggle of acceptance of the 'white' presence in his world?

He says he was never told any Dreaming stories, just vaguely about Biame, the All-Father (or Ancestral Being) who lives in the clouds, and he was shown a few sites around Dubbo, like the grinding sites on the river. Riley was also told, though, '… there were places. You'd be told, "You can't go near there" or "Don't go there, it's a dangerous place"'.[6]

The crucial point in his spiritual Indigenous diaspora comes from the meeting of Christianity, Indigenous people and religious beliefs. Riley was conscious of the ambiguity of Christian missionaries as agents of negative colonisation and questionable positive,

redemptive, assimilation. Although they 'saved' Aboriginal people physically from the guns and the violence, spiritually they subverted them, discouraging and preventing them from continuing their own religious and social practices, from speaking their own language. In personal conversations, an anger surfaced in Michael about what he felt he had lost.

In every Aboriginal home, despite the disjointed removals of family members and from place of birth as a result of former genocidal government policies, is a set, a wall, or boxes of family photos where the lineage of family, extended family (clan), country, and spiritual memory are invested. Michael told me his first photo was most probably a portrait of a family member, a snapshot. Like Mervyn Bishop before him, he bought a simple photographic kit from a local chemist and started to develop his own photos in his room at home when he was about 14.

> I was interested in the process – I was inquisitive. I just knew there were images I wanted to do.[7]

Many Aboriginal artists have come to a form of expression through the backdoor; in a roundabout way, that is. This isn't negative. It just enriches the experience, and the resultant artistic observation.

It could be said that all Aboriginal art is autobiographical in the sense of linking people, land, environment, and history. Michael's first film for Film Australia, *Boomalli: Five Koorie artists* (1988), was a fresh bright work on his peer group, the Boomalli artists. Working at Rapport Photo Agency around this time, he arranged a black-and-white studio portrait series of his friends in the Sydney black art community. In fact, a path that appears through most of his work is his direct associations with family, friends, and community.

> I found that I wanted to tell stories and get stories from Aboriginal people. The land around there is barren and flat, almost semi-arid desert. What I was trying to do within those images was not just show how farmers and graziers, whatever, people have changed the surface of the land, the country but to try to give an idea that Aboriginal spirituality is still there within that land even if the surface has changed. There's still a sense of beauty and spirituality there.[8]

Through the large, simply superimposed images of *cloud*, Michael was trying to minimalise things, to distil his ideas about physical reality and spirit. All are dichotomously connected to Dubbo and

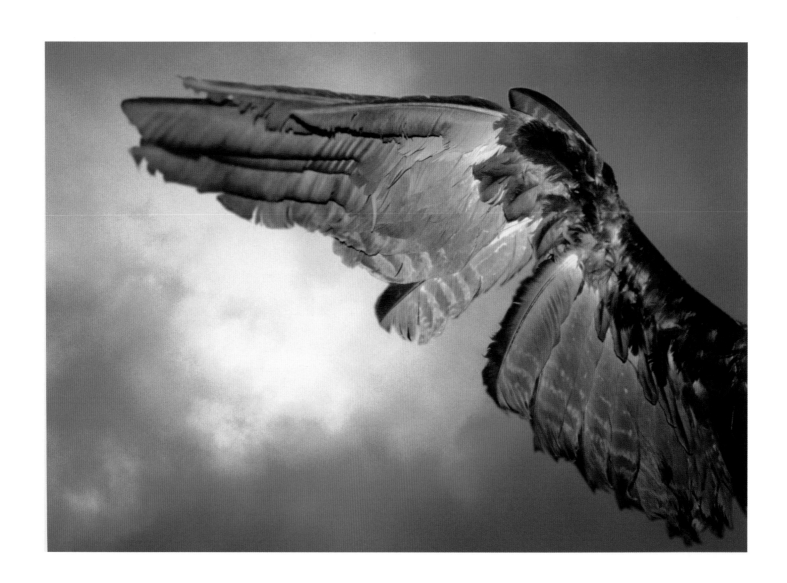

Untitled [*crow, left wing split open*] from the series *cloud* 2000/2005 chromogenic pigment print National Gallery of Australia, Canberra

Untitled [*cow*] from the series *cloud* 2000/2005 chromogenic pigment print National Gallery of Australia, Canberra

Riley and are also universal. They are not about a place but a state, the surrealistic cow with mud and manure on its hoofs floating by. In contrast to *Empire's* scenes of a decayed, overworked and desolated landscape, there is no physical land in the *cloud* imagery.

Aboriginal creation stories begin with a sunrise and follow the journeys of an original being across a physical, seasonal and emotional landscape – seeing, experiencing, and naming this and that plant, animal, climatic occurrence and emotional feelings. Religious song cycles follow this progression. Michael's set of large, single-subject memories can almost be thought of as a Wiradjuri song cycle of his land and his life.

One result of being the most urbanised population in the world is Australians' lack of awareness of what really happens in the rural inland – most of the continent, that is. *Galang-galang* is the Australian Plague Locust. Locust plagues are a fact of life around Dubbo. Local outbreaks covered the area in the early 1960s when Michael was born, during his teenage years in the 1970s – 1973, 1979–80 – and again in 1984 and 1994. A plague of sorts was happening at the time of the creation of *cloud* – autumn/spring 2000 – and now at the time of this writing (December 2005).

Usually starting in the north, the locust swarm can travel 500 kilometres overnight to reach the rich winter cereal pasture in the south-east of the continent. In the early 1970s, they covered the roads around the town of Dubbo: 'You could hear them crunching under your tyres, they stripped the bowling club lawn.'[9]

Yet beyond the economic imperative, how beautiful, free and graceful is *Galang-galang's* flight. In Indigenous religious terms, locusts, stick insects, grasshoppers, praying mantis are the happy spirit messengers from the land of the dead. A swarm of spirits, they tell of the change of seasons, the cycle of life. They are also seen as guardian spirits. It was this spiritual entity choreographer Stephen Page referred to in *Praying mantis dreaming*, Bangarra Dance Theatre's first full-length work – the guardian spirit that leads the central character from her sojourn back to her family and her culture. In one of the creation stories of my own people (Bandjalung), an old woman leads the children of the extended family into the cleft in a special rock where they turn into locusts. Each year, there is the 'flight of the children'. In Australia, two types of native insects are called locusts: the grasshopper type of Michael's image and the cicada. Both are cyclical in their swarming and both were food sources for Aboriginal people.

Many artists have constructed representations of the Australian landscape, including the area around Dubbo. One such was C.H. Kerry, who was invited in 1899 to record the life on a property at Quambone, on the Macquarie River, north of Dubbo. Superb though they are, his documentary images of the local Aboriginal people are an outsider's perspective of the ritual he was able to witness and record. The Aboriginal workers led a dual existence of interaction with the 'Western world', in working and continuing to live on the cattle station while still pursuing their Aboriginal religious ceremonial life. In an Aboriginal sense they were still on 'their land' and maintaining a spiritual relationship to it despite the colonial imposition of the cattle station.

By the time of Michael's birth, the search for the exotic authentic had shifted from the south-east to northern Australia. Australian Axel Poignant and US *Life* magazine photographer Fritz Gorro both visited Arnhem Land in the 1950s to document and 'compose' their subject matter. Michael's photos are less a simple documentary examination from outside than they are a spiritual vision of landscape from within – not a physical surface recording but an allusion to the spiritual within the land and his attachment to it.

In the early years of this new century, Australians are again re-examining their history and resultant identity. Central to this is the question of our place in the world, and recognition of our 'black armband' history. Photography arrived into the world soon after the first Europeans appeared in the Pacific in significant numbers. A relatively new technology, it has certainly changed, some say even advanced, over its lifetime. As cinema could be said to be the artform of the twentieth century, so photography could be said to be that of the preceding one. It came into popular use at the last rise and gasp of European colonialism: the final colonisation of Oceania, the South Pacific. It became a vehicle for recording the new exotic lands and informing 'un-exotic' Europe of the strange landscape, flora, fauna, and people. Ultimately and blatantly photography became another tool of colonialism, a tool with which to label, control, dehumanise and disempower its subjects who could only reply in defiant gaze at the lens controlled by someone else.

It's a common saying that the camera doesn't lie. In a sense, to photograph is to produce an image of something by allowing light to fall on it and the film inside. For many Indigenous artists, to take up photography as an artform was often a conscious move to counter this history of the medium.

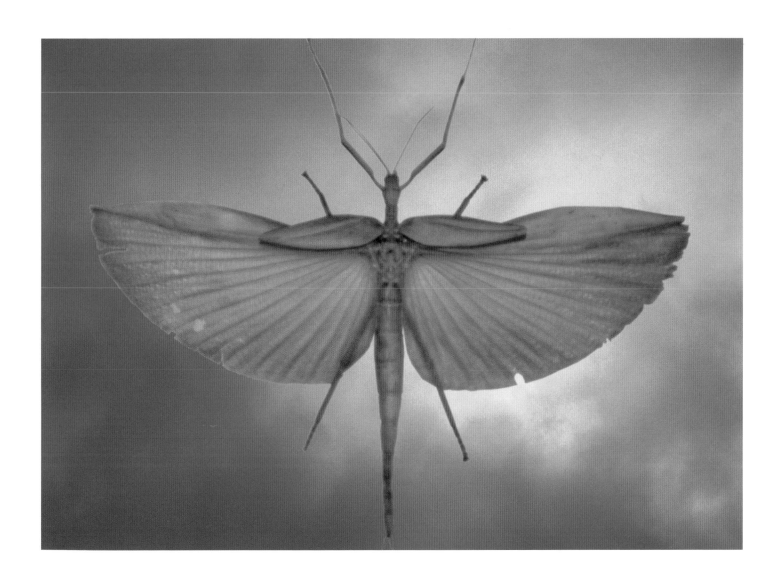

Untitled [*locust*] from the series *cloud* 2000/2005 chromogenic pigment print National Gallery of Australia, Canberra

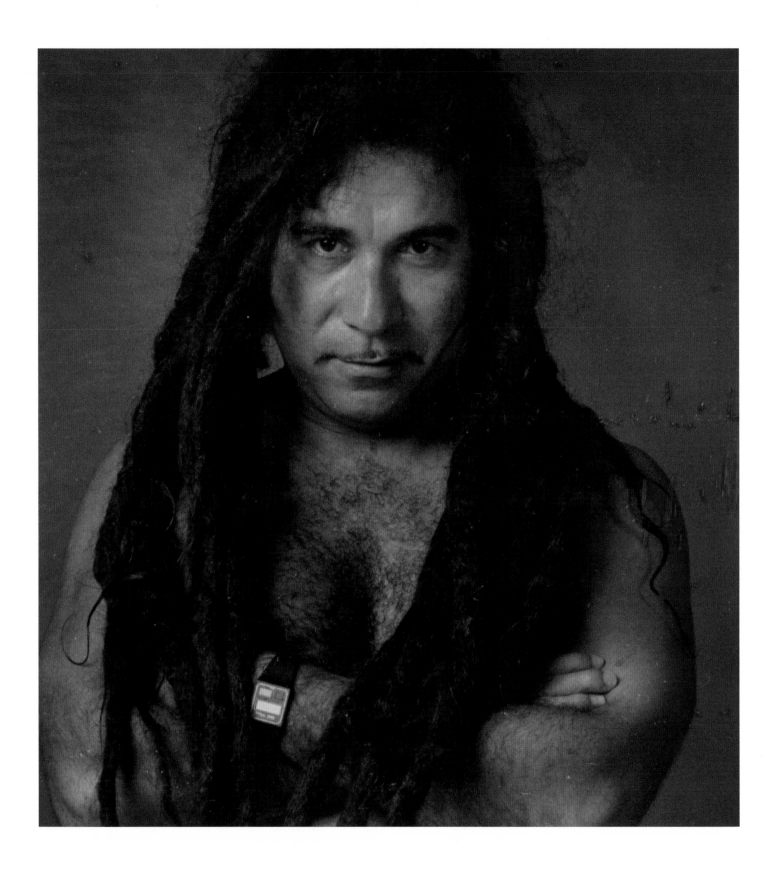

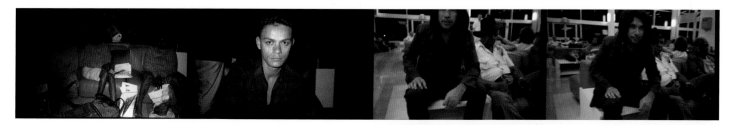

People leave but their spirit remains. Michael Riley was a worldly art practitioner and person. His quiet, seemingly aloof demeanour actually belied a deep-thinking person of extreme warmth, humour and generosity. His periods of silence, where he was physically present but also a strong, positive spiritual presence, were a very masculine thing.

The exceptionality of Riley's records is in the sensitive human articulation of an Aboriginal history and landscape: personally, physically, historically, and emotionally. A known and lived Aboriginal history very much rooted in the present.

> And the locusts sang, yeah, it give me a chill,
> Oh, the locusts sang such a sweet melody.
> Oh, the locusts sang their high whining trill,
> Yeah, the locusts sang and they were singing for me.[10]

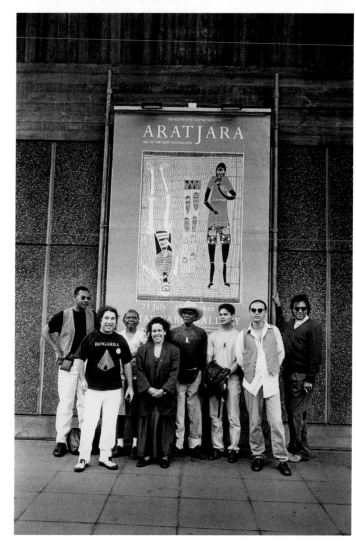

(top) Michael and Djon Mundine mid-1980s print from negative Michael Riley Foundation (above) *Aratjara* exhibition, Hayward Gallery, London left to right: Tom Mosby, Djon Mundine, unknown, Fiona Foley, Ginger Riley, Wayne Bergman, Michael, Ron Hurley, 1993 black-and-white photo Leon Morris
(opposite) *John (Djon)* from the series *Portraits by a window* 1990 gelatin silver photograph Anthony Bourke

Notes

1. *Wunggili/Wungguli* – 'visible projection of oneself: shadow, reflection, image, picture, [ext] replacement; photo(graph), movie, cinema; soul, spirit, ghost'. From Zorc, R. David, *Yolngu-Matha dictionary*, Batchelor, Northern Territory: School of Australian Linguistics, Darwin Institute of Technology, 1986, p. 269. An early version of this essay appeared in the exhibition leaflet *cloud: Michael Riley*, Sydney: Australian Centre for Photography, 2000.
2. Carmody, Kev, 'Thou shalt not steal' from the recording *Pillars of society*, Song Cycles Pty Ltd, 1989. Lyrics viewed 2 April 2006, <http://www.kevcarmody.com.au/recordings_songs.php?recID=2>.
3. McCarthy, Frederick K. D., Curator of Anthropology, Australian Museum, 'Introduction', *Australian Aboriginal art, bark paintings, carved objects, sacred and secular objects, an exhibition arranged by the State Art Galleries of Australia*, 1960–1961, exhibition catalogue, Sydney: Art Gallery of New South Wales, 1960, p. 7 and p. 15
4. Michael Riley in conversation with the author, Glebe, New South Wales, 2000.
5. Ibid.
6. Ibid.
7. Ibid.
8. Michael Riley, unpublished interview with David Burnett on his inclusion in the *Asia–Pacific triennial of contemporary art 2002*, Queensland Art Gallery.
9. Michael Riley in conversation with the author, Glebe, New South Wales, 2000.
10. Dylan, Bob, 'The day of the locusts', from the recording *New morning*, Big Sky Music, 1970. Lyrics viewed 2 April 2006, <http://www.bobdylan.com/songs/locusts.html>.

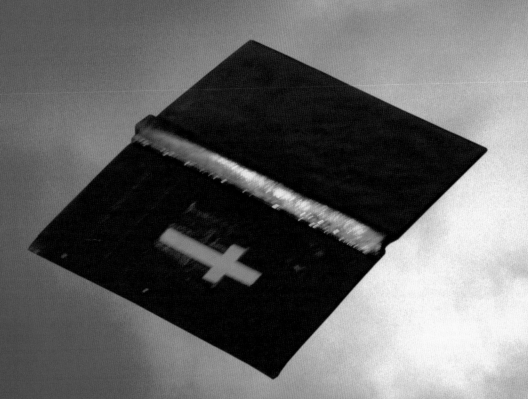

Lieutenant-General M. Harun-Ar-Rashid, High Commissioner for the People's Republic of Bangladesh, Michael Riley, Alasdair Foster, Sydney 2004
(opposite) *Untitled* [*bible*] from the series *cloud* 2000/2005 chromogenic pigment print National Gallery of Australia, Canberra

One of the joys of touring an exhibition overseas is seeing the familiar in a new light. So it was when I programmed Michael Riley's photo series *cloud* (2000) and the film *Empire* (1997) into a show called *Photographica Australis*. Commissioned by the Australia Council for the Arts, it was one of the showpiece exhibitions that complemented the Australian focus of the Spanish art fair ARCO held in Madrid in 2002. The gallery – a former water tower – consisted of a five-storey cylinder topped by a huge metal sphere and it was here that Michael's work was presented.

The response in Madrid was warm and engaged. Visitors sat for long periods under the huge metal dome, which arched overhead like the pre-Copernican heavens, contemplating the images suspended around the space and unfolding on the screens. That positive reception led to the exhibition's inclusion in FotoFestival Naarden 2003, in The Netherlands and later, through the agency of Asialink in Melbourne, a major tour of four Asian cities.

Presented at the National Gallery of Thailand, the Singapore Art Museum and Taipei Fine Arts Museum (2003–2004), the reworked exhibition was given extensive floor space, especially in Singapore and Taiwan where special galleries were created for the presentation of Michael's work.

The response was overwhelming with more than 140 000 visitors across the four Asian showings. Few if any of the visitors I spoke with knew of the history of the Indigenous peoples of Australia in the past 250 years, but most knew, or had personal experience of, other forms of colonisation. Even without the specific historical facts to decode the work, I found visitors were drawn to Michael's work. One woman I spoke with told me she could feel the intensity of the work although she could not interpret it until she read some of the historical information available. But that feeling, that sense of human connectedness, convinced her that the work was speaking to her personally and motivated a strong desire to understand the emotions it evoked.

The other showing in Asia, the third on the itinerary, was the *11th Asian art biennale*, Bangladesh. Taking cultural distinctiveness and globalisation as its theme, this extensive exhibition was spread over several palatial halls in Dhaka. It featured work by more than 300 artists from 44 countries in Asia, Africa and the Pacific region, with strong representation from the Middle East. Refreshingly, Australia was considered not as a colonial outpost of the old West but a novel multicultural experiment on the Pacific edge. The Australian works drew enthusiastic attention at the biennial and, again, Michael's work was found to be particularly beguiling.

After several visits and much deliberation by the international panel of judges (from Bangladesh, India, Iran and Turkey), they awarded *cloud* and *Empire* one of three gold medals (the other two going to a provocative installation about the plight of women in Iran by a female Iranian media artist and more traditional works by a Bangladeshi painter). Their choices signalled a concern that, while it was important to maintain diverse cultural distinctiveness, it was not enough simply to maintain the modes and forms of the past. Speaking on behalf of the judges, Gholam Hossein Nami (Iran) said, 'Continual imitation and repetition of traditional values will lead to the death of art'. In the work of Michael Riley they found, I believe, a near-perfect synthesis of cultural distinctiveness, awareness of tradition, lively visual language, urgent contemporary content and, perhaps most importantly, human emotional connectedness.

In Michael Riley's final body of work, *cloud* (2000), we see the image of a feather, lightly pending against a veiled 'true-blue', yet ethereal, Australian sky. Michael once described the feather and, in turn, himself as sort of a messenger, sending messages on to people and community and places, not bad messages but just simple messages, like here I am, this is me, this is a message to you.

This honest and just communication, absent of ego, was to dominate Michael's practice. With his maverick minimalist approach, his messages are clean, clear and sharp. In this way, Michael paradoxically exposed the complex layers, the realities and concerns of Aboriginal Australia.

Michael communicated with ease and confidence from behind the lens in both film and photography. The line that runs between his dual practices is a key to understanding the significance of his poetic messages. This was his *modus operandi*, the conduit between him and the world. From this objective position, Michael's critical eye distilled images and created film and photography that were often in conceptual parallel. This can be seen in his portraiture and documentary work of the 1980s and 1990s, which include his discerning studio black-and-white photographs of the chic, avantgarde Sydney Aboriginal community, Michael's milieu. Complementing these 'urban' works are his onsite studio and open cast-call photographic documentation of his mother's and father's rural communities of Moree and Dubbo, respectively. The films he made at this time, including *Boomalli: Five Koorie artists* (1988) and *Quest for country* (1993), corresponded with these works. What significantly underpins this period of work is Michael's family and social networks along with his unstated sense of belonging. These notions come forth to convey simple messages of the beauty, elegance and strength of the Aboriginal community.

There is a significant shift for Michael from the culturally-loaded portrait series, openly challenging the negative historical portrayal of Aboriginality, to what he described as his 'conceptual work'. This work originated with the award-winning ABC short film *Poison* (1991) and the photographic series, *Sacrifice* (1992). The principal message in both *Poison* and *Sacrifice* focused on notions of loss – the loss created by various addictions and substance abuse. In these transitional experimental works, Michael developed and explored new imagery, which became the mainstay of his visual language. In the duplicitous photographic constructions of *Sacrifice*, and later in the series *flyblown* (1998), its partner film *Empire* (1997) and finally *cloud*, he continually returns to the religious imagery of the crucifix and the Bible, coupled with

natural elements of the sky, water and earth.

In an attempt to resolve the irresolvable, Michael was a pragmatist, interrogating the iconic image. His method is based on distilling the arsenal of signs imposed on and by Aboriginal people, which originated from religious and social-political orders of the day.

Michael's images are generated by a poetic sequencing that contextualises an already existing re-contextualisation. In this way the re-imagining of the signs, both in still photography and film, provides an entry point to an undercurrent or allegorical platform. He supplies the viewer with subtle terms of agitprop that manage to recondition the political icon. In many respects, Michael's iconic overlays are signing in a similar manner to the sentinel ghost gums in the watercolour paintings of Albert Namatjira. Country is potent and central in these works, especially in *cloud* where it is politically present in its absence from the frame.

In all these dramatic photographic images, the erosion of the environment by modern Eurocentric systems is cast against the other impositions of language, religion and state. Belying these often barren and decaying landscapes is an unequivocal sense of beauty and subliminal resistance, which simultaneously discuss issues of placement and displacement of Aboriginal Australia.

Michael's formalised, yet sensitive messages float within measured and concise bodies of work, elevating an audience with gentle and open suggestions that will continue to inspire and enlighten.

Meridian off-site exhibition, *cloud* banners at Circular Quay, Sydney 2002
print from negative
(opposite) *Untitled* [*boomerang*] from the series *cloud* 2000/2005 chromogenic pigment print National Gallery of Australia, Canberra

Untitled [*feather*] from the series *cloud* image on poster, Istanbul, Turkey 2003 colour photo Anthony Bourke (opposite) *Untitled* [*crow, left wing, closed*] from the series *cloud* 2000/2005 chromogenic pigment print National Gallery of Australia, Canberra

■ Francisco Fisher

Imagine Michael's arm, similar to that of his *Untitled [wing]* from the series *cloud* (2000), and see how it bends to the window. In his hand is a small film transparency that with the soft afternoon light marks its colours to his face.

It made for a long and breathless hunt, the unearthing of wings, locusts, angels, Bibles and feathers that would eventually become the exhibition *cloud* (Australian Centre for Photography, Sydney, 2000). A lifetime of stored transparencies and proofs seeking out the sun, all made possible by wheeling his bed around the room to catch the last of it.

The persistent search for just the right cloud formations operated within silences on the painful days, punctuated by barely-there sighs when things were going right. The job of pairing objects to sky was a process of murmurs and smiles amidst the shuffle of nurses arranging tubes and flowers.

It was Michael's need to rationalise and find peace with his personal history that drove the making of the *cloud* exhibition. Without knowing where the money, equipment, time or technicians would come from, Michael's humour, resourcefulness and courage kept the creative process alive.

Filled with images that reference his spiritual and corporeal concerns, *cloud* to me epitomises Michael's artistic voice. A voice where public and private merge within the sacred in an active quest to understand meaning. It is a quiet and contemplative body of work that reverberates with sadness and anger. While there are moments of humour and great elation, the images illustrate the world Michael inhabited and the work he still had left to finish.

The ability to find strength when Michael shouldn't have is what informs *cloud*. It is a resilient, brave and gentle gaze full of longing, loss and mischief. A gaze that subverts social hypocrisy to create images that question, seduce and, above all, try to make sense of a life lived with love, loss and inequality.

I wanted to tell stories

Michael Riley[1]

I first started to do photography at Sydney College of the Arts. I was actually doing a traineeship there as a technician in the darkrooms. I'd also taken a class in image-making. I worked in photography for a few years as a freelance photographer, independent freelance photographer, and then I decided to do a traineeship at ABC, a two-year traineeship in producing and directing documentaries. I was thinking what I might've wanted to do was to be a cinematographer or something like that, but I found that I wanted to tell stories and get stories from Aboriginal people.

My mother comes from a place called Moree in New South Wales, northern New South Wales. She's from the Kamilaroi group of people. My father's Wiradjuri from the Dubbo area. I grew up in Dubbo and also taking trips back and forwards to Moree. I sort of like had contact with my mother's people and that country as well. The land around there is like quite barren and flat and almost sort of semi-arid desert, you could say.

What I was trying to do was show in those images how farmers or graziers or whatever, people have changed the surface of the land, country, but to try and give an idea that Aboriginal spirits – *ramadi* – is still there within that land, even though the surface has changed. You know, there's still a sense of beauty and a spiritual feeling there. The images from *Empire*, they're all shot in and around the Moree area and Narrabri, near Narrabri, Mount Kaputar. There's a sadness within the film itself and that sadness is that sense of loss of country, of culture, of peoples. One of the images is a sign called Slaughterhouse Creek and it's not far from Myall Creek, where the Myall Creek massacres happened. It's just one simple sign that sort of conveys one of the incidents that happened around that area, you know, that great loss and sadness.

The *Sacrifice* series, really what I was exploring there was how Aboriginal people were put on to reserves and missions like in the 1940s and earlier and regimented and told not to speak language, not to act as culture and you would have different tribal groups thrown in together. Some of the images in *Sacrifice*, like with the spoons, that's symbolic of addiction, like heroin addiction. The row of sardine, the fish, it's like how on reserves people were lined up and regimented and everyone have their place and everything. The image of flour, sugar and tea, that was like the staple you'd get every week on the reserve, the mission, and that's sort of all you got. Yes. I suppose, yes, just reflecting on that period of time when people did sort of start to lose culture, lose language, lose things, you know, because of the assimilation process and people trying, the government trying to put people on reserves to be good Christian Aboriginal people.

Empire, the way that I wanted to make the film was I wanted the film to almost hypnotise people, you know, and … they didn't really have to think about these things until afterwards maybe, you know. They look at the images and then they can think about what those images meant.

In the *cloud* series there are clouds in every shot. I just find a very sort of serene beauty in clouds, in the movements of clouds, how they change, and people take them for granted, you know. I mean, they're just there, you know. But once you isolate them and look at them there's this incredible changing sort of beauty in them.

Like with the *Sacrifice* series and the film and *cloud* I don't try to put down the Christian religion or the Catholic religion at all. I just try to reflect on it, you know. Yes. What I don't like about religion, I suppose, those types of religion, is the hypocrisy. Not so much the religion itself, the way people use it in hypocritical ways. You know, there's a piece at the end of the film and it's a sermon from a Lutheran missionary from Hermannsburg. It's from an ABC radio program in the 1940s and what it does is it just conjures up the attitude of the people, like government of the day and the missionaries of the day and the fact that Aboriginal people were quite patronised, almost treated as children, to be assimilated.

Note

[1] Michael Riley, unpublished interview with David Burnett on his inclusion in the *Asia–Pacific triennial of contemporary art 2002*, Queensland Art Gallery. Courtesy of the Queensland Art Gallery

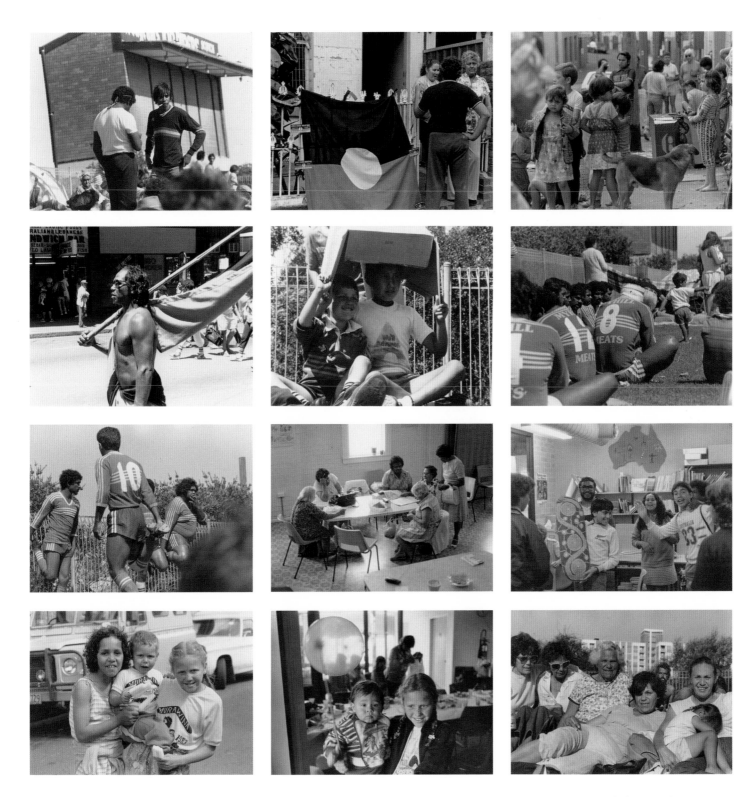

(clockwise from top left) *The knockout – supporters South Coast mob* late 1970s; *Barbara Silva, Sylvia Scott, Murawina Child Care Centre opening, Eveleigh Street* early 1980s; *Eveleigh Street, group of children outside Murawina* 1984; *Redfern Oval – stretching NGAKU team member, Kempsey* late 1970s; *David Prosser [school], Craig Madden, Jason Trindall [bearded man with group of laughing children]* early 1980s; *Wright family at New South Wales Aboriginal Football knockout* 1983; *Shiralee Ingram* early 1980s; *Murawina Children's Service, Redfern – Barbara Silva, Roslyn Silva on right and Karla Carr* early 1980s; *Redfern Oval nerves* late 1970s; *Dawson Drew* early 1980s; *Redfern Oval (New South Wales Aboriginal Football knockout) – kids getting shade* late 1970s; *Aboriginal Medical Service sewing class* early 1980s gelatin silver photographs Museum of Sydney

After image

Ben Riley

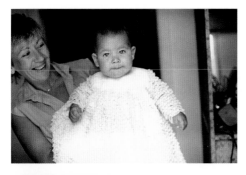

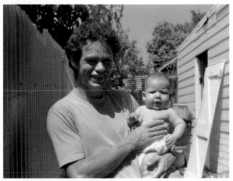

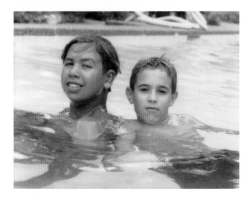

Yvonne (Ben's mum) and Ben 1985 print from negative Michael Riley Foundation; Michael with Ben 1985 print from negative Michael Riley Foundation; Ben Riley with Jemiah Ingram, Sydney mid-1990s print from negative Michael Riley Foundation
(opposite) *Untitled [feather]* from the series *cloud* 2000/2005 chromogenic pigment print National Gallery of Australia, Canberra

I was and still am very proud of my father, Michael Alen Riley, and his achievements in life. I feel all the experiences and challenges he went through, good and bad, helped him become the artist he is today. I am amazed by my dad's photographs – he had the ability to take photos of anything and make them so interesting and beautiful. He also could tell his life stories and experiences in symbolic ways.

I loved going to Boomalli Aboriginal Artists Co-operative with my dad as I was able to see his artwork in progress. Sometimes my father would let me take photos with his camera on art shoots; he would even put my name at the bottom if it was published as he was such an honest and fair man. He was the best father a son could ever have: he was loving, caring and supportive 100 per cent every day. My dad would always make me feel good about myself, which is one of the reasons I loved spending time with him. Our favourite thing to do was to watch movies together, either at home or at the cinemas, particularly the 007 James Bond and Batman movies.

Nothing was too much effort for my dad where I was concerned. He made my childhood special, taking me on camps, fishing trips, and other father-and-son adventures. Of all my dad's artworks, the *cloud* series (2000) is my favourite, and not just because blue is my favourite colour. I just found that it was full of symbolism. I thought it was quite different seeing a cow floating in the sky. My favourite photo is the one with a bird's wing spread across the sky with the clouds in the background.

I only realised how talented and well-known my father was when images from the *cloud* series were hung on banners at Circular Quay as part of the Festival of Sydney in 2003. I remember one time, waiting at a bus stop, looking at a poster hanging in the shelter, admiring its beauty and originality. It was a poster from the Art Gallery of New South Wales. Then I discovered who the artist was. It was my father, Michael Riley. It was from one of his first artworks, a series of portraits of five Aboriginal women, one of whom was my cousin, Maria.

I thought my dad's film, *Empire* (1997), was amazing and quite interesting. This film helped me realise that I am Indigenous, and that I should respect my heritage. Seeing my father do so much with his life in art has inspired me. I have decided to follow in my father's footsteps but to do so using a different medium, painting.

My first artwork was of an elder. My dad saw it partly finished and when he passed away I continued and completed it so I was able to place it with him at his burial. After he died I decided to continue with my painting but decided to do a more cultural painting using dots.

In memory of my father, Michael Alen Riley, I have decided as his only son to continue our name in the art world for years to come. I am very proud of my dad and always will be. I am proud of him and the heritage he gave me and sincerely hope my father's artworks will continue to hang in galleries all around the world to be admired by thousands, even millions, and maybe one day have our artworks hung side by side.

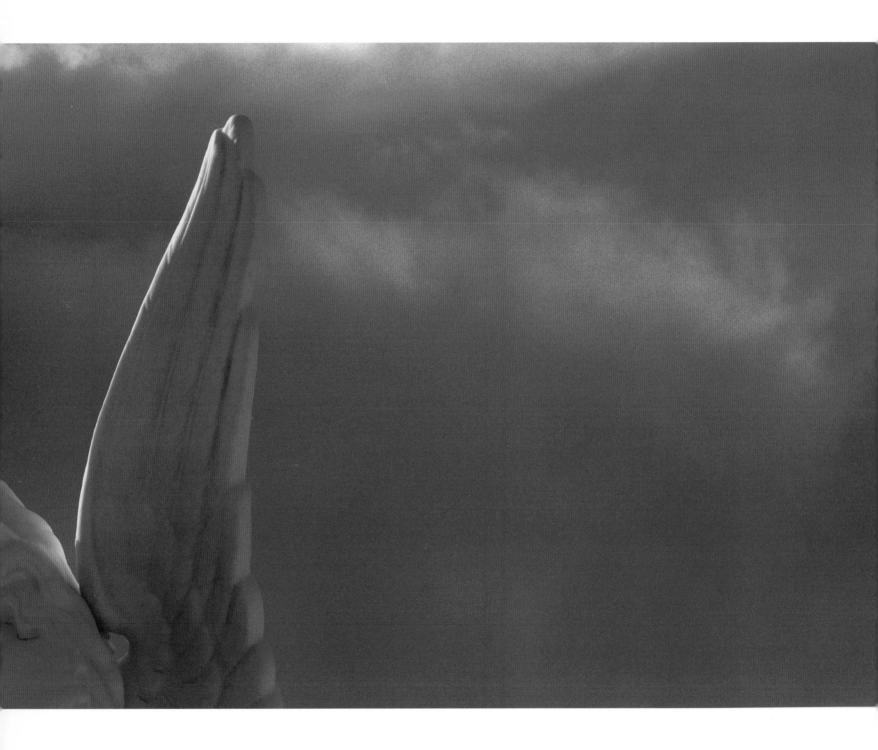

Untitled [*angel wing detail*] from the series *cloud* 2000/2005 chromogenic pigment print National Gallery of Australia, Canberra

Exhibition checklist

After 200 years

Bruce Baxter teaching culture at Robinvale Secondary College
1988
gelatin silver photograph
print 19.8 x 29.6 cm;
sheet 24.8 x 34.6 cm
Courtesy of Australian Institute of Aboriginal and Torres Strait Islander Studies, Canberra

Darcy Pettit hunting kangaroo with Seymour Western and Joe Hansford
1988
gelatin silver photograph
print 19.8 x 29.6 cm;
sheet 24.8 x 34.6 cm
Courtesy of Australian Institute of Aboriginal and Torres Strait Islander Studies, Canberra

Former dwelling on the original campsite near the bridge, Robinvale
1988
gelatin silver photograph
print 19.8 x 29.6 cm;
sheet 24.8 x 34.6 cm
Courtesy of Australian Institute of Aboriginal and Torres Strait Islander Studies, Canberra

Jean Sampson and Alex Baxter outside their home in Robinvale
1988
gelatin silver photograph
print 19.8 x 29.6 cm;
sheet 24.8 x 34.6 cm
Courtesy of Australian Institute of Aboriginal and Torres Strait Islander Studies, Canberra

Margaret Hannah at the Robinvale Childcare Centre with Michelle
1988
gelatin silver photograph
print 19.8 x 29.6 cm;
sheet 24.8 x 34.6 cm
Courtesy of Australian Institute of Aboriginal and Torres Strait Islander Studies, Canberra

Mark Morgan and Edward Urquhart on the bank of the Murray River, Robinvale
1986
gelatin silver photograph
print 20.1 x 29.7 cm;
sheet 25.0 x 34.6 cm
National Gallery of Australia, Canberra 90.1201

Michael and Yvonne Hill at home on their block outside Robinvale
1986
silver gelatin photograph
print 19.8 x 29.6 cm;
sheet 24.8 x 34.6 cm
Courtesy of Australian Institute of Aboriginal and Torres Strait Islander Studies, Canberra

Milton Coochee, seasonal workers, picking grapes on Michael Hill's
1988
gelatin silver photograph
print 19.8 x 29.6 cm;
sheet 24.8 x 34.6 cm
Courtesy of Australian Institute of Aboriginal and Torres Strait Islander Studies, Canberra

Mrs Myrtle Clayton outside her home at Euston across the river from Robinvale
1986
gelatin silver photograph
print 20.0 x 29.7 cm;
sheet 24.9 x 34.6 cm
National Gallery of Australia, Canberra 90.1202

Raymond 'Chocko' Fisher, seasonal workers, picking grapes on Michael Hill's
1988
gelatin silver photograph
print 19.8 x 29.6 cm;
sheet 24.8 x 34.6 cm
Courtesy of Australian Institute of Aboriginal and Torres Strait Islander Studies, Canberra

Staff outside the Murray Valley Aboriginal Co-operative, Robinvale
1988
gelatin silver photograph
print 19.8 x 29.6 cm;
sheet 24.8 x 34.6 cm
Courtesy of Australian Institute of Aboriginal and Torres Strait Islander Studies, Canberra

The Robinvale boomerang factory with Charlie, Kevin and Walter Pearce
1988
gelatin silver photograph
print 19.9 x 29.7 cm;
sheet 24.9 x 34.7 cm
Courtesy of Australian Institute of Aboriginal and Torres Strait Islander Studies, Canberra

A common place: Portraits of Moree Murries

Aunty Ruthie
1991
gelatin silver photograph
55.8 x 39.8 cm
Courtesy of Moree Plains Gallery

Glenn and son
1991
gelatin silver photograph
55.8 x 39.8 cm
Courtesy of Moree Plains Gallery

Jag
1991
gelatin silver photograph
55.8 x 39.8 cm
Courtesy of Moree Plains Gallery

Jessie and grandkids
1991
gelatin silver photograph
55.8 x 39.8 cm
Courtesy of Moree Plains Gallery

Jim
1991
gelatin silver photograph
55.8 x 39.8 cm
Courtesy of Moree Plains Gallery

Kenny Copeland
1991
gelatin silver photograph
55.8 x 39.8 cm
Courtesy of Moree Plains Gallery

Mary Stanley with son and daughter-in-law
1991
gelatin silver photograph
55.8 x 39.8 cm
Courtesy of Moree Plains Gallery

Michael and Jacko French
1991
gelatin silver photograph
39.0 x 55.0 cm
Courtesy of Moree Plains Gallery

Moree kids
1991
gelatin silver photograph
55.8 x 39.8 cm
Courtesy of Moree Plains Gallery

Moree women
1991
gelatin silver photograph
39.0 x 55.0 cm
Courtesy of Moree Plains Gallery

Mr and Mrs Lyall Munro
1991
gelatin silver photograph
print 55.9 x 39.0 cm;
sheet 60.8 x 50.4 cm
National Gallery of Australia, Canberra 91.816

Mum Maude
1991
gelatin silver photograph
55.0 x 39.0 cm
Courtesy of Moree Plains Gallery

Nanny Wright and dog
1991
gelatin silver photograph
55.0 x 39.0 cm
Courtesy of Moree Plains Gallery

Phyllis Draper
1991
gelatin silver photograph
55.0 x 39.0 cm
Courtesy of Moree Plains Gallery

The Drifter and the Crow (Trevor Cutmore and Herb Binge)
1991
gelatin silver photograph
55.0 x 39.0 cm
Courtesy of Moree Plains Gallery

cloud

Untitled [angel back, full wings]
2000
chromogenic pigment print, printed 2005
110.0 x 155.0 cm
National Gallery of Australia, Canberra 2005.294.6

Untitled [angel wing]
2000
chromogenic pigment print, printed 2005
110.0 x 155.0 cm
National Gallery of Australia, Canberra 2005.294.2

Untitled [bible]
2000
chromogenic pigment print, printed 2005
110.0 x 155.0 cm
National Gallery of Australia, Canberra 2005.294.1

Untitled [boomerang]
2000
chromogenic pigment print, printed 2005
110.0 x 155.0 cm
National Gallery of Australia, Canberra 2005.294.8

Untitled [cow]
2000
chromogenic pigment print, printed 2005
110.0 x 155.0 cm
National Gallery of Australia, Canberra 2005.294.7

Untitled [crow, left wing, closed]
2000
chromogenic pigment print, printed 2005
110.0 x 155.0 cm
National Gallery of Australia, Canberra 2005.294.3

Untitled [crow, left wing, split open]
2000
chromogenic pigment print, printed 2005
110.0 x 155.0 cm
National Gallery of Australia, Canberra 2005.294.9

Untitled [crow, right wing, closed]
2000
chromogenic pigment print, printed 2005
110.0 x 155.0 cm
National Gallery of Australia, Canberra 2005.294.4

Untitled [feather]
2000
chromogenic pigment print, printed 2005
110.0 x 155.0 cm
National Gallery of Australia, Canberra 2005.294.5

Untitled [locust]
2000
chromogenic pigment print, printed 2005
110.0 x 155.0 cm
National Gallery of Australia, Canberra 2005.294.10

Fence sitting

Untitled [brown grass]
1994
gelatin silver photograph
print 15.6 x 23.6 cm;
sheet 20.2 x 25.4 cm
Courtesy of Ms Rachel Perkins

Untitled [clouds]
1994
gelatin silver photograph
print 15.8 x 23.6 cm;
sheet 20.2 x 25.4 cm
Courtesy of Ms Rachel Perkins

Untitled [grasslands]
1994
gelatin silver photograph
print 15.6 x 23.6 cm;
sheet 20.2 x 25.4 cm
Courtesy of Ms Melissa Roncolato

Untitled [ocean]
1994
gelatin silver photograph
print 17.0 x 25.4 cm;
sheet 20.6 x 25.4 cm
Courtesy of Ms Rachel Perkins

Untitled [storm and grasslands]
1994
gelatin silver photograph
print 15.6 x 23.6 cm;
sheet 20.2 x 25.4 cm
Courtesy of Ms Rachel Perkins

flyblown

Untitled [bible]
1998
chromogenic pigment print
113.0 x 87.0 cm
National Gallery of Australia, Canberra 2004.318.5

Untitled [blue cross]
1998
chromogenic pigment print
113.0 x 87.0 cm
National Gallery of Australia, Canberra 2004.318.3

Untitled [blue sky with cloud]
1998
chromogenic pigment print
113.0 x 87.0 cm
National Gallery of Australia, Canberra 2004.318.9

Untitled [galah]
1998
chromogenic pigment print
113.0 x 87.0 cm
National Gallery of Australia, Canberra 2004.318.4

Untitled [gold cross]
1998
chromogenic pigment print
113.0 x 87.0 cm
National Gallery of Australia, Canberra 2004.318.2

Untitled [grey sky]
1998
chromogenic pigment print
113.0 x 87.0 cm
National Gallery of Australia, Canberra 2004.318.8

Untitled [long grass]
1998
chromogenic pigment print
113.0 x 87.0 cm
National Gallery of Australia, Canberra 2004.318.7

Untitled [red cross]
1998
chromogenic pigment print
113.0 x 87.0 cm
National Gallery of Australia, Canberra 2004.318.1

Untitled [water]
1998
chromogenic pigment print
113.0 x 87.0 cm
National Gallery of Australia, Canberra 2004.318.6

Portraits by a window

Alice and Tracey
1990
gelatin silver photograph
print 46.6 x 34.6 cm;
sheet 57.4 x 44.6 cm
National Gallery of Australia, Canberra 90.1381
Purchased with the assistance of the KODAK (Australasia) Pty Ltd Fund 1990

Avril and Miya
1990
gelatin silver photograph
print 44.0 x 37.4 cm;
sheet 55.0 x 47.7 cm
National Gallery of Australia, Canberra 90.1380
Purchased with the assistance of the KODAK (Australasia) Pty Ltd Fund 1990

Binni [Kirkbright-Burney]
1990
gelatin silver photograph
print 46.4 x 36.6 cm;
sheet 60.7 x 50.6 cm
Courtesy of Ms Linda Burney, MP

Charles and Adam
1990
gelatin silver photograph
print 48.4 x 37.4 cm;
sheet 60.8 x 50.6 cm
Courtesy of Ms Hetti Perkins

Darrell
c.1989
gelatin silver photograph
print 38.4 x 37.8 cm;
sheet 63.0 x 50.4 cm
National Gallery of Australia, Canberra 2004.317

Dennis [Dillon]
1990
gelatin silver photograph
print 45.4 x 36.0 cm;
sheet 60.8 x 46.4 cm
Courtesy of Mr Dillon Kombumerri

Delores
1990
gelatin silver photograph
print 47.0 x 32.8 cm;
sheet 60.4 x 48.6 cm
Courtesy of Mr Pat Corrigan

Dorothy
1990
gelatin silver photograph
print 50.8 x 38.0 cm;
sheet 60.4 x 50.6 cm
Courtesy of Mr Pat Corrigan

Hetti
1990
gelatin silver photograph
print 37.4 x 35.6 cm;
sheet 60.8 x 46.4 cm
Courtesy of Mr Pat Corrigan

Joe and Brenda
1990
gelatin silver photograph
print 45.8 x 36.0 cm;
sheet 60.6 x 50.2 cm
Courtesy of Ms Brenda L. Croft

John [Djon]
1990
gelatin silver photograph
print 22.6 x 21.1 cm;
sheet 30.2 x 24.0 cm
Courtesy of Mr Anthony Bourke

Kristina
1986
gelatin silver photograph
print 28.8 x 55.82 cm;
sheet 50.4 x 60.8 cm
Courtesy of Mr Pat Corrigan

Kristina
1986
gelatin silver photograph
print 29.8 x 59.2 cm;
sheet 50.4 x 60.8 cm
National Gallery of Australia,
Canberra 2005.35

Maria
1986
gelatin silver photograph
48.0 x 45.5 cm
Courtesy of Australian Institute of
Aboriginal and Torres Strait Islander
Studies, Canberra

Telphia
1990
gelatin silver photograph
print 50.8 x 34.7 cm;
sheet 60.7 x 49.3 cm
Courtesy of Mr Pat Corrigan

Tracey [hands up]
1986
gelatin silver photograph
27.0 x 55.6 cm
Courtesy of Black Fella's Dreaming
Museum

Sacrifice
Untitled [blurred six spoons]
1992
gelatin silver photograph
15.8 x 22.8 cm
National Gallery of Australia,
Canberra 93.1441.6
Purchased with the assistance of
the KODAK (Australasia) Pty Ltd
Fund 1993

Untitled [cemetery statue]
1992
gelatin silver photograph
22.2 x 15.0 cm
National Gallery of Australia,
Canberra 93.1441.11
Purchased with the assistance of
the KODAK (Australasia) Pty Ltd
Fund 1993

Untitled [cloud sky]
1992
gelatin silver photograph
15.8 x 22.8 cm

National Gallery of Australia,
Canberra 93.1441.3
Purchased with the assistance of
the KODAK (Australasia) Pty Ltd
Fund 1993

Untitled [cross on chest]
1992
gelatin silver photograph
22.6 x 15.6 cm
National Gallery of Australia,
Canberra 93.1441.10
Purchased with the assistance of
the KODAK (Australasia) Pty Ltd
Fund 1993

Untitled [crucifix]
1992
gelatin silver photograph
22.0 x 15.0 cm
National Gallery of Australia,
Canberra 93.1441.12
Purchased with the assistance of
the KODAK (Australasia) Pty Ltd
Fund 1993

Untitled [group of fish on paper]
1992
gelatin silver photograph
15.6 x 22.8 cm
National Gallery of Australia,
Canberra 93.1441.7
Purchased with the assistance of
the KODAK (Australasia) Pty Ltd
Fund 1993

Untitled [lillies]
1992
gelatin silver photograph
23.2 x 15.8 cm
National Gallery of Australia,
Canberra 93.1441.13
Purchased with the assistance of
the KODAK (Australasia) Pty Ltd
Fund 1993

Untitled [palms with stigmata]
1992
gelatin silver photograph
22.0 x 15.2 cm
National Gallery of Australia,
Canberra 93.1441.15
Purchased with the assistance of
the KODAK (Australasia) Pty Ltd
Fund 1993

Untitled [poppies]
1992
gelatin silver photograph
15.0 x 22.4 cm
National Gallery of Australia,
Canberra 93.1441.8
Purchased with the assistance of
the KODAK (Australasia) Pty Ltd
Fund 1993

Untitled [R.I.P.]
1992
gelatin silver photograph
15.0 x 22.2 cm
National Gallery of Australia,
Canberra 93.1441.1
Purchased with the assistance of
the KODAK (Australasia) Pty Ltd
Fund 1993

Untitled [single fish, cracked earth]
1992
gelatin silver photograph
15.8 x 22.8 cm
National Gallery of Australia,
Canberra 93.1441.4
Purchased with the assistance of
the KODAK (Australasia) Pty Ltd
Fund 1993

Untitled [single fish on grass]
1992
gelatin silver photograph
15.8 x 22.8 cm
National Gallery of Australia,
Canberra 93.1441.14
Purchased with the assistance of
the KODAK (Australasia) Pty Ltd
Fund 1993

Untitled [stone cross/crucifix]
1992
gelatin silver photograph
22.8 x 15.4 cm
National Gallery of Australia,
Canberra 93.1441.2
Purchased with the assistance of
the KODAK (Australasia) Pty Ltd
Fund 1993

Untitled [sugar, flour, tea]
1992
gelatin silver photograph
15.8 x 22.8 cm
National Gallery of Australia,
Canberra 93.1441.9
Purchased with the assistance of
the KODAK (Australasia) Pty Ltd
Fund 1993

Untitled [water, blurred]
1992
gelatin silver photograph
15.0 x 22.7 cm
National Gallery of Australia,
Canberra 93.1441.5
Purchased with the assistance of
the KODAK (Australasia) Pty Ltd
Fund 1993

They call me niigarr
Bomba
1995
collaged direct positive colour
photograph
89.0 x 111.9 cm
Courtesy of Boomalli Aboriginal
Artists Co-operative Ltd

Chocolate
1995
collaged direct positive colour
photograph
88.4 x 111.0 cm
Courtesy of Boomalli Aboriginal
Artists Co-operative Ltd

Dusty
1995
collaged direct positive colour
photograph
88.8 x 111.2 cm
Courtesy of Boomalli Aboriginal
Artists Co-operative Ltd

Golliwog
1995
collaged direct positive colour
photograph
88.8 x 111.7 cm
Courtesy of Boomalli Aboriginal
Artists Co-operative Ltd

Licorice
1995
collaged direct positive colour
photograph
87.8 x 110.7 cm
Courtesy of Boomalli Aboriginal
Artists Co-operative Ltd

Marbuck
1995
collaged direct positive colour
photograph
88.2 x 110.6 cm
Courtesy of Boomalli Aboriginal
Artists Co-operative Ltd

Nigger
1995
collaged direct positive colour
photograph
88.0 x 110.8 cm
Courtesy of Boomalli Aboriginal
Artists Co-operative Ltd

Niigarr
1995
collaged direct positive colour
photograph
87.8 x 110.4 cm
Courtesy of Boomalli Aboriginal
Artists Co-operative Ltd

Sambo
1995
collaged direct positive colour
photograph
88.8 x 111.2 cm
Courtesy of Boomalli Aboriginal
Artists Co-operative Ltd

Vegemite
1995
collaged direct positive colour
photograph
87.8 x 111.2 cm
Courtesy of Boomalli Aboriginal
Artists Co-operative Ltd

Yarns from the Talbragar Reserve
Gift of the Artist – Guardian Dubbo
Reginal Gallery
Alma Riley
1998
gelatin silver photograph
51.0 x 61.0 cm
Courtesy of Dubbo Regional Art
Gallery

Coral Peckham
1998
gelatin silver photograph
51.0 x 61.0 cm
Courtesy of Dubbo Regional Art
Gallery

David Riley
1998
gelatin silver photograph
51.0 x 61.0 cm
Courtesy of Dubbo Regional Art
Gallery

Dotty Burns
1998
gelatin silver photograph
51.0 x 61.0 cm
Courtesy of Dubbo Regional Art
Gallery

Florence Nolan (Florrie Carr)
1998
gelatin silver photograph
51.0 x 61.0 cm
Courtesy of Dubbo Regional Art
Gallery

Keith Murphy
1998
gelatin silver photograph
51.0 x 61.0 cm
Courtesy of Dubbo Regional Art
Gallery

Maggie Smith-Robinson
1998
gelatin silver photograph
51.0 x 61.0 cm
Courtesy of Dubbo Regional Art
Gallery

Malcolm Burns
1998
gelatin silver photograph
51.0 x 61.0 cm
Courtesy of Dubbo Regional Art
Gallery

Margaret Riley
1998
gelatin silver photograph
51.0 x 61.0 cm
Courtesy of Dubbo Regional Art
Gallery

Mary Toomey (Cookie Carr)
1998
gelatin silver photograph
51.0 x 61.0 cm
Courtesy of Dubbo Regional Art
Gallery

Merle and Frank Pearce
1998
gelatin silver photograph
51.0 x 61.0 cm
Courtesy of Dubbo Regional Art
Gallery

Pat Doolan
1998
gelatin silver photograph
51.0 x 61.0 cm
Courtesy of Dubbo Regional Art
Gallery

Ronald Riley
1998
gelatin silver photograph
51.0 x 61.0 cm
Courtesy of Dubbo Regional Art
Gallery

Ruby McGuinness
1998
gelatin silver photograph
51.0 x 61.0 cm
Courtesy of Dubbo Regional Art
Gallery

Tucker Taylor
1998
gelatin silver photograph
51.0 x 61.0 cm
Courtesy of Dubbo Regional Art
Gallery

Violet Fuller
1998
gelatin silver photograph
51.0 x 61.0 cm
Courtesy of Dubbo Regional Art
Gallery

Will Burns
1998
gelatin silver photograph
51.0 x 61.0 cm
Courtesy of Dubbo Regional Art
Gallery

Willy Hill
1998
gelatin silver photograph
51.0 x 61.0 cm
Courtesy of Dubbo Regional Art
Gallery

1988 March [Bicentennial protest march]
1988
gelatin silver photograph
print 19.6 x 24.3 cm;
sheet 20.0 x 24.8 cm
Courtesy of Museum of Sydney

A scene from Eveleigh Street, Redfern
1984
gelatin silver photograph
print 18.8 x 24.2 cm;
sheet 20.4 x 25.4 cm
Courtesy of Museum of Sydney

Aboriginal Medical Service sewing class
early 1980s
gelatin silver photograph
12.9 x 17.9 cm
Courtesy of Museum of Sydney

Adam
1990
gelatin silver photograph
print 57.8 x 43.8 cm;
sheet 60.8 x 50.4 cm
Courtesy of Ms Hetti Perkins

AIDT dancers
early 1980s
type-c colour photograph
12.5 x 18.0 cm
Courtesy of Museum of Sydney

Anti-Bicentennial march, Redfern Park, Sydney, January 1988
1988
gelatin silver photograph
print 18.4 x 24.2 cm;
sheet 19.9 x 25.4 cm
Courtesy of Museum of Sydney

Avril
1986
gelatin silver photograph
print 18.8 x 24.6 cm;
sheet 20.2 x 25.4 cm
Courtesy of Ms Avril Quaill

Barbara Silva, Sylvia Scott, Murawina Child Care Centre opening, Eveleigh Street
early 1980s
gelatin silver photograph
print 19.0 x 24.2 cm;
sheet 20.1 x 25.4 cm
Courtesy of Museum of Sydney

Binni and Willurai [Kirkbright-Burney]
1990
gelatin silver photograph
print 13.1 x 18.6 cm;
sheet 14.8 x 19.6 cm
Courtesy of Ms Linda Burney, MP

Clevo Koories at anti-James Hardie asbestos rally, Sydney, 1984
1984
type-c colour photograph
29.6 x 41.8 cm
Courtesy of Museum of Sydney

Dallas Clayton and Binni [Kirkbright-Burney], land rights rally, 1982
1982
type-c colour photograph
20.3 x 25.2 cm
Courtesy of Museum of Sydney

David Prosser [school], Craig Madden, Jason Trindall [bearded man with group of laughing children]
early 1980s
gelatin silver photograph
12.9 x 17.9 cm
Courtesy of Museum of Sydney

Dawson Drew
early 1980s
gelatin silver photograph
print 19.9 x 25.4 cm;
sheet 20.0 x 25.4 cm
Courtesy of Museum of Sydney

Eileen, Charlie, Adam and Hetti
1990
gelatin silver photograph
print 13.8 x 21.1 cm;
sheet 21.0 x 25.1 cm
Courtesy of Ms Hetti Perkins

Eveleigh Street, group of children outside Murawina
1984
gelatin silver photograph
print 18.4 x 24.1 cm;
sheet 19.7 x 25.4 cm
Courtesy of Museum of Sydney

Gary
1989
gelatin silver photograph
print 23.2 x 20.4 cm;
sheet 30.4 x 24.0 cm
Courtesy of Mr Anthony Bourke

Gary Foley speaking at anti-James Hardie asbestos rally, Sydney 1984
1984
type-c colour photograph
20.2 x 25.2 cm
Courtesy of Museum of Sydney

Graham Simpson, Todd Carroll
early 1980s
type-c colour photograph
29.7 x 21.0 cm
Courtesy of Museum of Sydney

'I'm proud to be an Aborigine'
early 1980s
type-c colour photograph
20.2 x 25.3 cm
Courtesy of Museum of Sydney

James Hardie asbestos mining protest march (1984)
1984
type-c colour photograph
print 19.9 x 25.5 cm;
sheet 20.9 x 26.3 cm
Courtesy of Museum of Sydney

James Williams' daughter, Ngiarain
1984, Sydney, New South Wales
type-c colour photograph
25.3 x 20.2 cm
Courtesy of Museum of Sydney

Jenny Munro
early 1980s
type-c colour photograph
20.3 x 30.4 cm
Courtesy of Museum of Sydney

Jenny Munro speaking at anti-James Hardie asbestos rally, Sydney, 1984
1984
type-c colour photograph
20.2 x 25.3 cm
Courtesy of Museum of Sydney

Kristina [no glasses]
1984
gelatin silver photograph
29.7 x 42.0 cm
National Gallery of Australia, Canberra 2005.1036

Lilly Madden and elders sewing at the Aboriginal Medical Service
early 1980s
gelatin silver photograph
18.8 x 24.2 cm
Courtesy of Museum of Sydney

Lilly Madden and elders sewing at the Aboriginal Medical Service II
early 1980s
gelatin silver photograph
12.9 x 17.9 cm
Courtesy of Museum of Sydney

Linda Burney and Binni
early 1980s
direct positive colour photograph
23.0 x 32.2 cm
Courtesy of Ms Linda Burney, MP

Linda Burney and Willurai
1990
direct positive colour photograph
20.2 x 25.3 cm
Courtesy of Ms Linda Burney, MP

Little boy with Pepsi can at Aboriginal Football knockout
early 1980s
gelatin silver photograph
print 18.5 x 24.2 cm;
sheet 20.0 x 25.5 cm
Courtesy of Museum of Sydney

Mission
1990
triptych; direct positive colour photographs
individual prints 63.0 x 52.0 cm;
framed triptych 78.6 x 18.6 cm
Courtesy of Ms Linda Burney, MP

Murawina Child Care Centre [children in cots at Murawina, Eveleigh Street]
early 1980s
gelatin silver photograph
13.0 x 18.0 cm
Courtesy of Museum of Sydney

Murawina Children's Service, Redfern – Barbara Silva, Roslyn Silva on right and Karla Carr
early 1980s
gelatin silver photograph
12.8 x 18.0
Courtesy of Museum of Sydney

Nanna Wright fishing
early 1980s
direct positive colour photograph
22.0 x 34.0 cm
Courtesy of Ms Cathy Craigie

New South Wales Aboriginal Football knockout
early 1980s
type-c colour photograph
20.2 x 25.3 cm
Courtesy of Museum of Sydney

Protest march [group of people sitting on grass at Central]
early 1980s
type-c colour photograph
20.3 x 30.4 cm
Courtesy of Museum of Sydney

Railway bridge, Lawson Street, Redfern
1986
type-c colour photograph
29.7 x 42.0 cm
Courtesy of Museum of Sydney

Redfern All Blacks in action (1979)
1979
gelatin silver photograph
12.6 x 17.9 cm
Courtesy of Museum of Sydney

Redfern All Blacks in action (1979) II
1979
gelatin silver photograph
12.6 x 17.9 cm
Courtesy of Museum of Sydney

Redfern All Blacks in action (1979) III
1979
type-c colour photograph
12.8 x 17.9 cm
Courtesy of Museum of Sydney

Redfern Oval nerves
late 1970s
gelatin silver photograph
print 18.5 x 24.2 cm;
sheet 19.9 x 25.4 cm
Courtesy of Museum of Sydney

Redfern Oval (New South Wales Aboriginal Football knockout) – kids getting shade
late 1970s
gelatin silver photograph
print 18.9 x 24.2 cm;
sheet 20.0 x 25.4 cm
Courtesy of Museum of Sydney

Redfern Oval – stretching NGAKU team member, Kempsey
late 1970s
gelatin silver photograph
print 18.0 x 24.2 cm;
sheet 19.9 x 25.4 cm
Courtesy of Museum of Sydney

Shiralee Ingram
early 1980s
gelatin silver photograph
13.0 x 18.0 cm
Courtesy of Museum of Sydney

Spirit clouds
1997
triptych direct positive colour photograph
56.0 x 28.0 cm
Courtesy of Monash Gallery of Art

Team portrait
1979
type-c colour photograph
12.7 x 18.0 cm
Courtesy of Museum of Sydney

The knockout – supporters South Coast mob
late 1970s
gelatin silver photograph
print 18.8 x 24.1 cm;
sheet 20.3 x 25.4 cm
Courtesy of Museum of Sydney

The Rileys: Dantoine, Megan, Tabatha, Nole, Douglas and Christopher [five children, one green paddlepop]
early 1980s
type-c colour photograph
29.6 x 41.9 cm
Courtesy of Museum of Sydney

Toni and Maria (Polly) Cutmore
early 1980s
colour photograph
14.3 x 23.7 cm
Courtesy of Ms Cathy Craigie

Tracey [head down]
1986, Sydney, New South Wales
gelatin silver photograph
print 24.1 x 35.7 cm;
sheet 30.3 x 40.5 cm
Courtesy of Mr Anthony Bourke

Vivien O'Darby [Viv Ndaba]
early 1980s
type-c colour photograph
18.0 x 12.8 cm
Courtesy of Museum of Sydney

Wright family at New South Wales Aboriginal Football knockout
1983
gelatin silver photograph
12.9 x 17.9 cm
Courtesy of Museum of Sydney

Young footy players
early 1980s
gelatin silver photograph
print 24.2. x 18.8 cm;
sheet 25.4 x 19.8 cm
Courtesy of Museum of Sydney

FILMS

A passage through the aisles
1994
film: 6 mins
Producer: Joy Toma, Associate Producer: Debbie Lee
Courtesy of SBS Television

Blacktracker
1996
film: 30 mins
Producer: Michael Riley
Courtesy of ABC Television – Indigenous Documentary Fund

Boomalli: Five Koorie artists
1988
film: 16mm, 28 mins
Producer: Paul Humfress
Courtesy of Film Australia

Breakthrough series: Alice
1988
film: 16mm, 15 mins
Executive Producer: Ron Saunders, Producer: Pamela Williams, Courtesy of Film Australia for the Department of Education, Employment and Training

Dreamings: The art of Aboriginal Australia
1988
film:16mm, 30 mins
Producer: Janet Bell,
Courtesy of Film Australia

Empire
1997
film: 35 mm, 18 mins
Executive Producer: David Jowsey, Courtesy of ABC Television Indigenous Production Unit

Eora
1995
film: 16 mm, transferred to synchronized laser disc, 60 mins
Executive Producer: Gary Warner, Producer: Mic Gruchy, Co-Producer/Artistic Director: David Prosser, Produced by Blackfella Films for Museum of Sydney
Courtesy of Museum of Sydney and Historic Houses Trust NSW

Frances
1990
film: 3 mins
Courtesy of ABC Television

I don't wanna be a bludger
1999
film: 30 mins
Directors: Michael Riley and Destiny
Deacon
Courtesy of Art Gallery of New
South Wales and Roslyn Oxley9
Gallery

Kangaroo dancer
1994
film
Producers: Rachel Perkins and Ned
Lander
Courtesy of Blackfella Films

Malangi: A day in the life of a bark painter
1991
film: 30 mins
Producer and Director: Michael Riley
Courtesy of ABC Television

Poison
1991
film: 29 mins
Executive Producer: Vaughan
Hinton, Producer: Michael Riley
Courtesy of ABC Television–
Indigenous Production Unit

Quest for country
1993
film: 24 mins
Courtesy of SBS Television

Tent boxers
2000
film: 30 mins
Courtesy of ABC Television–
Indigenous Documentary Fund
– series 3

The Masters
1996
film: 13 x 15 mins
Courtesy of SBS Television

*Welcome to my Koori world [Delores'
Koori world]*
1993
film: 5 x 12 mins
Courtesy of ABC Television

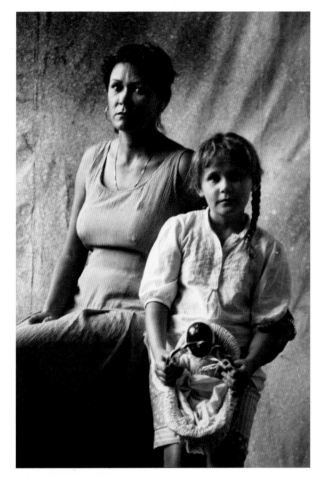

Sheryl Connors and daughter, Christina Parnell 1990 proof sheet,
print from negative Michael Riley Foundation
(opposite) *Dorothy* from the series *Portraits by a window* 1990
gelatin silver photograph Pat Corrigan

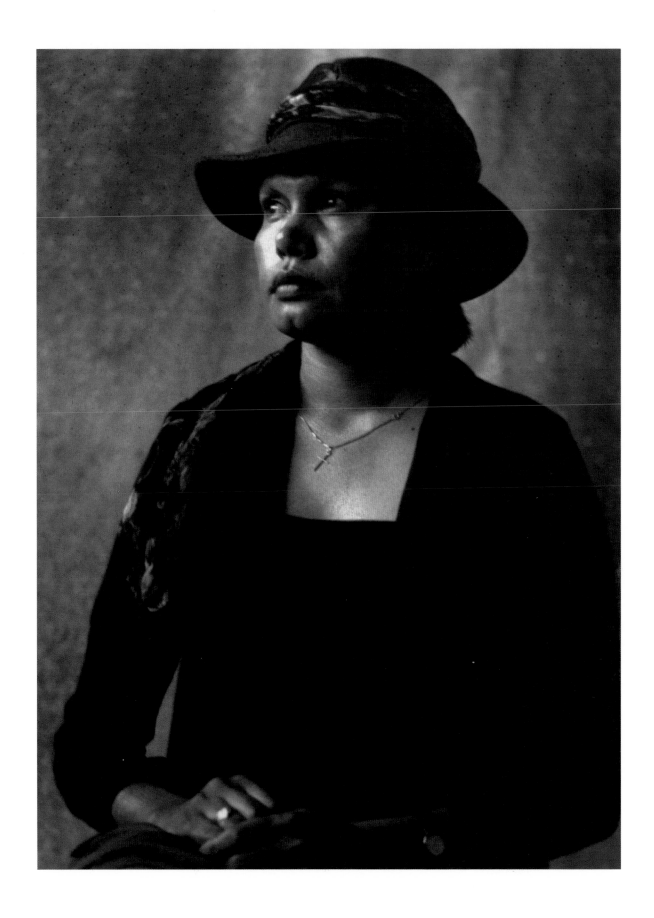

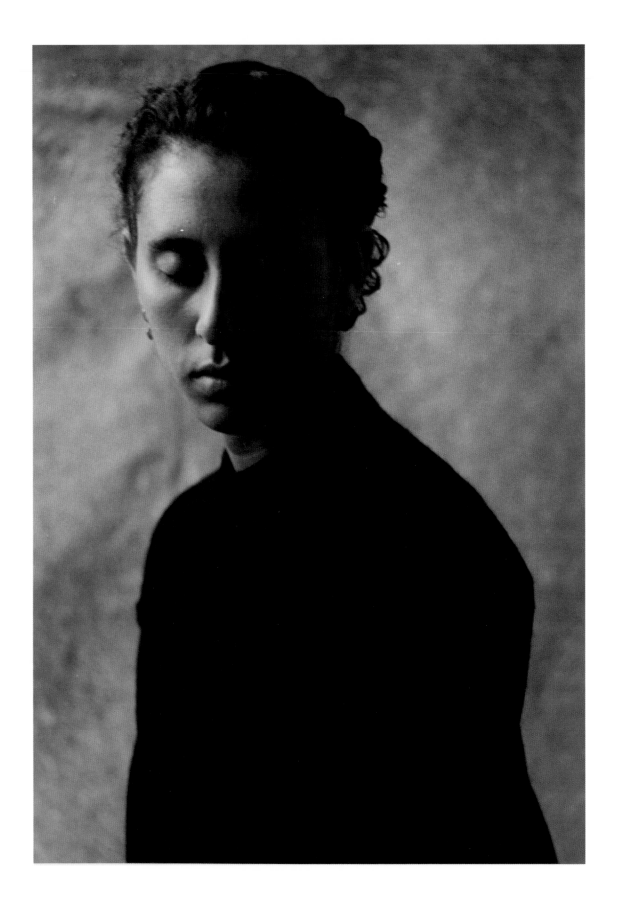

Chronology

1770

Captain James Cook and *The Endeavour* sail into Botany Bay.

1788

Governor Arthur Phillip, marines and convicts land at Botany Bay.

1823

Government policy aims to convert Aboriginal peoples to Christianity, teaching them the habits of clothes, prayer, work and industry, thus making them Christian, 'civilised' and useful at the same time.

1825

The first mission is established at Wellington Valley, and gives all missions a bad name by kidnapping Aboriginal children.

1849

The village of Dubbo, on the western plains of New South Wales, is proclaimed. Surveyor John Oxley had noted the presence of Indigenous people in the area in 1818. Robert Delhunty established a pastoral station called 'Dubbo' between 1829 and 1833.

1850

All Aboriginal missions in New South Wales are closed by this date.

1862

Moree is gazetted. The town is named after a local pastoral run and a Kamilaroi term meaning either 'long waterhole', or 'rising sun'.

1883

The New South Wales Aborigines Protection Board is established. The board's policy is that all Aboriginals should live on reserves. In 1883 there were 25 Aboriginal reserves totalling 1414 hectares. By 1900 there were 133 reserves. Most of the reserves would have been considered insufficient to support one white family, but they were expected to support whole Aboriginal communities.

1883–1969

Thousands of Aboriginal children, known as the Stolen Generations are taken from their parents and placed in white training institutions.

1884

Alexander Riley (Alec 'Tracker' Riley), Michael Riley's paternal grandfather, is born at Nymagee. His parents were John (Jack) Riley and Mary Caligan.

1898

Talbragar Aboriginal Reserve is established on the outskirts of Dubbo.

1901

The Commonwealth of Australia is inaugurated on 1 January 1901. In March, elections are held for the new Federal Parliament.

1904

Maude Dunn, Michael Riley's maternal grandmother, is born.

1905

The Aborigines Inland Mission (AIM) is established by Retta Dixon in the Hunter Valley of New South Wales.

1908

Reuben (Bengalla) Wright, Michael's maternal grandfather, is born at Bengalla Station.

1911–1950

Tracker Riley works for the New South Wales Police Force, achieving the rank of Sergeant.

1915–1939

Station managers and policemen are authorised to remove Aboriginal children from their parents to protect their moral or spiritual welfare.

1920s–1930s

Aboriginal people begin to organise themselves politically, demanding political rights and equality, and successfully seeking inquiries into the operations of the Aborigines Protection Board.

1924

Alexander 'Tracker' Riley marries Ethel Taylor on 24 June at Wellington. Ethel Taylor was born in Dubbo to Robert Taylor (named after George Taylor, then Protector of Aborigines) and an unknown mother. Alexander and Ethel have eight children, including Michael's father, Allen.

1929

The New York stock market crashes and the Great Depression begins. In Australia, Aboriginal people are most affected.

Reuben (Bengalla) Wright and Maude Dunn marry at Boomi. They have 10 children, including Michael Riley's mother, Dorothy.

Delores from the series *Portraits by a window* 1990 gelatin silver photograph
Pat Corrigan

1938

26 January, Australia Day, is declared the inaugural Day of Mourning for Aboriginal People. In March, the Committee for Aboriginal Citizen Rights is formed in Sydney.

1939

Michael Riley's maternal grandparents, Reuben (Bengalla) and Maude Wright, move from Boggabilla to Moree Aboriginal Reserve to manage a pre-natal hostel.

The Aborigines Protection Board is abolished and the Aborigines Welfare Board is established in its place.

1952

Bengalla and Maude Wright move to Dubbo where Bengalla works as a Police Tracker. Dorothy Wright meets Michael's father, Allen (Rocko) Riley.

1952–1972

Dawn magazine is published by the New South Wales Aborigines Welfare Board. *Dawn* and *New Dawn* are published until 1972.

1960s

The modern land rights movement begins.

1960

Michael Riley is born in Dubbo and spends the first years of his life on Talbragar Aboriginal Reserve.

1964

The Australian Institute of Aboriginal and Torres Strait Islander Studies is established in Canberra.

1965

The Aboriginal Freedom Ride takes place throughout northern New South Wales. The participants achieve their objective of publicising discrimination by successfully picketing the Moree Baths to allow Aboriginal people into the facility.

1967

In a national referendum held in May, voters accept proposals that Aboriginal people be counted in the census and that a discriminatory clause in the Commonwealth Constitution, preventing the Federal Government from legislating for Aboriginal people, be deleted.

1968

On 1 December, the Arbitration Commission decision, made almost three years before – that Aboriginal people must be paid award wages if they work in industries covered by awards – takes effect. As a result, Aboriginal employees lose their jobs and families are forced to move onto settlements.

1969

The Aborigines Welfare Board is abolished.

1970

Tracker Riley dies and the last family group at Talbragar moves into Dubbo.

Identity magazine is published. It provides a public voice for Aboriginal writers. The National Black Theatre is formed – out of this grows the Aboriginal Islander Dance Company.

1970s

In Redfern, Sydney, the Aboriginal Legal Service and the Aboriginal Medical Service are established.

1971

The Commonwealth Government establishes a Ministry for Environment, Aborigines and the Arts.

1972

The Abriginal Tent Embassy is erected on the lawns of the Provisional Parliament House, Canberra, on 26 January.

The Federal Department of Aboriginal Affairs (DAA) is established, replacing the Office of Aboriginal Affairs. The Department plays an important role in the Aboriginal arts and crafts industry and eventually it inherits the company, Aboriginal Arts and Crafts Pty Ltd.

1973

Government funding supports the formation of more than 1000 Aboriginal-managed enterprises and services in social welfare, education and business.

The Aboriginal Arts Board is established by the Whitlam Government.

1975

On 20 February, the Senate unanimously passes a motion introduced by Senator Neville Bonner, Australia's first Aboriginal Member of Parliament:
that the Senate accepts the fact that the indigenous people of Australia, now known as Aborigines and Torres Strait Islanders, were in possession of this entire nation prior to the 1788 First Fleet landing at Botany Bay, urges the Australian Government to admit prior ownership by the indigenous people, and introduce legislation to compensate the people now known as Aborigines and Torres Strait Islanders for the dispossession of their land.

1976

The *Aboriginal Land Rights (Northern Territory) Act 1976* establishes the basis upon which Aboriginal people in the Northern Territory can claim rights to land based on traditional occupation.

Michael Riley moves to Sydney to begin a carpentry apprenticeship.

The Aboriginal and Islander Dance Theatre (AIDT) is formed.

1982

The Mabo Case – *Eddie Mabo and Others v. The State of Queensland* – begins. Eddie Mabo and four others take legal action to gain legal title to their family lands.

The Pascoe Report, *Improving focus and efficiency in the marketing of Aboriginal artefacts*, recommends that Aboriginal Arts and Crafts Pty Ltd concentrate only on commercial objectives and withdraw from its unprofitable social and cultural activities.

1983

In March, a new Labor Government takes office, with a policy of national land rights legislation and justice for Aboriginal Australians.

Michael Riley undertakes a Koori photography course at the Tin Sheds, University of Sydney. He then works at the Sydney College of Fine Arts as a technician in the Photography Department.

Contemporary Aboriginal art, Bondi Pavilion, Sydney, includes Michael's work, alongside that of his cousin Yurry Craigie.

1984

Michael is one of the artists included in the Sydney exhibition, *Koorie art '84.*

The Eora Arts Centre is established in Redfern, Sydney. The centre trains Aboriginal people in the visual and performing arts, music, dance, acting, mime, painting and photography.

Aboriginal Arts Australia Ltd (AAAL) is established by the Aboriginal Development Commission to develop national and international Aboriginal art markets.

The Commonwealth Aboriginal and Torres Strait Islander Heritage (Interim Protection) Act 1984 comes into force, protecting significant Aboriginal sites and objects.

1985

Perspecta 1985 – A survey exhibition of contemporary Australian art at the Art Gallery of New South Wales does not include any Aboriginal artists. Aboriginal people in Sydney begin producing their own feature films. *Fringedwellers*, produced by Bruce Beresford, and *Short changed*, with an original screenplay by the Aboriginal playwright Robert Merritt, are screened at the 1986 Cannes Film Festival.

At a special ceremony at Uluru (Ayers Rock), Northern Territory, the title deeds to Uluru are handed over to the traditional Anangu owners.

1986

Michael Riley's work is included in *NADOC '86 Exhibition of Aboriginal and Islander photographers* – the first Indigenous photography show – at the Aboriginal Artists Gallery, Sydney, and in *Urban Koories*, held at the Willougby Art Workshop, Sydney.

1987

First National Black Playwrights' Conference is held in Canberra at the Australian National University.

Boomalli Aboriginal Artists Co-operative is formed by Bronwyn Bancroft, Euphemia Bostock, Brenda L. Croft, Fiona Foley, Fernanda Martins, Arone Raymond Meeks, Tracey Moffatt, Avril Quaill, Michael Riley and Jeffrey Samuels. *Boomalli au-go-go* launches the co-operative in Chippendale, Sydney.

At a meeting of the Aboriginal Arts Australia Ltd board, the Minister suggests the company take over the funding of community-based art centres. Art centres view this suggestion as a threat to their independence and 16 communities break away to form the Association of Northern and Central Australian Aboriginal Artists (ANCAAA).

1988

The Bicentenary of the European settlement of Australia, as well as the official 21st birthday of Aboriginal people in the Commonwealth of Australia (Aboriginal people were included in the census for the first time in 1967), are celebrated.

The Aboriginal National Theatre Trust (ANTT) is established in Sydney as a direct result of the First National Black Playwrights' Conference.

Michael Riley's work is represented in *Art and Aboriginality*, exhibited at the Sydney Opera House before travelling to Portsmouth (England).

Michael directs *Dreamings: The art of Aboriginal Australia* which accompanies the exhibition to the Asia Societies, New York, USA and *Boomalli: Five Koorie artists* for Film Australia.

1989

The New South Wales Taskforce on Aboriginal Heritage and Culture recommends that responsibility for Aboriginal heritage be removed from the National Parks and Wildlife Service and that a separate Aboriginal Heritage Commission be established.

A resolution on prior ownership and dispossession is passed at the opening of the new Parliament House in Canberra.

The National Aboriginal and Torres Strait Islander Arts Committee (NATSIAC) replaces the Aboriginal Arts Board.

The second National Black Playwrights' Conference is held at Macquarie University, Sydney. Michael Riley, employed at the Aboriginal Programs Unit at ABC Television, is hired to document the two-week workshop.

1990

The Aboriginal and Torres Strait Islander Commission is formed.

Michael's first solo exhibition, *Portraits by a window* is held at the Hogarth Galleries, Sydney, and his work is included in the exhibition *After 200 years: Photographs of Aboriginal and Islander Australia today*, held at the National Gallery of Australia, Canberra.

1991

The Council for Aboriginal Reconciliation is established under the *Council for Aboriginal Reconciliation Act 1991*.

Michael's solo exhibition, *A common place: Portraits of Moree Murries,* is held at Rebecca Hossack Gallery, London, and Hogarth Galleries, Sydney.

Michael Riley directs *Malangi: A day in the life of the eminent bark painter*, and *Poison*.

1992

The Mabo Case is settled in the High Court, declaring 'the land in the Murray Islands is not Crown land' and that 'the Meriam people are entitled as against the whole world to possession, occupation, use and enjoyment of the Murray Islands'. Eddie Mabo dies before the court gives judgement.

Michael's solo exhibition, *Sacrifice,* is held at the Hogarth Galleries, Sydney.

1993

The United Nations Year of Indigenous Peoples is celebrated.

The Federal Government passes the *Native Title Act* 1993.

With colleague Rachel Perkins, Michael forms Blackfella Films. His work is included in the major survey exhibition *Aratjara: Art of the First Australians*, exhibited at the Kunstsammlung Nordrhein-Wesfalen, Düsseldorf, Louisiana Museum, Humlebaek, Denmark and Hayward Gallery, London.

Michael directs *Welcome to my Koori world*, and *Quest for country*, which is included in *Spirit to spirit*, an international Indigenous film festival.

1994

Michael's solo exhibition, *Fence sitting*, is held at the Hogarth Galleries, Sydney, and his work is included in *Urban focus: Aboriginal and Torres Strait Islander art*, National Gallery of Australia.

1995

Michael's solo exhibition, *They call me niigarr*, is held at the Hogarth Galleries, Sydney. He is commissioned by the Museum of Sydney to write and direct *Eora*.

1996

The exhibitions *Guwanyi: Stories of Redfern Aboriginal community* (Museum of Sydney, with Gadigal Information Services, Sydney) and *Spirit + place* (Museum of Contemporary Art, Sydney) include Michael's work. Michael directs *Blacktracker* for ABC Television.

1997

The report of the Inquiry into the Separation of Aboriginal and Torres Strait Islander Children from their Parents, *Bringing them home*, is tabled in Federal Parliament.

The Australia Council for the Arts announces its first national Indigenous arts policy. An increase of $500 000 is made in funding.

Michael directs *Tent boxers*, a documentary for ABC Television. He is commissioned to write and direct *Empire* for the SOCOG Festival of the Dreaming, Sydney.

1998

Michael's solo exhibitions, *flyblown* and *Empire*, are shown at Gallery Gabrielle Pizzi, Melbourne. Michael is included in the National Gallery of Australia's touring exhibition, *Re-take: Contemporary Aboriginal and Torres Strait Islander photography*.

1999

Yarns from the Talbragar Reserve is exhibited at Dubbo Regional Art Gallery, Dubbo, and Art Gallery of New South Wales, Sydney.

Oltre il mito (Beyond myth), including work by Michael Riley, is shown by Gallery Gabrielle Pizzi in Venice as part of the *al latere* section of the 48th Venice Biennale. The film *I don't wanna be a bludger* is commissioned by the Art Gallery of New South Wales for *Living here now: Art and politics – Australian perspecta*.

2000

As part of the fifth annual National Reconciliation Week, *Corroboree 2000*, vast crowds walk across the Sydney Harbour Bridge. In the following months similar walks occur throughout the country.

Beyond the pale: Contemporary Indigenous art, Adelaide biennial of Australian art (Art Gallery of South Australia) includes *flyblown* and *Empire*. Michael participates in the *Biennale of contemporary art*, Festival of Pacific Arts, Noumea, New Caledonia. Michael's solo exhibition *cloud*, accompanied by *Empire*, is shown at the Australian Centre for Photography, Sydney.

2002

Photographica Australis, Sala de Exposiciones del Canal de Isabel II, Madrid, Spain, organised by the Australian Centre for Photography, Sydney, includes Michael's work. *cloud* and *Empire* is shown at Campbelltown City Bicentennial Gallery, Campbelltown, New South Wales. *cloud* is shown at Gallery Gabrielle Pizzi, Melbourne.

2002–3

As part of the Festival of Sydney, banners of *cloud* are hung over Circular Quay, Sydney.

2003

cloud and *Empire* are selected for inclusion in *Poetic justice: 8th international Istanbul biennial*, Turkey.

2004

A selection of Michael's work, including portraits of Sydney Aboriginal people, *A common place: Portraits of Moree Murries* and *cloud*, is exhibited at the Australian Museum.

Michael Riley dies, age 44, on 31 August.

2005

cloud is exhibited at the Museum of Sydney, Sydney. *cloud* and *Sacrifice* are exhibited at Stills Gallery, Paddington, Sydney.

2006

In June a selection of images from *cloud*, along with work by Paddy Bedford, John Mawurndjul, Ningura Napurrula, Lena Nyadbi, Judy Watson, Tommy Watson and Gulumbu Yunupingu, is permanently installed as part of the Australian Indigenous Art Commission at the new Musée du quai Branly, Paris.

Michael Riley: sights unseen opens at the National Gallery of Australia on 14 July.

Notes

Information for this chronology has been drawn from the following sources. In some instances, short passages of text have been directly quoted.

Affirmations of identity: Aboriginal and Torres Strait Islander visual artists resource kit, Sydney, NSW: Board of Studies New South Wales, 2001, pp. 42–43.

Australia Dancing, *Aboriginal Islander Dance Theatre (1976–)*, online directory of dance resources, nd, viewed 2 May 2006, <http://www.australiadancing.org/subjects/3081.html>.

Jonas, Bill, Langton, Marcia and AIATSIS staff, *The little red, yellow and black (and green and blue and white) book: A short guide to Indigenous Australia*, Canberra, ACT: Australian Institute of Aboriginal and Torres Strait Islander Studies on behalf of the Council for Reconciliation, 1994, pp. 31, 33, 34, 35, 38–39, 49, 51–52.

Parbury, Nigel, *Survival: A history of Aboriginal life in New South Wales*, Sydney: Ministry of Aboriginal Affairs (New South Wales), 1986, pp. 46, 51, 86, 88, 99–100, 106–107, 118, 128–132, 135–137, 142, 148–150, 156.

Perkins, Hetti and Fink, Hannah (eds), *Papunya tula: Genesis and genius*, exhibition catalogue, Sydney, NSW: Art Gallery of New South Wales, 2000, pp. 304, 308–312.

Whitlam Institute, University of Western Sydney, *Aboriginal Arts Board, Press Statement No. 83*, #-collection, viewed 2 May 2006, <http://www.whitlam.org/collection/1973/19730503_Aboriginal_Arts/>.

(below) *Michael and Jacko French* from the series *A common place: Portraits of Moree Murries* 1991 gelatin silver photograph National Gallery of Australia, Canberra

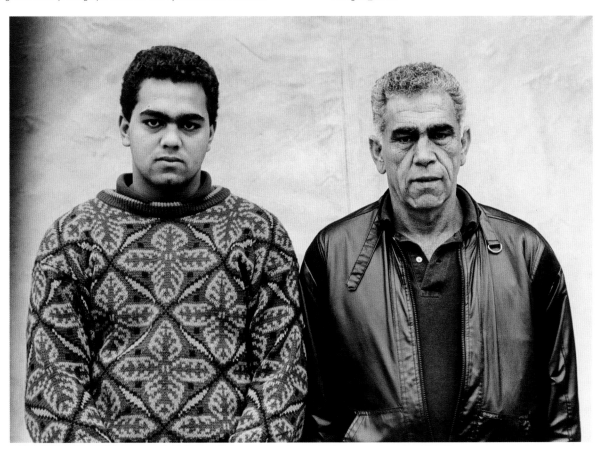

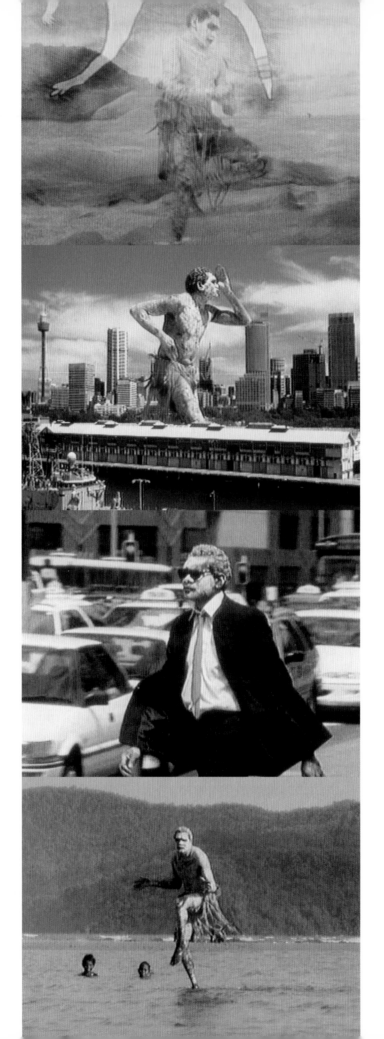

Glossary

ABC TV – The Australian Broadcasting Corporation is the national broadcaster. The Indigenous Programs Unit, formerly the Aboriginal Programs Unit, of the television division was established in 1989, following recommendations of the Royal Commission into Aboriginal Deaths in Custody.

Aboriginal Arts Board (AAB) Now the Aboriginal and Torres Strait Islander Arts Board of the Australia Council for the Arts, the federal funding body for arts and culture, the AAB was established in 1973 by the Whitlam Labor Government.

Aboriginal and Islander Dance Theatre (AIDT) was established as an ongoing performance group in 1976. It originally consisted of young people participating in *Careers in Dance*, a full-time dance training course for Aboriginal and Islander students initiated in 1975 by the Aboriginal Arts Board and led by Carole Johnson. The company, which eventually became NAISDA (National Aboriginal and Islander Skills Development Association) College, expanded to include teachers, graduate students and advanced students. AIDT became a professional performance group in 1988 and was formally launched as a company in 1991 under the artistic directorship of Raymond Blanco. Prior to that date it operated without a formal structure.

Aboriginal and Torres Strait Islander people/Indigenous people An Aboriginal or Torres Strait Islander person is someone who identifies as Aboriginal or Torres Strait Islander/Indigenous and is accepted as such by their specific Indigenous community or the one in which they live. Indigenous people in Australia live in remotely located communities – 'remote' from metropolitan areas, not in relation to their traditional country – rural regions and urban settings in all parts of the country. The effects of colonisation and displacement over two centuries severely impacted upon thousands of Indigenous people, who were driven from their traditional lands and often had access to their languages and cultural practices denied or fractured. However, over the past three or so decades there has been a resurgence of cultural pride and activity throughout the country, particularly among Indigenous people living in towns and cities. Comprising less than 2 per cent of the overall population of Australia, they face many obstacles in gaining equal rights with non-Indigenous Australians.

Aboriginal flag was designed by a Luritja–Wombai artist, Harold Thomas, in 1971. It was first raised by Thomas at Victoria Square, Adelaide, on National Aborigines Day, 12 July 1971. It was flown at the Aboriginal Tent Embassy in Canberra the following year. Of the three colours in the flag, black symbolises Aboriginal people, yellow represents the sun, the constant renewer of life, and red depicts the earth and also ochre, which is used by Aboriginal people in ceremonies.

(opposite) Screen grabs from *Kangaroo dancer* 1994 Blackfella Films

Aboriginal National Theatre Trust (ANTT) was established in Sydney in 1988 as a direct result of the First National Black Playwrights' Conference, held in January 1987 at the Australian National University in Canberra.

Aboriginal reserves in New South Wales came into being after the establishment of the Aborigines Protection Board in 1883. Reserves were established in many areas of New South Wales as land grants, proclaimed during the reign of Her Majesty Queen Victoria (1838–1901). Although the last missions in New South Wales were closed in 1850, many reserves were often referred to as 'missions' by the Aboriginal residents. Elsewhere in Australia, missions such as Yirrkala in north-east Arnhem Land, Northern Territory, continued well into the twentieth century.

Aboriginal Tent Embassy On the morning of 26 January 1972, the Aboriginal Tent Embassy appeared on the lawns of the Provisional Parliament House, Canberra, manned by a number of prominent Indigenous activists and drawing black and white supporters from everywhere. Both the embassy and the newly created Aboriginal flag, flying from the tent pole, represented the unity of purpose of Indigenous people across Australia. The embassy effectively demonstrated that Indigenous people are members of a nation separate to white Australia and that they intended to see this reflected in the political process.

Agitprop is a slang word applied to any form of mass media, such as a television program or film, that tries to influence opinion for political, commercial or other ends, especially if it aims to convince people, through the use of highly emotional language, of problems in present-day society or politics (which may or may not exist if analysed in an unbiased manner). Agitprop sometimes, although not always, uses indirect methods to reach its goals, such as conveying a political message via a television drama that's marketed as a form of entertainment rather than political education.

Ancestral beings are spiritual or mythical beings whose existence preceded human life on earth and who, through their epic journeys, created the landscape as it is today. They may be human or animal, animate or inanimate, and in many cases transform from one thing or state to another. They are a continuing influence on the world through processes such as spirit conception, and provide the underlying source of spiritual power.

Ancestral past refers to the time when ancestral beings occupied the earth, or the dimension in which ancestral beings still exist.

Assimilation was a policy pursued by Australian governments towards Aboriginal people which forced them to adopt Euro-Australian lifestyles and eventually to become assimilated within the Australian population as a whole. The policy often involved the repression of

Indigenous cultural practices, and in many parts of Australia was associated with the removal of Aboriginal children from their families. In the 1970s assimilation was replaced by policies that provided Indigenous people with far greater autonomy, resulting in increased recognition of their rights and the value of their cultural practices.

Bark painting refers to the practice of producing paintings on sheets of eucalyptus stringy bark that have been flattened over an open fire. Today, the tradition is most closely associated with Arnhem Land in northern Australia, but evidence suggests it may have been more widespread at the time of European colonisation, in regions where bark was used to make huts and shelters.

Black deaths in custody The Royal Commission into Aboriginal Deaths in Custody was established in 1987. The Commission examined all deaths in custody in each State and Territory which occurred between 1 January 1980 and 31 May 1989, and the actions taken in respect of each death.

Blak is a term coined by Indigenous artist and activist Destiny Deacon in the early 1990s as a direct means of 'refiguring and redefining the English colonisers' language', ie subverting black to blak.

Boomalli Aboriginal Artists Co-operative was established in Sydney in 1987 by 10 Aboriginal artists. The founding members were Bronwyn Bancroft, Euphemia Bostock, Brenda L. Croft, Fiona Foley, Fernanda Martins, Arone Raymond Meeks, Tracey Moffatt, Avril Quaill, Michael Riley and Jeffrey Samuels. Boomalli, meaning 'to strike, to make a mark', is a language word from at least three nations – Bundjalung, Kamilaroi and Wiradjuri. Exhibitions held by the members of the organisation have left their artistic, cultural and political marks on the city of Sydney and all those who have experienced them.

Clan A group of people connected by descent who hold certain rights in common. In many parts of Australia, rights in land and paintings are vested in clans, often (but not always) formed on the basis of descent through the father (patrilineal clans). However, such clans are by no means a universal feature of Australia.

Corroboree A word used across much of Australia to refer to Aboriginal ceremonies. It originally came from the language of the Dharuk people from the Sydney region of New South Wales. Corroboree is also noted as being from the French word caribiberie, meaning dance.

Dreamtime/Dreaming are terms first used by W.B. Spencer and F. Gillen to refer to the time of world creation or the ancestral past. It is a fairly literal translation of the Arrernte word *altyerrenge*, which corresponds with similar terms in many other central-Australian languages. The term has been overused in popular literature and has almost become a cliche, but nonetheless refers to an important component of Aboriginal cosmologies.

Freedom Ride In 1965 a group of university students, led by Arrernte activist Charles Perkins, conducted a highly publicised 'Freedom Ride' through northern New South Wales to expose the apartheid prevalent in the region.

Indigenous There are two distinct Indigenous groups within Australian territory: Aboriginal people and Torres Strait Islanders. Aboriginal people are not a homogeneous mass but comprise hundreds of distinct nations throughout the continent, each with their own languages and dialects, just as many different nationalities constitute Europe.

Kinship refers to connections between family members. Among Aboriginal groups this term covers relationships both within and between generations, and through both mothers' and fathers' lines of descent across many generations. People also have kinship with certain animals and plants through common descent from or relationship to a particular ancestral being/creation ancestor.

Koori is the generic term that Aboriginal people from the south-eastern region of Australia use in reference to themselves. Indigenous people in some northern areas of New South Wales refer to themselves as Goori or Murri.

Land rights Since the 1960s, the matter of land rights has been one of the major political issues for Indigenous people in Australia. Until the 1967 referendum, Aboriginal people were not even considered full citizens in their own country and had no rights to their land. Since the passing of the *Aboriginal Land Rights (Northern Territory) Act 1976*, Indigenous people in many parts of northern and central Australia have gained title to their land. However, in many other parts of Australia, Aboriginal rights in land remain minimal. Since the Mabo judgement of the High Court in 1992, however, the possibility of extending land rights through native title claims has existed, though to date it remains largely untested. Indigenous people throughout southern regions of Australia, in the east and the west, are currently seeking native title to their traditional lands.

Moiety literally means a division in two halves. In Australia, it refers to a division of society into two intermarrying halves, with a corresponding division of the whole universe along the same lines.

Murri is the generic term that Aboriginal people from the northern part of New South Wales, and throughout Queensland, use in reference to themselves.

NAIDOC Week – formerly NADOC Week – was founded in 1957 to focus Australians' attention on the Aboriginal communities in their midst. The abbreviation stands for 'National Aboriginal and Islander Day Observance Committee'. Since 1940, the National Missionary Council of Australia (NMCA) had been encouraging churches to observe the Sunday before the Australia Day weekend as Aboriginal Sunday. The NMCA had taken up a suggestion by William Cooper, who, following his successful promotion of a 'day of mourning' on Australia Day 1938, had written to that body seeking help in establishing a permanent Aborigines Day. In 1955 the NMCA changed the date to the first Sunday in July and secured the support of federal and state governments, as a result of which NADOC was formed. The establishment of the federal Department of Aboriginal Affairs boosted the activities of NADOC, which in 1974 became an all-Aboriginal body. In 1975 NADOC extended Aboriginal Day into National Aborigines Week, during which the Aboriginal people's cultural heritage and contribution to Australian society are celebrated. Various activities are arranged for each day of the week wherever it is celebrated. Since 1976 the committee has run as a federal body and in 1989 the word 'Islander' was added to the title.

National Black Playwrights' Conference The First National Black Playwrights' Conference was held in Canberra in January 1987, at the Australian National University. It was organised by Brian Syron (1935–1993), an Aboriginal actor and director with international experience. Syron was also instrumental in establishing the Australian National Playwrights Conference in 1973. The second National Black Playwrights' Conference was held in Sydney in 1989.

National Sorry Day was established on 27 May 1998, one year after the report of the National Inquiry into the Separation of Aboriginal and Torres Strait Islander Children from their Families was published. It is held in recognition of the Stolen Generations, and was established in response to the National Sorry Books. These books travelled the country and were signed by thousands of non-Indigenous people as a sign of profound regret for injustices to Indigenous people in Australia over the past two centuries.

Native title On 3 June 1992 the High Court of Australia passed a judgement in recognition of traditional laws and customs of Indigenous Australians in relation to land or waters, through the historic Mabo case. The High Court called this type of ownership 'native title', which means a title owned by Indigenous people. The Commonwealth *Native Title Act 1993* recognises and protects the Aboriginal and Torres Strait Islander Peoples' common law native title rights and interests. Land rights are grants created by governments. Native title is a right that has always been there from the beginning of time.

New South Wales Aboriginal Education Consultative Group (AECG) was established in Sydney in 1977. The AECG is a community-based organisation designed to promote discussion amongst the diverse Aboriginal communities involved in developing Aboriginal education policy in New South Wales. The AECG focuses on empowerment and self-determination with equity, cultural integrity and the community base fundamental to their beliefs and practices. The organisation advises the New South Wales Minister for Education and Youth Affairs as well as other key government departments and the New South Wales Teachers Federation.

New South Wales Aboriginal Rugby League Knockout was established in 1973 by the country's oldest Aboriginal rugby league football club, the Redfern All Blacks, officially founded in 1944 in inner-city Sydney. The Knockout is played in the previous year's winning team's city or town and has become a contemporary form of corroboree, drawing thousands of Aboriginal people together over the October long weekend to celebrate and encourage their teams' performances and catch up with family and friends.

Rapport Photo Agency was established in 1980 by Caleb Carter, Bruce Hart, Robert McFarlane, Philip Quirk and Rob Walls.

Redfern sitting on the fringes of the City of Sydney, is the oldest surviving urban Aboriginal community in Australia. Within this small inner-city suburb, there are a number of Aboriginal organisations that complement and supplement the work of organisations in the heart of the city. These organisations include the first Aboriginal Medical, Legal, Housing, and Child Care Services, as well as the home of the Black Theatre Company and the Eora Centre.

SBS Television – Special Broadcasting Service (SBS) is Australia's multicultural and multilingual public broadcaster. SBS is unique. Its radio and television services broadcast in more languages than any other network in the world. Sixty-eight languages are spoken on SBS Radio. Programs in more than 60 languages are broadcast on SBS Television, and Online, and SBS New Media provides text and audio-on-demand services in more than 50 languages.

Stolen Generations Indigenous children have been forcibly removed from their families and communities since the very first days of the European occupation of Australia. In that time, very few Indigenous families have escaped the effects of removal of one or more children. The National Inquiry into the Separation of Aboriginal and Torres Strait Islander Children from their Families concluded that between one in three and one in 10 Indigenous children were forcibly removed from their families and communities between 1910 and 1970. These children are referred to as the 'Stolen Generations'.

Terra nullius describes the British legal fiction that Australia was an unoccupied land at the time of its invasion by the British and therefore became a settled, as opposed to a conquered, land. Hence Indigenous people were deemed to have no existence in law. In 1770, Cook declared Australia *terra nullius* – 'empty land' – invalidating the 250 or so distinct nations that had inhabited the continent for thousands of generations. *Terra nullius* was overturned in 1992 by the High Court of Australia, following a 10-year action by Koiki (Eddie) Mabo and four other Torres Strait Islanders, inhabitants of the Murray Islands, for a declaration of native title to their traditional lands.

Tracker/tracking Aboriginal police and police trackers played important roles during the nineteenth and twentieth centuries. The first experiments with 'native police' forces commenced in Victoria in 1837, with subsequent forces set up in 1839 and 1842. Members of the native police forces were all male. Many Aboriginal men and some women worked as police trackers. Their bush expertise was used to assist in police hunts on a casual basis, while others worked for longer stints, with duties such as doing the rounds, grooming horses, and offering general assistance. Often they were only paid a few shillings a week, with rations supplied to their families. Aboriginal trackers were immortalised in Aboriginal oral histories and in fictional works such as Ion Idriess' *Mantracks* (1935). Henry Reynolds' *With the white people* (1990) depicts the important role of the trackers in Australian history.

Tribe has not proved a useful term in Australia. 'Language group' and 'clan', or simply 'social group', are the preferred concepts.

Urban Aboriginal art is a term which first came to prominence in the 1980s in response to the new generation of urban-based Indigenous artists, working predominantly in Sydney, Brisbane, Melbourne and Perth. The term is somewhat problematic, suggesting a juxtaposition between urban and traditional Indigenous art, which was never the intention of the original artists involved in the movement. 'Contemporary Indigenous art' is a more inclusive term and refers to all Indigenous art being created today, irrespective of media or style.

Notes

This glossary draws on a number of sources, all of which are listed below. Some entries are direct quotations; in other cases the texts have been used as sources of information.

Blakness: Blak city culture, exhibition catalogue, South Yarra, Victoria: Australian Centre for Contemporary Art in conjunction with Boomalli Aboriginal Artists Co-operative, 1994, p. 18.

Carter, Paul and Hunt, Susan, *Terre Napoleon: Australia through French eyes, 1880–1804,* Sydney: Historic Houses Trust of New South Wales in association with Hordern House, 1999, p. 64.

Caruana, Wally, *Aboriginal art,* London: Thames and Hudson, 1993, p. 214.

Croft, Brenda L. (ed.), *Beyond the pale: Adelaide biennial of Australian art,* exhibition catalogue, Adelaide: Art Gallery of South Australia, 2000, pp. 8, 26, 55, 85.

Horton, David (ed.), *Encyclopaedia of Aboriginal Australia: Aboriginal and Torres Strait Islander history, society and culture,* Canberra: Aboriginal Studies Press for the Australian Institute of Aboriginal and Torres Strait Islander Studies, 1994, p. 754

Ilan pasin (This is our way): Torres Strait art, exhibition catalogue, Cairns, Qld: Cairns Regional Gallery, 1998.

Issacs, Jennifer, *Spirit country: Contemporary Australian aboriginal art,* South Yarra, Vic: Hardie Grant, 1999, p. 230.

Morphy, Howard, *Aboriginal Art,* London: Phaidon Press, 1998, pp. 422–424.

National Inquiry into the Separation of Aboriginal and Torres Strait Islander Children from their Families (Australia), *Bringing them home: Report of the National Inquiry into the Separation of Aboriginal and Torres Strait Islander Children from their Families,* Sydney: Human Rights and Equal Opportunity Commission, 1997.

Ryan, Judith, with Akerman, Kim, *Images of power: Aboriginal art of the Kimberley,* exhibition catalogue, Melbourne: National Gallery of Victoria, 1993, pp., 10–11, 112.

Taylor, Luke (ed.), *Painting the land story,* Canberra: National Museum of Australia, 1999, p. 101.

True colours: Aboriginal and Torres Strait Islander artists raise the flag, exhibition catalogue, Chippendale, NSW: Boomalli Aboriginal Artists Co-operative, 1994, pp. 10–11.

Online sources

Australia Dancing, *Aboriginal Islander Dance Theatre (1976–),* online directory of dance resources, nd, viewed 2 May 2006, <http://www.australiadancing.org/subjects/3081.html>.

City of Sydney, 'Aboriginal organisations in Sydney' on *Barani: Indigenous history of Sydney,* 2002, website, viewed 2 May 2006, <http://www.cityofsydney.nsw.gov.au/barani/themes/theme5.htm>.

Reconciliation and Social Justice Library, 'National report volume II – The role of native police', AustLII Databases, nd, viewed 2 May 2006, <http://www.austlii.edu.au/au/special/rsjproject/rsjlibrary/rciadic/national/vol2/10.html>.

'Redfern All Blacks' on *Gadigal information services,* website, nd, viewed 2 May 2006, <http://www.gadigal.org.au/main.php?option=redfern&itemid=5&parentid=redfern>.

SBS Corporation, 'Overview', corporate website, 2002, viewed 2 May 2006, <http://www20.sbs.com.au/sbscorporate/index.php?id=>.

Torres Strait Regional Authority, 'Understanding native title', online fact sheet, 2006, viewed 2 May 2006, <http://www.tsra.gov.au/www/index.cfm?pageID=127>.

Whitlam Institute, University of Western Sydney, *Aboriginal Arts Board, Press Statement No. 83,* #-collection, viewed 2 May 2006, <http://www.whitlam.org/collection/1973/19730503_Aboriginal_Arts/>.

Wikipedia contributors, 'Agitprop' in *Wikipedia, the free encyclopaedia,* revised 30 April 2006, viewed 2 May 2006, <http://en.wikipedia.org/wiki/Agitprop>.

Us Mob drummer and singer, Rock against Racism gig, Melbourne c.1984
black-and-white photograph Cathy Craigie

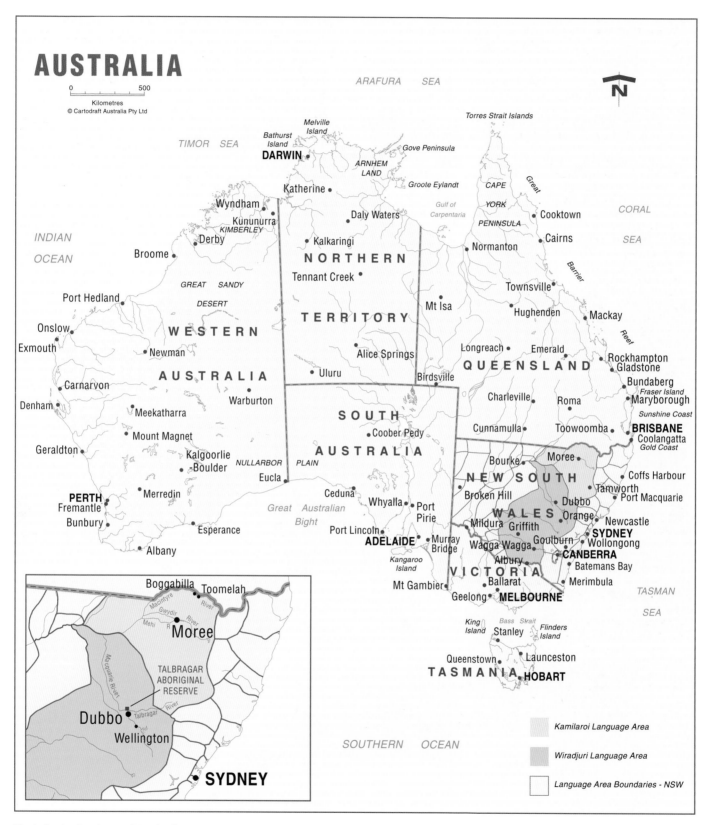

Map indicating Kamilaroi and Wiradjuri language areas. Produced by Graham Keane, Cartodraft Australia Pty Ltd

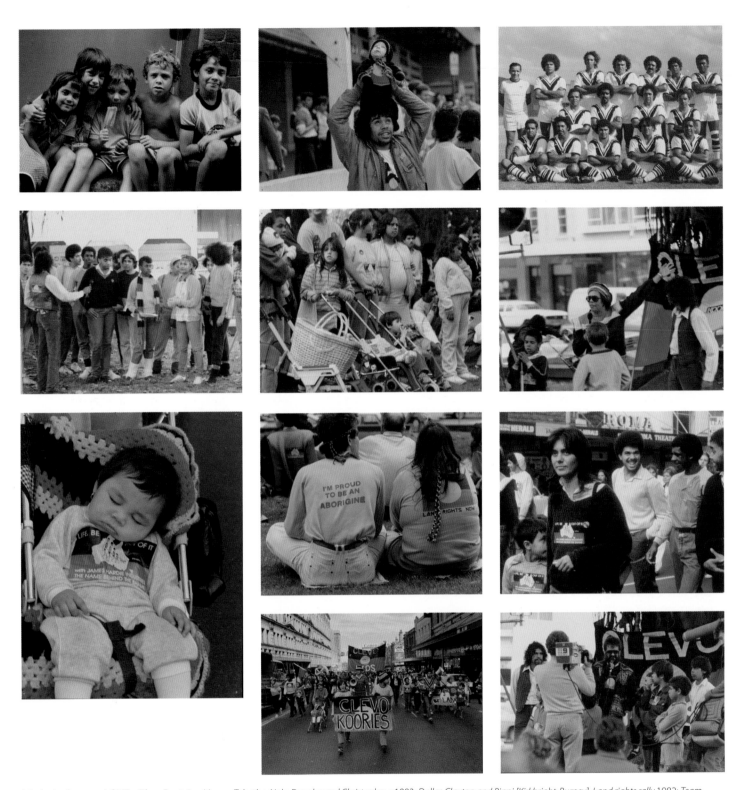

(clockwise from top left) *The Rileys: Dantoine, Megan, Tabatha, Nole, Douglas and Christopher* c.1983; *Dallas Clayton and Binni [Kirkbright-Burney], Land rights rally* 1982; *Team portrait* 1979; *Jenny Monroe speaking at anti-James Hardie asbestos rally, Sydney* 1984; *James Hardie asbestos mining protest march* 1984; *Gary Foley, speaking at anti-James Hardie asbestos rally, Sydney* 1984; *Clevo Koories at anti-James Hardie asbestos rally, Sydney* 1984; *James Williams' daughter, Ngiarain* 1984; *AIDT dancers* early 1980s; *New South Wales Aboriginal Football knockout* early 1980s; *'I'm proud to be an Aborigine'* early 1980s type-c colour photographs Museum of Sydney

Select bibliography

11ᵗʰ Asian art biennale, Bangladesh 2003, exhibition catalogue, Bangladesh: Shilpakala Academy, 2003.

A Koori perspective tour: An Artspace touring exhibition, exhibition catalogue, Surry Hills, NSW: Artspace, 1990.

Abstracts: New Aboriginalities, exhibition catalogue, England: South West Aboriginal Print Project (SWAPP), 1996.

Across: An exhibition of indigenous art and culture, exhibition catalogue, Canberra: Canberra School of Art Gallery, Institute of the Arts, Australian National University, 2000.

After 200 years: Photographs of Aboriginal and Islander Australia today, exhibition catalogue, Canberra: Australian Institute of Aboriginal and Torres Strait Islander Studies, 1990.

'Along the mail route' in *Dawn: A magazine for Aboriginal people of New South Wales*, July 1952, Sydney: New South Wales Aborigines Welfare Board, p. 10.

Aratjara: Art of the first Australians: traditional and contemporary works by Aboriginal and Torres Strait Islander artists, exhibition catalogue, Koln, Germany: DuMont, 1993.

Asia–Pacific triennial of contemporary art, exhibition catalogue, Brisbane: Queensland Art Gallery, 2002.

Australian Broadcasting Corporation, 'Michael Riley', filmmaker biography, 1997, ABC Indigenous Programs Unit website, viewed 1 May 2006, <http://www.abc.net.au/ipu/mriley.htm>.

Australian Film Commission, 'Inspiration: Michael Riley' in *The black book online*, artist's biography, Australian Film Commission website, <http://www.blackfoot.afc.gov.au/inspiration_detail.asp?id=6>.

Australian Museum, 'New Michael Riley exhibition debuts at Australian Museum', media release, 26 May 2004, viewed 1 May 2005, <http://www.amonline.net.au/archive.cfm?id=1781>.

Best, Susan, 'Place-making in a liminal zone' in *Art and Australia*, vol. 38, no. 3, 2001, pp. 428–433.

Blakness: Blak city culture, exhibition catalogue, South Yarra, Victoria: Australian Centre for Contemporary Art in conjunction with Boomalli Aboriginal Artists Co-operative, 1994.

Boomalli Aboriginal Artists Co-operative, 'Artist members: Michael Riley', Boomalli Aboriginal Artists Co-operative website, viewed 1 May 2006, <http://www.boomalli.or.au/programs/share/index.asp?P=361&L=2&NID=1&ICID=35&>.

Boomalli newsletter, special issue, no. 3, autumn 1996, Strawberry Hills, NSW: Boomalli Aboriginal Artists Co-operative, 1996.

Briggs-Smith, Noeline, *Winanga li, Moree mob,* vol. 1, Moree, NSW: Northern Regional Library and Information Service, 1999.

Briggs-Smith, Noeline, *Burrul wallaay (big camp), Moree mob,* vol.2, Moree, NSW: Northern Regional Library and Information Service, 2003.

Budai, Anita-Gigi, 'Group exhibition review' in *Monument*, no. 35, April/May 2000, p. 109.

Button, James, 'Artists' stories will live on forever in Paris museum' in *The Sydney Morning Herald*, 10 September 2005, p. 19.

Cameron, Dan (ed.), *Poetic justice: 8th international Istanbul biennial*, exhibition catalogue, Istanbul: Istanbul Foundation for Culture and Arts, 2003.

Carter, Paul and Hunt, Susan, *Terre Napoleon: Australia through French eyes, 1880–1804*, Sydney: Historic Houses Trust of New South Wales in association with Hordern House, 1999.

Caruana, Wally, *Aboriginal art*, London: Thames and Hudson, 1993.

cloud: Michael Riley, exhibition catalogue, Sydney: Australian Centre for Photography, 2000.

Clouded over: Representation of clouds in art, exhibition catalogue, Perth: Lawrence Wilson Art Gallery, University of Western Australia, 2004.

Coleman, Gordon, 'A man hunter's story: Alex Riley in retirement' in *Dawn: A magazine for the Aboriginal people of New South Wales*, vol. 2, issue 5, May 1953, Sydney: New South Wales Aborigines Welfare Board, 1953, p. 6.

Collins, Daryll, 'Artnotes' in *Art Monthly*, no. 129, May 2000, p. 33.

Contemporary Aboriginal art 1990: From Australia, exhibition catalogue, Redfern, NSW: Aboriginal Arts Management Association in association with Third Eye Centre, 1990.

Cosic, Miriam, 'Past and present' in *The Australian*, 10 July 2004, p. B18.

Croft, Brenda L., 'Blak lik mi' in *Art and Australia*, vol. 31, no. 1, Spring 1993, pp. 63–67.

Croft, Brenda L., 'Tribute: Michael Riley' in *Art and Australia*, vol. 42, no. 3, Autumn 2005, p. 392.

Croft, Brenda L., 'Touching the sublime' in *The Australian*, 2 September 2004, p. 14.

Croft, Brenda L., 'Picture this' in *New view: Indigenous photographic perspectives from the Monash Gallery of Art permanent collection*, exhibition catalogue, Wheelers Hill, Vic: Monash Gallery of Art, 2003.

Croft, Brenda L., 'Exhibition review' in *Periphery*, no. 40–41, Spring/Summer 1999–2000, pp. 52–55.

Croft, Brenda L., 'No need looking' in *Photofile: Traces*, no. 66, 2002, pp. 24–29.

Croft, Brenda L., 'Michael Riley: sights unseen' in '*World of antiques and art* issue 70, February–August 2006' p. 48.

Croft, Brenda L. (ed.), *Beyond the pale: Adelaide biennial of Australian art,* exhibition catalogue, Adelaide: Art Gallery of South Australia, 2000.

Croft, Brenda L., 'Indigenous Australian photography' in Lenman, Robin (ed.), *The Oxford companion to the photograph*, Oxford, UK: Oxford University Press, 2005.

Croft, Brenda L. in Taylor, Luke (ed.), *Painting the land story*, Canberra: National Museum of Australia, 1999.

De Lorenzo, C., 'Delayed exposure: Contemporary Aboriginal photography', in *Art and Australia*, vol. 31, no. 1, Spring 1993.

Dewdney, Andrew and Phillips, Sandra (eds.), *Racism, representation and photography*, Sydney: Inner City Education Centre, 1993.

Fenner, Felicity, 'Cryptic kitchen images' in *The Sydney Morning Herald*, 30 September, 1994.

'Grand old man of Talbragar has his memories', in *Dawn: A magazine for the Aboriginal people of New South Wales*, vol. 16, no. 1, January 1967, p. 1.

Gray, Anna (ed.), *Australian art in the National Gallery of Australia*, Canberra: National Gallery of Australia, 2002.

High tide: Contemporary Indigenous photography, exhibition catalogue, St Kilda, Vic: Linden–St Kilda Centre for Contemporary Arts, 2002.

Holmes, Natalie, 'Seven little Australians' in *Rolling Stone*, October 1990, pp. 78–81.

Huppatz, D.J., 'Beyond the pale' in *Like*, no. 12, Winter 2000, pp. 54–55.

Johnson, Vivien, *Australian art + Aboriginality*, exhibition catalogue, Portsmouth, UK: Aspex Gallery, 1987.

Kean, John, 'Beyond the pale' in *Artlink*, vol. 20, no. 1, 2000, pp. 68–69.

Koorie art '84, exhibition catalogue, Surry Hills, NSW: Artspace, 1984.

Langton, Marcia, *'Well I heard it on the radio and I saw it on the television': An essay for the Australian Film Commission on the politics and aesthetics of film-making by and about Aboriginal people and things,* North Sydney, NSW: Australian Film Commission, 1993.

Lee, Gary, 'Picturing: Aboriginal social and political photography' in *Artlink,* vol. 20, no. 1, March 2000, pp. 45–49.

Living here now: Art and politics – Australian perspecta, exhibition catalogue, Sydney: Art Gallery of New South Wales, 1999.

Low, L., 'You can take the boy out of Dubbo, but he'll bring his memories' in *The Sydney Morning Herald,* 4–5 December 2003, p. 7.

Mascarenhas, Alan, 'A river runs through with a message for survival' in *The Sydney Morning Herald,* 5 May 2004, p. 14.

McFarlane, Robert, 'Alive and clicking' in *The Sydney Morning Herald,* 27 December 2005, p. 22.

McFarlane, Robert, 'Images break free of time and place' in *The Sydney Morning Herald,* 31 May 2005, p. 18.

Meridian: Focus on contemporary Australian art, exhibition catalogue, Sydney, Australia: Museum of Contemporary Art, 2002.

Morphy, Howard, *Aboriginal art,* London: Phaidon Press, 1998.

Muirhead, John, 'Empire: Michael Riley' (review) in *Artlink,* vol. 19, no. 3.

Mundine, Djon, 'Obituary' in *Photofile: Contemporary photomedia + ideas,* issue 73, Summer 2005, pp. 62–63.

Mundine, Djon, 'His focus came from the heart' in *The Sydney Morning Herald,* 30 September 2004, p. 36.

National Aboriginal and Torres Strait Islander Heritage Art Award, exhibition catalogue, Canberra: Australian Heritage Commission, 1994.

National Inquiry into the Separation of Aboriginal and Torres Strait Islander Children from their Families (Australia), *Bringing them home: Report of the National Inquiry into the Separation of Aboriginal and Torres Strait Islander Children from their Families,* Sydney: Human Rights and Equal Opportunity Commission, 1997.

Neill, Rosemary, 'Cultures reign on the Seine' in *The Australian,* 23 October 2004, p. 14.

Newton, Gael, 'Michael Riley, 1960–2004' in *Artonview,* no. 40, Summer 2004, pp. 40–41.

Obituary: Alexander 'Tracker' Riley' in *Dawn: A magazine for the Aboriginal people of New South Wales,* vol. 1, no. 10, January 1971, Sydney: New South Wales Aborigines Welfare Board, p. 16.

Oltre il mito (Beyond myth), 48th Venice Biennale, exhibition catalogue, Venice: Edizioni Multigraf, 1999.

Papastergiadis, Nikos in Croft, Brenda L. (ed), *Beyond the pale: Adelaide biennial of Australian art,* exhibition catalogue, Adelaide: Art Gallery of South Australia, 2000.

Parbury, Nigel, *Survival: A history of Aboriginal life in New South Wales* Sydney: Ministry of Aboriginal Affairs, 1986.

Photographica Australis: Sala de Exposiciones del Canal de Isabel II, exhibition catalogue, Sydney: Australian Centre for Photography, 2002.

Photographica Australis: Asia tour, exhibition catalogue, Sydney: Australian Centre for Photography, 2003.

Plater, Diana (ed.), *Other boundaries: Inner-city Aboriginal stories,* Sydney: Jumbunna Aboriginal Education Centre, University of Technology, Sydney, and Leichhardt Municipal Council, Bagnall Publications, 1993.

Points of view: Australian photography 1985–95, exhibition catalogue, Sydney: Art Gallery of New South Wales, 2005.

'Police trackers: A fast vanishing race' in *Dawn: A magazine for the Aboriginal people of New South Wales,* vol. 6, no. 5, May 1957, Sydney: New South Wales Aborigines Welfare Board, p. 16.

'Police trackers: The final jottings from ex-Sergeant Tracker Riley's scrapbook' in *Dawn: A magazine for the Aboriginal people of New South Wales,* vol. 6, no. 7, July 1957, Sydney: New South Wales Aborigines Welfare Board, p. 9.

Quaill, Avril, *Marking our times: Selected works of art from the Aboriginal and Torres Strait Islander collection at the National Gallery of Australia,* Canberra, ACT: National Gallery of Australia, 1996.

Re-take: Contemporary Aboriginal and Torres Strait Islander photography, exhibition catalogue, Canberra: National Gallery of Australia, 1998.

Ridgeway, Senator Aden, *Vale Michael Riley: Artist, photographer, film maker,* Australian Democrats Press Release, 31 August 2004, viewed 1 May 2006, <http://www.democrats.org.au/news/index.htm?press_id=4018>.

Riley, Michael, *Yarns from the Talbragar Reserve: Photographs by Michael Riley,* exhibition catalogue, Dubbo, NSW: Dubbo Regional Art Gallery, 1999.

Ryan, Judith, with Akerman, Kim, *Images of power: Aboriginal art of the Kimberley,* exhibition catalogue, Melbourne: National Gallery of Victoria, 1993.

Spirit and place: Art in Australia 1861–1996, exhibition catalogue, Sydney: Museum of Contemporary Art, 1996

Stills Gallery, 'Michael Riley', artist's biography, Stills Gallery website, viewed 1 May 2006, <http://www.stillsgallery.com.au/artists/riey/index.php?obj_id=about&nav=0>.

Sutton, Peter (ed.), *Dreamings: The art of Aboriginal Australia,* exhibition catalogue, Ringwood, Vic: Viking in association with the Asia Society Galleries, New York, 1988.

'Tears for deadly artist' in *Deadly Vibe,* issue 93, November 2004, viewed 1 May 2006, <http://www.vibe.com.au/vibe/corporate/celebrity_vibe/showceleb.asp?id=392>.

'The Police tracker: Stories from Sgt. Riley's scrapbook' in *Dawn: A magazine for the Aboriginal people of New South Wales,* vol. 6, no. 6, June 1957, Sydney: New South Wales Aborigines Welfare Board, p. 14.

'The vanishing reserves' in *Dawn: A magazine for the Aboriginal people of New South Wales,* vol. 11, no. 11, November 1962, Sydney: New South Wales Aborigines Welfare Board, p. 6.

'They say' in *Dawn: A magazine for the Aboriginal people of New South Wales,* vol. 6, no. 6, June 1957, Sydney: New South Wales Aborigines Welfare Board, p. 3.

'Today's best' in *The Sydney Morning Herald,* 17 January 2003, p. 14.

True colours: Aboriginal and Torres Strait Islander artists raise the flag, exhibition catalogue, Chippendale, NSW: Boomalli Aboriginal Artists Co-operative, 1994.

(opposite) Screen grabs from *Eora* 1995 Museum of Sydney

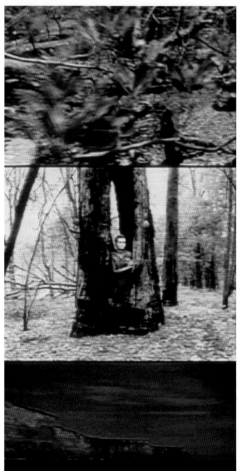

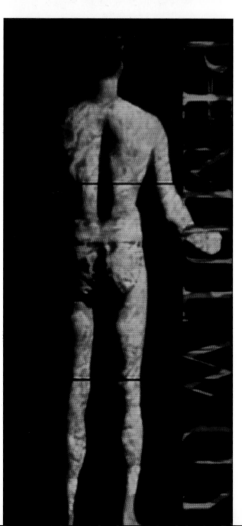

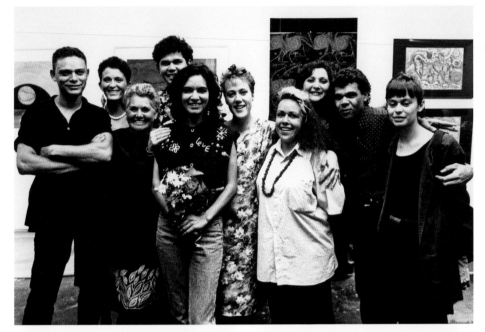

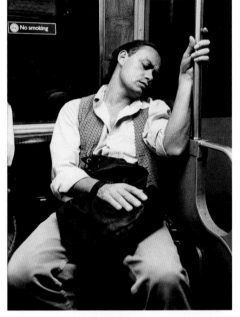

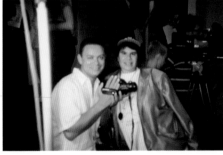

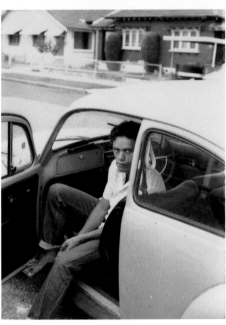

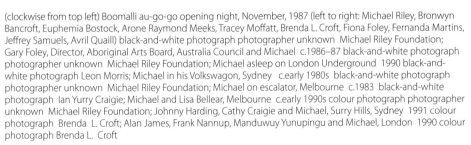

(clockwise from top left) Boomalli au-go-go opening night, November, 1987 (left to right: Michael Riley, Bronwyn Bancroft, Euphemia Bostock, Arone Raymond Meeks, Tracey Moffatt, Brenda L. Croft, Fiona Foley, Fernanda Martins, Jeffrey Samuels, Avril Quaill) black-and-white photograph photographer unknown Michael Riley Foundation; Gary Foley, Director, Aboriginal Arts Board, Australia Council and Michael c.1986–87 black-and-white photograph photographer unknown Michael Riley Foundation; Michael asleep on London Underground 1990 black-and-white photograph Leon Morris; Michael in his Volkswagon, Sydney c.early 1980s black-and-white photograph photographer unknown Michael Riley Foundation; Michael on escalator, Melbourne c.1983 black-and-white photograph Ian Yurry Craigie; Michael and Lisa Bellear, Melbourne c.early 1990s colour photograph photographer unknown Michael Riley Foundation; Johnny Harding, Cathy Craigie and Michael, Surry Hills, Sydney 1991 colour photograph Brenda L. Croft; Alan James, Frank Nannup, Manduwuy Yunupingu and Michael, London 1990 colour photograph Brenda L. Croft

Contributors

Joyce 'Dooki' Abraham (née Wright) is a member of the Kamilaroi people of Moree. She is the maternal aunt of Michael Riley, a member of Boomalli Aboriginal Artists Co-operative, and lives in Sydney.

Melissa Abraham is a member of Boomalli Aboriginal Artists Co-operative and Michael's cousin. She lives in Sydney.

Brent Beale is from the Kamilaroi people and lives in Moree with his partner Jackie French and their sons. He worked with Michael on the first Kamilaroi exhibition held in Sydney, *Moree mob* (1989), and was Indigenous curator at Moree Plains Regional Gallery when it opened. He is also an artist.

Anthony 'Ace' Bourke is a freelance researcher and curator, with over two decades involvement in the contemporary Indigenous visual arts/cultural industry. With Tracey Moffatt he initiated the first Indigenous photography exhibition in Sydney in 1986. He lives in Bundeena, New South Wales.

Dorothy Burns is a member of the Wiradjuri people of Dubbo. She is the mother of Will Burns and lives in Dubbo.

Will Burns is a member of the Wiradjuri people of Dubbo and has been an activist, closely involved with many local Indigenous community organisations, for many years. He is the Catchment Officer, Aboriginal Communities, Central West CMA, Dubbo. Michael's paternal grandmother and Will's paternal grandmother were sisters. Michael and Will grew up together on Talbragar Aboriginal Reserve, Dubbo, from 1960 to 1968–69. Will lives in Dubbo with his family.

Cathy Craigie is a member of the Kamilaroi people from Moree. She has been involved in the Indigenous visual arts/cultural industry for two and a half decades, working with community and government organisations. The founder of Koori Radio, she was Director of the Aboriginal and Torres Strait Islander Arts Board of the Australia Council for the Arts. Cathy is Michael's maternal cousin and lives in Sydney with her family.

Edna Craigie (née Cutmore) is the mother of Cathy and Ian 'Yurry' Craigie. She has been closely involved in the establishment of many Aboriginal community organisations, both in Sydney and Moree. She lives in Moree.

Ian 'Yurry' Craigie is a member of the Kamilaroi people from Moree. He undertook a traineeship at the Australian Centre for Photography, Paddington, in the early 1980s and encouraged Michael in his early endeavours with photography. Yurry lives in Moree with his family.

Brenda L. Croft is a member of the Gurindji and Mutpurra peoples from the Northern Territory. She is Senior Curator of Aboriginal and Torres Strait Islander Art at the National Gallery of Australia, Canberra. She is also an artist and has been involved in the Indigenous visual arts/cultural industry since the early 1980s. She is a founding member of Boomalli Aboriginal Artists Co-operative.

Destiny Deacon is a Melbourne-based artist. She is a member of the Kuku–Erub/Mer peoples from far-north Queensland and the Torres Strait Islands.

Francisco Fisher has worked in the arts for over 12 years. He is currently an arts consultant, designer and occasional artist.

Alasdair Foster is the director of the Australian Centre for Photography and managing editor of *Photofile* magazine.

Virginia Fraser is an artist and writer who lives in Melbourne. Her video and installation practice is both solo and collaborative and includes working with Destiny Deacon since the early 1990s.

Gloria 'Dort' French (née Cutmore) is a member of the Kamilaroi people and lives in Moree. She is the mother of Maria 'Polly' Cutmore and Jackie French; sister of Edna Craigie; and aunt of Cathy and Ian 'Yurry' Craigie.

Bruce Hart is a photographer who lectured in photography in London and Sydney from 1975 until 2004. His work is represented in the Victoria and Albert Museum, London, *Bibliotheque nationale*, Paris, and in many Australian collections. He now resides with his wife, writer Cheryl Walsh, in Iowa City, USA.

Wendy Hockley (née Riley) is the elder sister of Michael. She lives in Sydney.

Joe Hurst is a member of Boomalli Aboriginal Artists Co-operative and long-time friend and colleague of Michael. He was set designer on the film *Poison* and assisted with the studio setting for *Portraits by a window*. He is from western New South Wales and lives in Sydney.

Jonathan Jones is a Kamilaroi–Wiradjuri artist and curator. In 2000–2002, Jones was the curator at Boomalli Aboriginal Artists Co-operative. He is currently employed at the Art Gallery of New South Wales as Co-ordinator, Aboriginal Programs.

Victoria Lynn is an independent curator/writer based in Melbourne.

Ruby McGuinness is the daughter of Alec 'Tracker' Riley. She lives in Dubbo.

Diane McNaboe (née Riley) is a member of the Wiradjuri and Kamilaroi peoples of Dubbo and Moree. She is Michael's cousin and lives in Dubbo, where she works in Aboriginal education.

Lydia Miller is a Kuku–Yalanji woman from far-north Queensland and currently holds the position of Executive Director, Aboriginal and Torres Strait Islander Arts of the Australia Council.

Tracey Moffatt is an artist who lives and works both in Queensland and in New York. Highly regarded for her formal and stylistic experimentation in film, photography and video, there have been over 50 solo exhibitions of her work in Europe, the United States of America and Australia. Her films have been screened at the Cannes Film Festival, the Dia Centre for the Arts in New York, and *Centre national de la photographie*, Paris.

Djon Mundine OAM is a member of the Bandjalung people of northern New South Wales. He has had an extended career as a curator, activist, writer, and occasional artist and is renowned as the concept curator for the Aboriginal Memorial installation permanently exhibited at the National Gallery of Australia. Djon is currently Research Professor at Minpaku Museum of Ethnology in Osaka, Japan.

Lyall Munro Jnr is a member of the Kamilaroi people and lives in Moree and Sydney. He has been an activist for the past four decades and is closely involved with many Aboriginal community organisations, including the Aboriginal Legal Service.

Gael Newton is Senior Curator of Photography at the National Gallery of Australia, Canberra, and author of a number of reference works, exhibition catalogues and monographs on the history of photography. In the early 1990s, using the KODAK Australasia Pty Ltd Fund for emerging photoartists, she began a special focus collection of contemporary Indigenous photographers for the National Gallery of Australia permanent collection, recognising the significance of the emergence of Indigenous urban photographers in the mid-to-late 1980s.

Nikos Papastergiadis is a Reader and Associate Professor at the University of Melbourne. He has written extensively on art and cultural difference. His most recent books include *Spatial aesthetics* (London: Rivers Oram Press, 2006) and, as co-editor with Scott McQuire, *Empires, ruins and networks* (Melbourne: Melbourne University Press, 2005).

Hetti Perkins is a member of the Eastern Arrernte and Kalkadoon Aboriginal communities. She is the Senior Curator of Aboriginal and Torres Strait Islander Art at the Art Gallery of New South Wales in Sydney.

Rachel Perkins is a member of the Eastern Arrente and Kalkadoon Aboriginal communities. She is an independent filmmaker. In 1993, she established Blackfella Films with Michael Riley.

Frances Peters-Little is a filmmaker and historian. She is currently Deputy Director, Australian Centre for Indigenous History at the Australian National University (ANU).

Matthew Poll is Artistic Director of Boomalli Aboriginal Artists Co-operatve.

Avril Quaill is Principal Project Officer at the Queensland Indigenous Arts Marketing and Export Agency in the Queensland Government Department of State Development, Trade and Innovation. She was formerly Associate Curator, Indigenous Australian Art at the Queensland Art Gallery (2002–2004) and Senior Assistant Curator, Aboriginal and Torres Strait Islander Art at the National Gallery of Australia, Canberra (1995–2002) . She is a founding member of the Boomalli Aboriginal Artists Co-operative, Sydney.

Lisa Reihana is an artist and cultural producer. She has exhibited her multimedia work extensively, directed art documentaries and has written on Maori art and filmmaking.

Ben Riley is the son of artist Michael Riley. Born in Sydney in 1984, his interests include painting, writing and fishing. Ben currently lives in Brisbane.

Bernadette Yhi Riley is Michael Riley's paternal cousin. She worked with Michael on *Blacktracker* (1996) and has been involved in numerous Indigenous community organisations. She lives in Dubbo.

Dorothy Riley (née Wright) is a member of the Kamilaroi people of Moree. She is Michael's mother and lives in Dubbo.

Ron Riley is a member of the Wiradjuri people of Dubbo and has been actively involved in Indigenous community organisations for many years. He is the brother of Michael's father, Allen 'Rocko' Riley. He lives in Dubbo.

Lynette Riley-Mundine is Michael Riley's maternal and paternal cousin. She has worked in Aboriginal education since the mid-1980s. She lives in Sydney.

Troy J. Russell is a filmmaker. He directed an award-winning film called *The foundation 1963–1975* and was cinematographer on Melissa Abraham's short film, *11:11*. His animation, *The Bungalunga man,* created with his brother Shane, won a jury prize special commendation at the 1995 Annecy International Animation Festival in France. Troy is currently a freelance graphic artist and plays bass for the band, The Black Turtles.

Deborah Ryan is a member of the Wiradjuri people of Dubbo, where she lives and works in Aboriginal education. She is Michael's cousin.

Jeffrey Samuels is from western New South Wales. He is a founding member of Boomalli Aboriginal Artists Co-operative. He was involved in the exhibitions *Koorie art '84* (1984) and *Urban Koories* (1986), both of which included Michael's work. He has lived in Sydney since the 1970s.

Darrell Sibosado is a member of the Bardi people of north-west Western Australia. He has lived in Sydney since the mid-1980s, when he enrolled at the Aboriginal and Islander Dance Theatre. He has worked in the Indigenous visual arts/cultural industry over the past two decades.

Peter 'P.J.' Swan is a member of the Kamilaroi people of Moree. He assisted Michael on the organisation of the photographic shoot for *A common place: Portraits of Moree Murries*. He lives in Moree.

Warwick Thornton and Beck Cole are Aboriginal filmmakers from central Australia. They are based in Sydney.

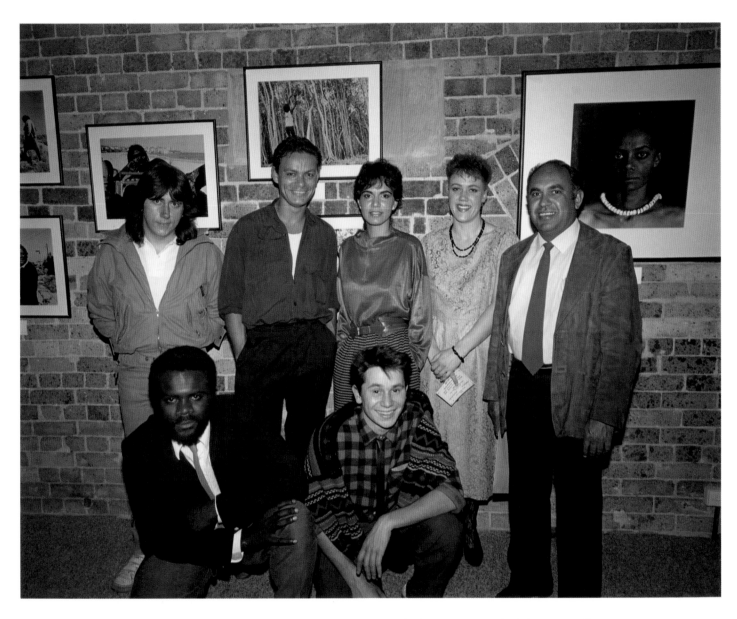

NADOC '86 Exhibition of Aboriginal and Islander photographers opening night, 6 September 1986 (back: Darren Kemp, Michael Riley, Tracey Moffatt, Brenda L. Croft, Mervyn Bishop; front: Tony Davis, Chris Robinson) 1986 black-and-white print Michael Riley Foundation photograph: Willam Yang

Acknowledgments

It has been a great honour and, at the same time, extremely humbling for me to work on *Michael Riley: sights unseen.* Michael's family, friends, colleagues, supporters and admirers have generously given their time and memories in the most open manner and I cannot thank them enough. This major retrospective for one of Australia's most significant contemporary artists, *Michael Riley: sights unseen*, and the accompanying publication have been very much a collaborative effort, and I would like to gratefully acknowledge the support of the many individuals without whose assistance the project could not have been realised.

Firstly, I must thank all my colleagues at the National Gallery of Australia, Canberra. I wish to particularly thank the staff of the Aboriginal and Torres Strait Islander Art Department, Tina Baum, Curator, and Simona Barkus, Trainee Assistant Curator, for their immeasurable assistance. Also, considerable thanks to volunteer intern, Majella Brown, and former staff members, Susan Jenkins and Stephen Gilchrist, for their work before they left the Gallery. Gael Newton, Senior Curator, International and Australian Photography, has provided invaluable advice on this project. Beatrice Gralton and Katrina Power of the Exhibitions and Registration departments have also been wonderful, juggling endless lists, meetings and other projects like two glamorous circus stars. Sincere thanks to Adam Worrall, Patrice Riboust, Helen Motbey, Ruth Patterson, Andrew Powrie and David Alcorn for their invaluable input towards the look, design, and feel of the exhibition and publication. Thank you also to José Robertson and Kaoru Alfonso of the Multimedia department, who have been so helpful in advising on audio/visual requirements, sourcing and tracking film material, and to Brenton McGeachie, Leanne Handreck and all in Imaging Resources Unit. I would also like to thank the Travelling Exhibitions team, especially Dominique Nagy, who flew in such small planes to Moree and Dubbo with me on research, and Belinda Cotton, whose work on the touring aspect of *Michael Riley: sights unseen* has been magnificent; Vicki Marsh from the Research Library; Elizabeth Malone, Alix Fiveash and Todd Hayward from Marketing and Public Affairs; and John Kearns and Barbara Reinstadler from the Finance department. To staff in Public Programs and Education – thank you for all your help. Many thanks to those in Development, Conservation, Registration and Framing whose contributions were always thorough and cheerful. I would like to express my appreciation to all my colleagues in Australian Art, especially Deborah Hart, Senior Curator of Australian Art and curator of *Imants Tillers: One world many visions,* which will be showing concurrently with *Michael Riley: sights unseen* in Canberra. Finally, special thanks must go to Ron Radford, Director, National Gallery of Australia; Dr Brian Kennedy, former Director; and Ruth Patterson, Assistant Director, Marketing and Merchandising, for their essential support for this retrospective exhibition.

The exhibition and associated publication would not have been possible without the assistance of many other individuals and organisations.

Curatorial researchers Anthony 'Ace' Bourke and Jonathan Jones were instrumental in chasing up the most obscure research material and collating it into a format that was easy to access. Given Michael Riley's lack of recordkeeping, they must be doubly congratulated on their contribution. Heartfelt thanks also to Bernadette Yhi Riley for her help with our research trip to Dubbo; Cathy Craigie for her help with the Moree research trip; and my 'sister', Hetti Perkins, for all her advice as a friend, colleague and member of the Michael Riley Foundation.

I would like to thank the sponsors and funding organisations without whose support the exhibition and this publication would not have been realised: the Michael Riley Foundation; and the Aboriginal and Torres Strait Islander Arts Board of the Australia Council for the Arts. Thank you also to Boomalli Aboriginal Artists Co-operative, especially to Matthew Poll, Artistic Director, for assistance with interviews.

It was fulfilling and inspiring reading and listening to all the individual contributions which have enhanced my understanding of Michael Riley's life and allowed me to attempt to bring his life's work to the broad audience it deserves. I am eternally indebted to all those listed as contributors – you are very special people.

Many lenders have contributed to the exhibition and I would like to thank the following for their generosity: Pat Corrigan; Hetti Perkins;

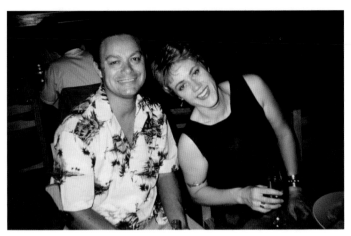

Michael and Brenda L. Croft, Sydney 1996

Rachel Perkins; Linda Burney; Sheryl Connors and the Australian Museum; Dubbo Regional Cultural Centre and Art Gallery and Western Plains Regional Cultural Centre; Katrina Rumley, Moree Plains Regional Gallery; Monash Art Gallery; Ruark Lewis; Elaine Pelot Syron and Black Fella's Dreaming Museum; Di Hoskings, Sally McNicol and Craig Greene at the Australian Institute of Aboriginal and Torres Strait Islander Studies; Julie Ewington and Ben Wickes at Queensland Art Gallery; Cara Pinchbek, Jonathan Jones and Hetti Perkins at the Art Gallery of New South Wales; Beth Hise, Inara Walden and Tim Curling-Butcher at the Museum of Sydney; Amanda Duthie, Pauline Clague and staff at ABC Television; Film Australia; the Australian Film Commission; Blackfella Films; Roslyn Oxley9 Gallery; Wendy Hockley and Dorothy Riley; Bernadette Yhi Riley; Cathy Craigie; Lisa Bellear; Anthony 'Ace' Bourke; Yurry Craigie; Gloria 'Dort' French; Tracey Moffatt; Jane Scott and Monash Gallery of Art; Avril Quaill; Dillon Kombumberri; Melissa Roncolato; Boomalli Aboriginal Artists Co-operative; and special thanks to the Michael Riley Foundation.

In addition, I would like to say a special thanks to the publications team for their work on the catalogue, *Michael Riley: sights unseen*. It was a joy working with editor Kathryn Favelle, whose advice was always on the money; and Kirsty Morrison, who responded to Michael Riley's artistic vision in the design and layout of the publication. Also, thanks to Erica Seccombe, Raylee Singh and Bill Phippard.

Finally, I would like to thank the following people for their contribution to what has been an exhilarating project: Robert McFarlane, colleague and friend of Michael's; Ronald Briggs, Australian Indigenous Services, State Library of New South Wales; Noelene Briggs-Smith; Telphia Joseph; and Elizabeth Ann McGregor, Judith Blackall and Keith Munro at the Museum of Contemporary Art, Sydney.

This was truly a collaborative effort and I hope that we have done Michael proud.

Brenda L. Croft
Senior Curator, Aboriginal and Torres Strait Islander Art
National Gallery of Australia

Index

This index is arranged alphabetically, word for word. *Italic* page numbers refer to captions for illustrations.

Michael's grandparents house, Moree Aboriginal Reserve mid-1980s Michael Riley Foundation